THE MAKING OF A MODERN MUSEUM

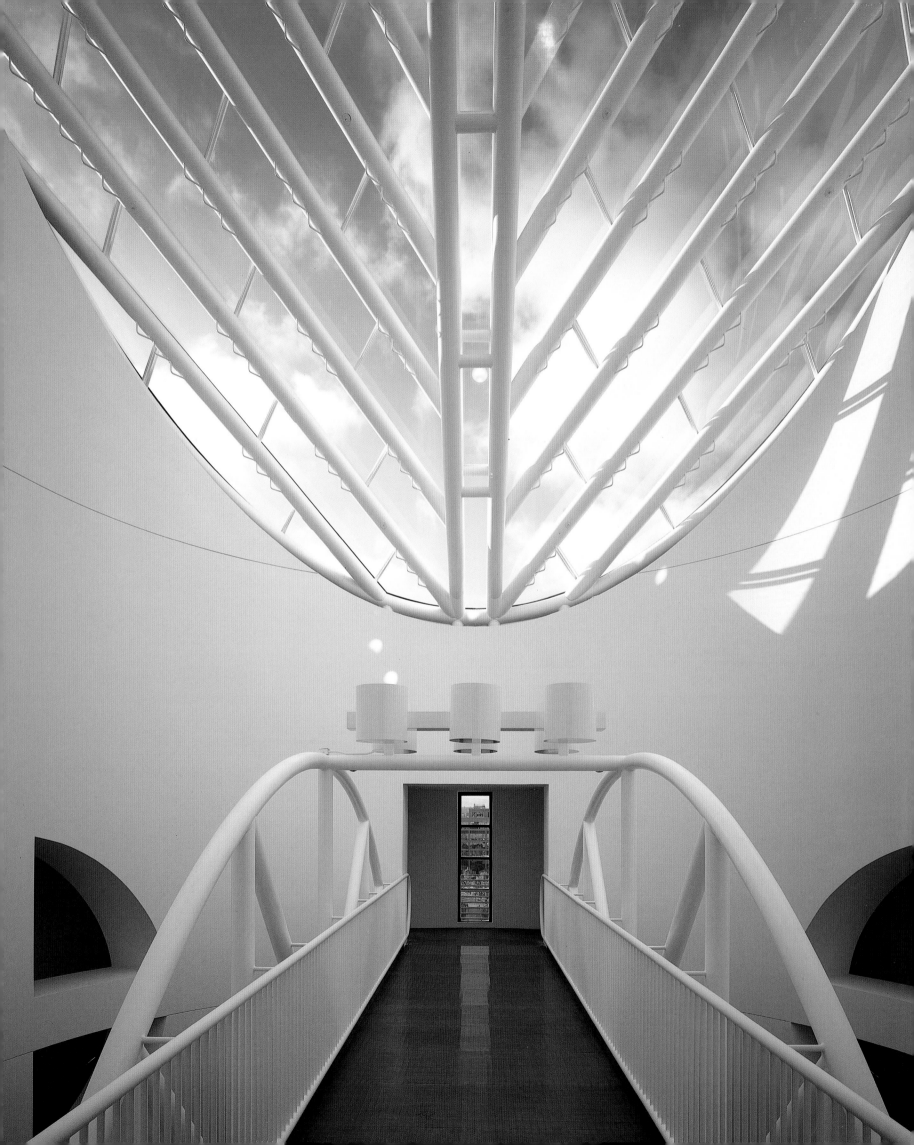

THE MAKING OF A MODERN MUSEUM

San Francisco Museum of Modern Art

The Making of a Modern Museum is published on the occasion of the sixtieth anniversary of the San Francisco Museum of Modern Art and the inauguration of the Museum's new building on January 18, 1995.

Library of Congress Cataloging-in-Publication Data:

The making of a modern museum: San Francisco Museum of Modern Art / [executive editor, John R. Lane].
 p. cm.
 ISBN 0-918471-32-x (hardcover). —ISBN 0-918471-31-1 (softcover)
 1. Art, Modern—20th century—Exhibitions. 2. Art—California—
San Francisco—Exhibitions. 3. San Francisco Museum of Modern Art—
Exhibitions. I. San Francisco Museum of Modern Art.
 N6487.S2S254 1995
709'.04'007479461—dc20 94-17616
 CIP

Executive Editor: John R. Lane
Editor: Kara Kirk
Designer: Tracy Davis
Editorial Assistant: Alexandra Chappell
Photography Coordinators: Jennifer Small and Rachel Ruben
Text Composition: Phoebe Bixler, San Anselmo
Printing: Global Interprint, Inc., Petaluma

Cover:
Exterior view of the new SFMOMA building (detail).
Frontispiece:
View of the atrium skylight and bridge from the fifth floor lobby.
Back Cover:
View of the atrium skylight and bridge from below.
Photography by Richard Barnes

Printed and bound in Hong Kong.

This is an extraordinary moment in the history of the San Francisco Museum of Modern Art. With the inauguration of a splendid new facility, appropriately timed to coincide with the date of its sixtieth anniversary, this museum and its supporters have much to celebrate. It is impossible to appreciate the significance of the creation of a new SFMOMA without taking into account the contributions of its trustees, past and present. A standard of excellence and steadfast determination to offer the San Francisco Bay Area a genuinely important art museum characterized this institution from the very start. I believe that previous generations of trustees would view the accomplishments embodied so dramatically in our new building as nothing less than an altogether fitting evolution of their aspirations for the Museum.

The San Francisco Museum of Art (as it was called until 1975) opened in its first permanent home in the War Memorial Veterans Building, located in the city's Civic Center, on January 18, 1935. This moment was the realization of a dream long held by a devoted set of advocates: to bestow this community with a vital center for the presentation and appreciation of art. At last, SFMOMA had a solid foundation on which to build an exceptional program of exhibiting, collecting, and educating, and San Francisco had a museum of international contemporary art, only the second of its kind in the country. That the Museum made great growth and achieved success almost immediately can be attributed to the active and effective involvement of a small cadre of SFMOMA's founding trustees. William W. Crocker, who served as the Museum's president (1935–1948) and chairman of the board (1948–1964), played a crucial role in assuring the Museum's financial stability in its early years. Others, including Albert M. Bender, William L. Gerstle, Charles Kendrick, and Timothy L. Pflueger, will be remembered for their guidance in establishing the Museum and its policies and for fostering the growth of the permanent collection through their many generous benefactions of artwork. The Women's Board, also founded in 1935, played a key role in the early development of the Museum as well, particularly its strong engagement in educational activities aimed at enriching and enlivening the experience of contemporary art.

From the outset this dedicated group set a course for SFMOMA that distinguished it from many other museums. An early mission statement cites one of its salient features: "In addition to the permanent collection, the major appeal of the Museum will be the periodic changing of exhibits…. The broad policy of the Museum in obtaining vitally interesting contemporary art will assure San Francisco of many colorful displays… [and] will keep the exhibits liquid, thereby maintaining continuous public interest." This goal was amply borne out; in the first two years of its existence, the Museum mounted an astounding 146 shows.

Throughout its history the Board of Trustees has been presided over by a number of committed individuals whose leadership qualities and dedication to the Museum are worth noting here. Brayton Wilbur, who succeeded William W. Crocker as president of the Board (1948–55); E. Morris Cox (1955–60), Jaquelin Hume (1960–63), Moses Lasky (1963–64), Elise Stern Haas, who, after serving for many years on the Museum's Women's Board, was elected the first woman president of the Board of Trustees (1964–66); Mortimer Fleishhacker, Jr. (1966–68); Charles C. de Limur (1968–69); William M. Roth (1969–73); Mrs. John L. Bradley (1973–75); Eugene E. Trefethen, Jr. (1975–81) all served as Board president. In 1981, with the growth of the Museum and the increasing demands on trustee leadership, the responsibilities of the head of the Board were divided between a chairman and a president. Eugene E. Trefethen, Jr., first served in the newly created role of chairman (1981–82), followed by Evelyn D. Haas (1982–84), and myself. Serving as president during this time were Evelyn D. Haas (1981–82 and 1984–88), Alan L. Stein (1982–84), Sandra S. Hobson (1988–89), and Elaine McKeon (1989 to the present).

Today, with a new generation of trustees charged with bringing SFMOMA into the twenty-first century, the pioneering goals of the Museum's founding trustees remain a steady vision, despite the vast and complex changes that have transformed the art world since their plan was first articulated. The Museum's current trustees—who are named individually on page 149 of this publication—have capably carried on this tradition with their firm pledge to offer an artistic legacy to the community, the nation, and the world. Their continued

dedication to SFMOMA's mission to collect, preserve, present, and interpret the most important and innovative art of this century culminates in the inauguration of our new building.

By the Museum's fiftieth anniversary in 1985, it had become apparent that SFMOMA could not continue as a viable institution in its Civic Center quarters. The Museum needed a facility that would not only welcome and serve visitors more comfortably, but would also allow it to host superior exhibitions for the public, to present its important permanent collection, and to provide the space that would encourage future gifts of art.

Nevertheless, when a group of trustees and longtime friends of the San Francisco Museum of Modern Art gathered around a conference table in late 1988 and contemplated an unprecedented capital fund-raising campaign for this new building, no one was certain the Museum could raise the $85 million we determined was needed. Later that spring, after completing a quiet planning study which helped to satisfy us that we could succeed in reaching that figure—a goal that no other cultural organization in Northern California had ever endeavored to meet—we went to the Board of Trustees in June 1989 and gained approval to launch the New Museum Campaign.

The New Museum Campaign has exceeded its goal of $85 million and raised more than $90 million in gifts to construct and endow the new SFMOMA. Staged over a five-year period, the campaign met its first mark of $65 million in September 1990, spurred to that impressive target by a challenge grant of $10 million offered by a family well known in the Bay Area for its generous philanthropy. With that enormous grant matched in equal measure by another trustee and his family, and supplemented by additional trustee gifts, the resulting $65 million raised in one year's time represents what we understand to be a record for charitable giving by a board of trustees.

Phase I of the four-phased campaign was directed by what many people consider to be the finest leadership group ever assembled for a fund-raising campaign in the Bay Area; its members included our most generous supporters who, after making their own landmark contributions, went on to meet with and obtain gifts and pledges from a myriad of individuals, companies, and foundations. I join the Museum in saluting the stalwart members of the New Museum Campaign Cabinet: Gerson Bakar, John G. Bowes, Donald G. Fisher, Evelyn D. Haas, Mimi L. Haas, Peter E. Haas, Elaine McKeon, Stuart G. Moldaw, Charles R. Schwab, Eugene E. Trefethen, Jr., Phyllis Wattis, William Wilson III, and the Museum's director, John R. Lane. I had the honor of chairing this distinguished group of civic leaders, a group that convened regularly and cheerfully throughout each stage of the cam-

paign. Without their record-setting contributions of financial support, guidance, and plain hard work the new Museum could never have been achieved.

Cabinet member Peter Haas led the effort to secure support from the Bay Area business community, and two additions to the Cabinet, Roselyne C. Swig and Steven H. Oliver, agreed to lead Phases II and III, respectively, of the overall effort. Phase II exceeded its target of $15 million, with over $17 million pledged in time for spectacular groundbreaking ceremonies on April 7 and 8, 1992. The Phase III effort, highlighted by the Architects Club and Builders Club programs, raised the final $5 million and introduced the Museum to a large number of new friends. Phase IV, executed in a mail and telephone campaign concurrent with Phase III, reached out to hundreds of SFMOMA members and raised almost $1 million. This campaign represents a private-sector effort of the first order, with over 90% of the money raised coming from private individuals and family foundations, 6% from foundations, 3% from corporations, and under 1% from government sources.

Concurrent with the massive fund-raising effort was a lengthy negotiating process to secure the land that would enable SFMOMA to move downtown and build a freestanding museum. After considerable negotiations with the Redevelopment Agency of the City and County of San Francisco, in January 1991 the Museum finalized the acquisition of its Third Street site in Yerba Buena Gardens, the Agency's 87-acre, mixed-use project in the South-of-Market area. I am grateful to the Agency, and particularly its former Executive Director Ed Heldfeld, for their efforts on behalf of the Museum.

The Campaign could not have been successful without a talented and dedicated staff running an exciting program in the old Museum, while at the same time working out the detailed specifications for the new one. Everyone has had two jobs for the last five years and we are most fortunate to have had an outstanding director in Jack Lane, who has assembled a wonderful staff and has very definitely put his personal mark on the new Museum.

It is with great pleasure that I offer heartfelt thanks and gratitude to all of the committed individuals who have joined forces to build a new monument and cultural resource for the Bay Area and beyond. They have made the transformation of SFMOMA a reality, and the legacy of their efforts will be enjoyed by residents and visitors for generations to come.

Brooks Walker, Jr.
Chairman, Board of Trustees

The dream of Modernism has been to reinvent everything, looking to the present and the future rather than the past for forms that speak authoritatively about and advocate the improvement of the contemporary human experience. But given the weight of the histories that accrue to well-established cultural institutions, the opportunity to start all over again, to try to get it just right, is rarely offered. The San Francisco Museum of Modern Art, which opened in 1935 as the first museum of modern art in America outside New York, is that exceptional case in which a venerable arts organization determined to utterly transform itself. And so, on the occasion of its sixtieth anniversary, SFMOMA set about to open a new building that, through the unapologetic grandness of its architecture, the generosity of its public spaces and visitor services, and the quality of its galleries and educational facilities, would announce symbolically its coming of age as an institution of the first importance to the cultural life of the San Francisco Bay Area and, on an international level, as a contributor of consequence to contemporary artistic culture.

The Museum has been able to accomplish this radical physical change while remaining true to the founding concepts that have informed and sustained its commitment to the service of art for sixty years. This enduring and inspiring vision was articulated in the 1930s by Grace McCann Morley, the Museum's first director, who believed deeply in contemporary art and artists, and in the importance of early modernism in its own right and as an essential historical precedent to the work of today. Dr. Morley was also strongly committed to fostering the diversity of cultures and media from which new art arises, and in the idea that modern and contemporary art is a source of aesthetic pleasure and enlightened learning for a broadly defined public.

This publication, edited by Kara Kirk, designed by Tracy Davis, and directed by Inge-Lise Eckmann, presents a compilation of those elements for which the Museum is most proud: its new building designed by Mario Botta, depicted in a photographic essay by Richard Barnes; its history, encapsulated in an essay by Teresa M. Tauchi; and its collections, represented by selected highlights and elucidated by the commentaries of Andrew W. Mellon Foundation Assistant Curator of Painting and Sculpture Janet C. Bishop, Elise S. Haas Chief Curator and Curator of Painting and Sculpture Gary Garrels, Assistant Curator of Photography Douglas R. Nickel, Curator of Photography Sandra S. Phillips, former Curator of Architecture and Design Paolo Polledri, Curator of Media Arts Robert R. Riley, Chief Conservator J. William Shank, and Curator of Education and Public Programs John Weber.

Marking the culmination of the building project and capital campaign—decade-long endeavors from concept to completion that required the farsighted, generous, and dedicated efforts of a great many individuals to create a new physical facility and provide an appropriate endowment for its operation—this book celebrates an extraordinary achievement. It has been the great, good fortune of SFMOMA that the strength of the ideas for this institution's advancement has merited a remarkable level of high-minded cooperation, a spirit that has characterized every phase of the project's development. The exceptional skills and admirable values of Brooks Walker, Jr., chairman of the Board of Trustees since 1984, were absolutely central in sustaining and directing this goodwill to such a productive end, and his keen mind and artful leadership were essential ingredients in virtually every success. It has been a privilege and a pleasure to serve the Museum and its Board under his stewardship during this period of dramatic institution-building.

Foremost among the criteria by which the stature of an art museum is judged is its permanent collection. It was the *The 20th Century*, SFMOMA's fiftieth-anniversary exhibition organized by my predecessor Henry T. Hopkins for the winter of 1984–85, an astonishing show commanding the entirety of the galleries and featuring some six hundred works from the permanent collection and fifty promised gifts, that demonstrated decisively the depth and scope of the collection. This seminal exhibition also confirmed how utterly inadequate the War Memorial Veterans Building in the Civic Center had become to the Museum's dual responsibility of presenting an active special exhibitions program and showing a meaningful selection of its own artwork. This plight was further exacerbated by a very real concern that the lack of exhibition space would discourage patrons from making gifts to what was largely a hidden collection. With the determination made to build a new Museum that would have twice the gallery space (and one which incorporates expansion plans that allow eventually for tripling it), Trustees Donald G. Fisher, Mimi L. Haas, and Toby Schreiber provided instrumental guidance to the process of developing the collection with the result that since 1985 the Museum's

art holdings have doubled, thanks in part to generous collectors and in part to the purchases made possible by contributions from the members of the Accessions Committee. The entire curatorial staff, and most particularly our late colleague John Caldwell, played a critical part in encouraging the collecting community and galvanizing it around the Museum, a development that is already paying important dividends and has happy implications for the future. During the inaugural year, SFMOMA will be showing many works of art of exceptional importance given in honor of the new Museum.

From a distinguished international field, Mario Botta was the unanimous choice of the Architect Selection Committee, to whom he seemed ideally suited, both by artistic and philosophical bent and by personal temperament, to design our new building. This perception has been validated over the course of an intense, five-year architect-client relationship. We asked Botta to give us a strong, memorable exterior, exhilarating interior public spaces, and quiet, handsome galleries that would take advantage of the unsurpassed quality of the Bay Area's natural light. He responded to our wishes with a clear vision, one that always addressed the Museum's requirements without ever sacrificing architectural principles and his personal design integrity. We offer him profound thanks for the wonderful building he has created for us—his first museum and his first project in the United States—and enthusiastic acknowledgment of the pleasure we derived from working with him.

Similar gratitude is extended to Trustees Gerson Bakar, the indefatigable, creative personality behind the relocation of the Museum to Yerba Buena Gardens, and Thomas B. Swift, who, possessed of a combined passion for sophisticated architecture and a masterly grasp of design development and construction, oversaw the management of the building project. Trustee Phyllis Wattis, with her superb prescience, was among the first donors to make a major commitment to the concept of moving the Museum to the South-of-Market Street neighborhood. Board President Elaine McKeon led the extraordinary efforts of both the Groundbreaking and Grand Opening Celebration committees, which were dedicated to creating special events commensurate with the significance and aspirations of the new Museum. Trustee and past Chairman Evelyn D. Haas, adding her own exceptional talents to a family legacy of deep commitment to SFMOMA, vigorously headed the Museum's successful endeavor to expand its membership, and Trustee Frances F. Bowes, with incomparable devotion and imagination—and in the face of the formidable needs of the capital campaign—led the effort to increase the annual fund that supports the Museum's artistic programs and operations.

We acknowledge with sincere appreciation our capital campaign counsel, Christopher Hest of Fitzgerald & Graves, architect selection advisors James N. Wood, Joseph Esherick, and John Morris Dixon, and the entire project group that worked to create the building, including Ugo Früh of Mario Botta Architetto; Richard Young of Bechtel International Company; Hellmuth, Obata & Kassabaum, Inc.; Swinerton & Walberg Company; Helen Sause of the San Francisco Redevelopment Agency; the many consultants, subcontractors, and suppliers; and the members of the SFMOMA team, particularly M.C. Abramson, Dirk Foreman, Marcy Goodwin, Gregory Johnson, and Kent Roberts.

A great many SFMOMA staff members, both past and present (a current list of the Museum's staff appears on pages 150–51 of this publication), have been involved in activities in support of the new Museum, including architectural program development; planning and supporting the work of the capital campaign; long-range financial planning; enterprise activities planning; preparing for and implementing the move of the collections, personnel, and offices; new building operations planning; public relations and marketing programming; artistic and education programs development; and organizing the opening events. All of this was accomplished at the same time as those individuals were carrying out their regular duties on behalf of an active, ongoing museum, and I appreciate what each of them has given toward the realization of this grand undertaking. I wish particularly to thank my colleagues on the Museum's senior management staff: Director of Public Relations and Marketing P. Chelsea Brown, Deputy Director Inge-Lise Eckmann, Chief Curator Gary Garrels, Director of Development Virginia Carollo Rubin, and Chief Financial Officer Ikuko Satoda. Their personal contributions transcend the highest notions of professionalism.

To past and current trustees who have guided and cared for this museum, to my predecessors and their staffs who cultivated its programs and collection, to the generous donors of funds and works of art and the volunteers who have sustained and enriched this organization over the years, to the many individuals who have contributed to the creation of our splendid new building and the endowment to operate it, and to our members and visitors—past, present, and future—who animate this institution and provide it a lively reason to exist, I offer heartfelt thanks. And, to the new SFMOMA, I wish the joy of your sixtieth birthday!

John R. Lane
Director

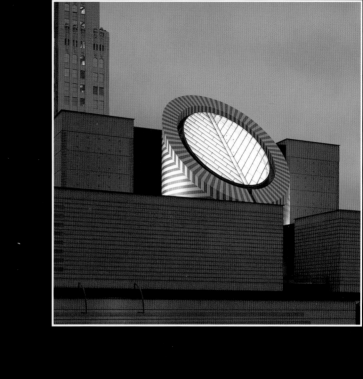

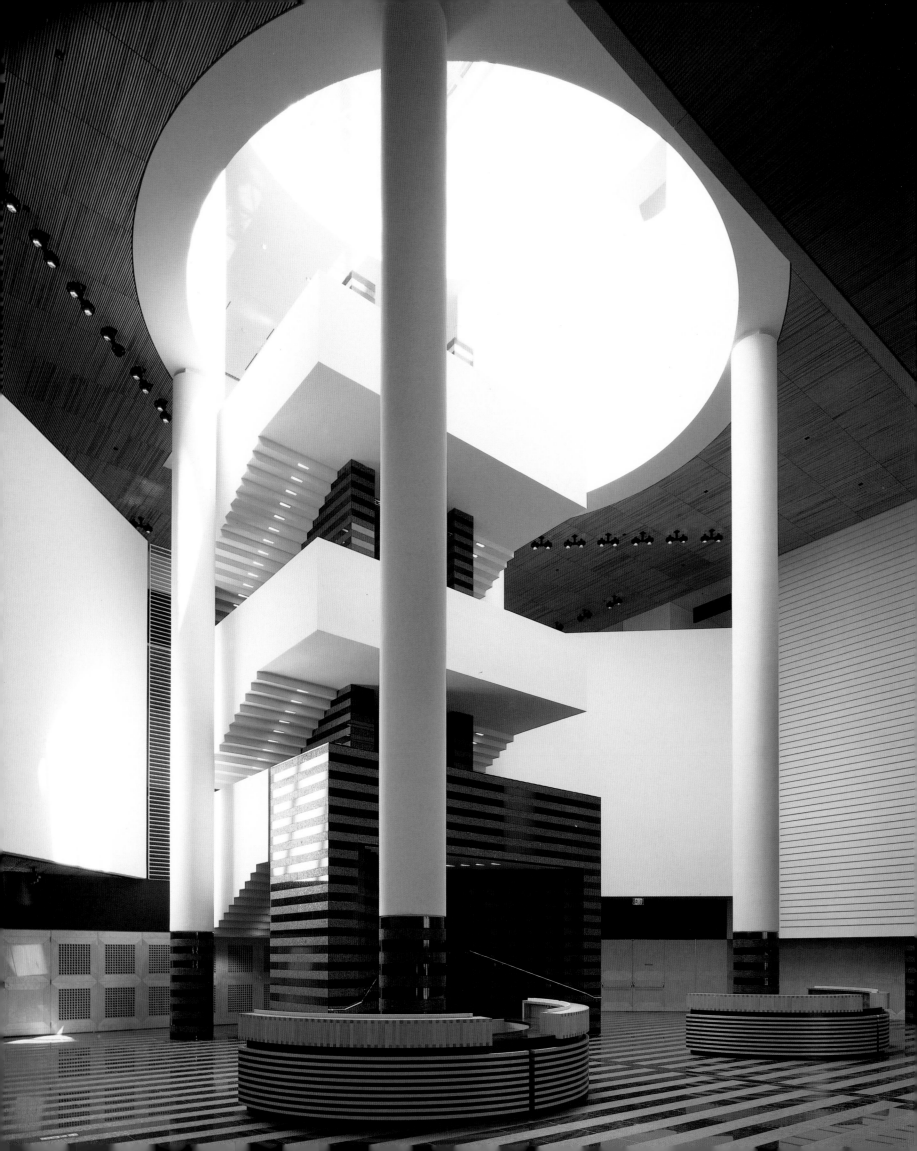

ENVISIONING A NEW MUSEUM

Monumental in scale, classic in spirit. The new San Francisco Museum of Modern Art is a benchmark in the history of American museum architecture. By virtue of its magnitude and grandeur, it is the first building designed from the outset to reflect symbolically the relatively new role that museums of modern and contemporary art have assumed as institutions of the first importance to the cultural life of their communities. This bold, modernist structure, with its powerful geometric forms and burnt-sienna façade, assumes a commanding presence in the midst of downtown San Francisco's architectural landscape.

Inside, an enormous central skylight—a single "window on the sky" housed in the building's soaring cylindrical turret—bathes the piazza-inspired atrium below with the unsurpassed light of the Bay Area, revealing the elegant rhythm of the striped granite floors and rich texture of the birch-wood walls. Quiet refuge is found upstairs in pristine gallery spaces that offer the ideal setting for great works of modern and contemporary art.

When SFMOMA selected Mario Botta to design its new facility on Third Street adjacent to Yerba Buena Gardens, the commission represented the esteemed Swiss architect's first building project in the United States and his first museum. In its completed form, the new SFMOMA is the realization of Botta's vision to "discover that perfect balance where architecture and art enrich one another." The design conveys the architect's distinctive tribute to the modernist tradition, as well as his acute sensitivity to space, proportion, natural light, materials, and, most importantly, the artworks themselves.

Botta has equated the role of today's museum with religious temples of earlier times. In his design for the San Francisco Museum of Modern Art, the architect has upheld his dedication to the idea of the spiritual role of the museum in a secular society by creating a humanist environment of enlightenment for art and for the viewer's intellectual and spiritual life.

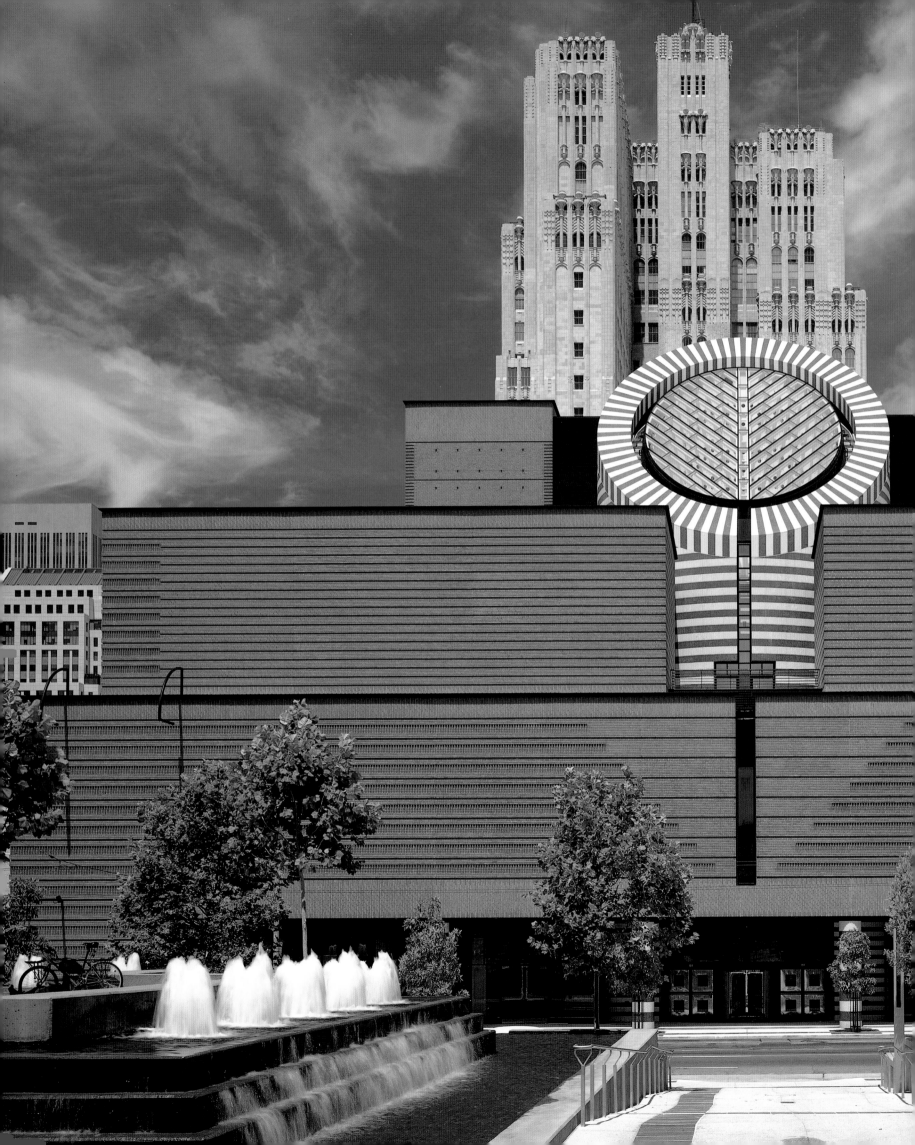

Left:

The San Francisco Museum of Modern Art, looking eastward from Yerba Buena Gardens. A pure and powerful design rooted in the modernist tradition, the building features a stepped-back brick-and-stone façade distinguished by a central cylindrical turret. In the background is the Pacific Telephone and Telegraph building, 1925, designed by architect Timothy Pflueger, one of the founding trustees of SFMOMA.

Previous pages:

The Museum's turret rises jewel-like against the night sky. Seen from the interior during the day, the turret's skylight illuminates the dramatic five-story atrium and central staircase. Museum visitors first enter into the atrium—the heart of the building—from which they can gain access to all public areas including the theater, cafe, store, events space, classrooms, and galleries. Reflecting Botta's affinity for natural materials, the atrium is paved in striated granite and the lower portion of the walls is finished with a wainscoat of Nordic icebirch. The four central columns, structural elements supporting the turret, are enclosed in a decorative material and have granite bases.

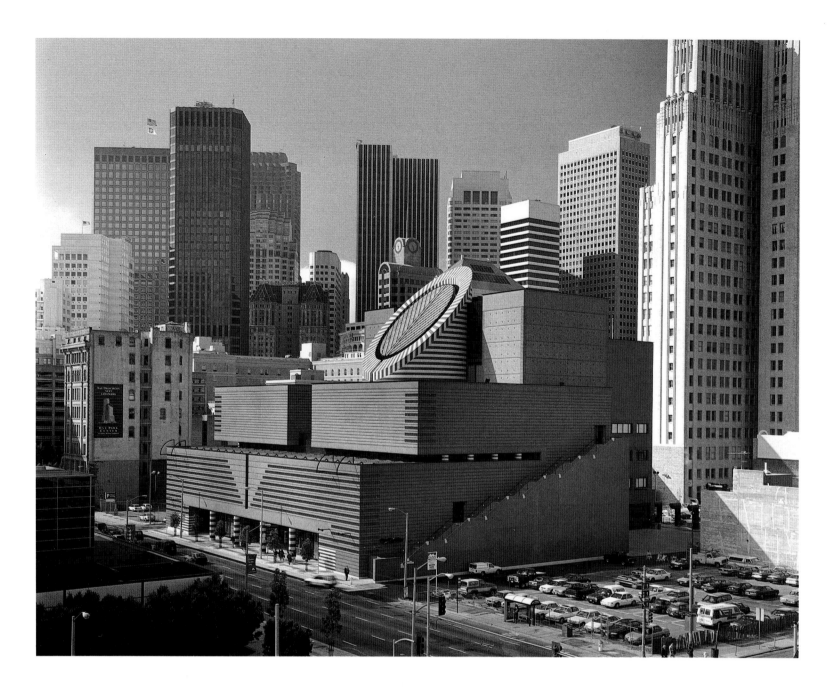

Above:

In its new downtown location the Museum serves as an anchor for Yerba Buena Gardens, a twelve-block area that includes the Moscone Convention Center, the Ansel Adams Center for Photography, and the Center for the Arts. The forerunner of a number of new projects slated for this neighborhood, the Museum will eventually be flanked by taller buildings that will provide a greater context for its massive façade. Until then, visible on the south side of the Museum is a staircase cascading gracefully down the side of the building—a life-safety code requirement turned by Botta into a dramatic architectural element. Located at the rear of the building are three floors of staff offices. Detailing in the cladding shows a band of rotated bricks starting at the wedge shape above the main entrance with horizontal brick joints raked to exaggerate the horizontal expression of the building and to create a rhythmic shading pattern.

Right:

A close-up of the cylindrical skylight looking northeast. At night, the luminous turret creates a glowing landmark on the San Francisco skyline. The turret, truncated at a forty-five degree angle, is finished in Botta's signature style by bands of contrasting black-and-white granite. Although the turret is elliptical in plan, when viewed frontally from the adjacent gardens it appears to be round.

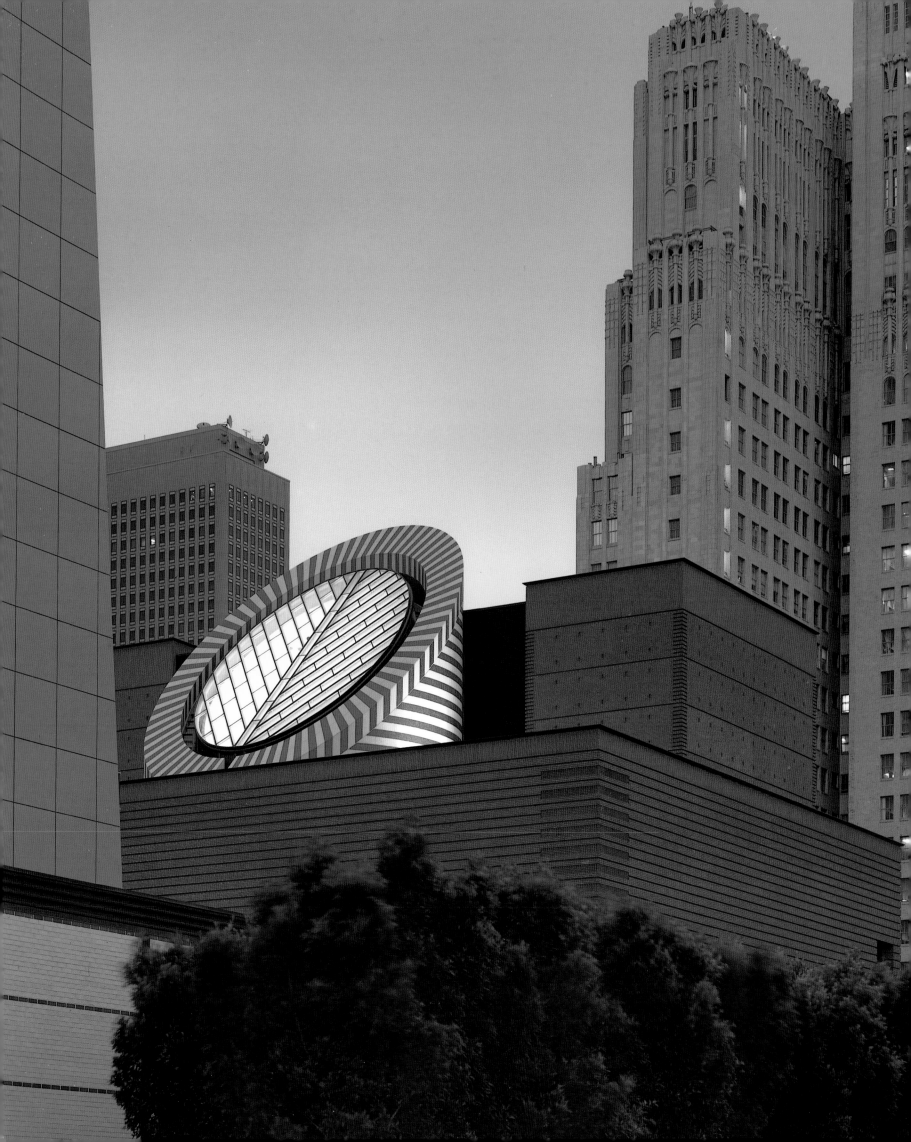

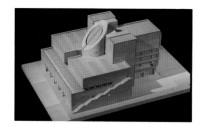

Museum Trustees and Director John R. Lane agree to find a new home for SFMOMA.

July

SFMOMA's new site at 151 Third Street, in the emerging Yerba Buena Gardens neighborhood, is announced.

September

Swiss architect Mario Botta is selected as project architect.

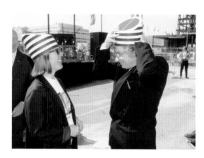

September

Revisions to Botta's original design are completed.

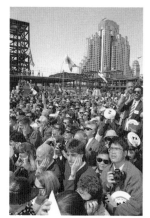

Members of the New Building Steering Committee review plans with the architect. Pictured left to right: Brooks Walker, Jr., Gerson Bakar, Mario Botta, Thomas B. Swift, and John R. Lane.

Mario Botta is presented with a commemorative hat by hat designer and SFMOMA staff member Pam Steele.

Several thousand spectators catch an earful of Survival Research Laboratories' performance at the ground-breaking ceremony.

September

Botta unveils his design concept for the new museum to great critical acclaim.

Phase I of the New Museum Campaign is successfully concluded, with $65 million pledged.

January

SFMOMA's acquisition of the Third Street site from the San Francisco Redevelopment Agency is finalized with the signing of the Disposition and Development Agreement.

April

Construction of the new SFMOMA is initiated with a rousing groundbreaking ceremony.

The conclusion of Phase II of the capital campaign brings the fund-raising effort's total to just over $80 million.

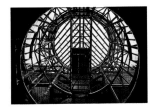

January
The new building is "topped out," as the highest beam is placed in the steel skeleton.

June
The construction of the new museum is completed, save the MuseumCafe and special events space.

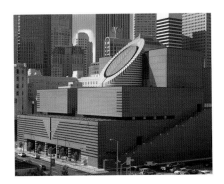

July
SFMOMA staff members move their offices to the new downtown facility, continuing their preparations for the grand opening and inaugural exhibitions.

September
The Museum's Civic Center quarters close permanently after Labor Day.

October
The construction of MuseumCafe and the special events space is completed.

January
The conclusion of Phases III and IV of the capital campaign brings the fundraising total to more than $90 million.

The new San Francisco Museum of Modern Art is opened to the public. The inauguration of the Museum's 151 Third Street building coincides with the sixtieth anniversary of the institution's opening in the War Memorial Veterans Building on January 18, 1935.

■

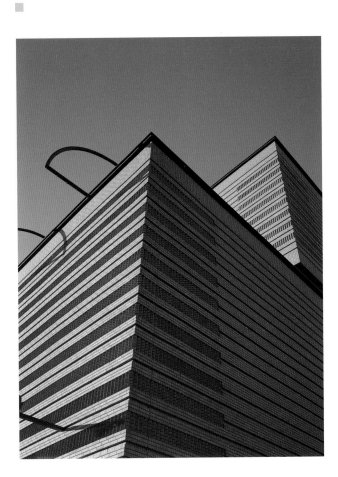

This view of the southwest corner shows the rotated brick bands as they wrap around the sides of the building, forming quoins. As an earthquake precaution, the cladding is actually composed of precast brick panels.

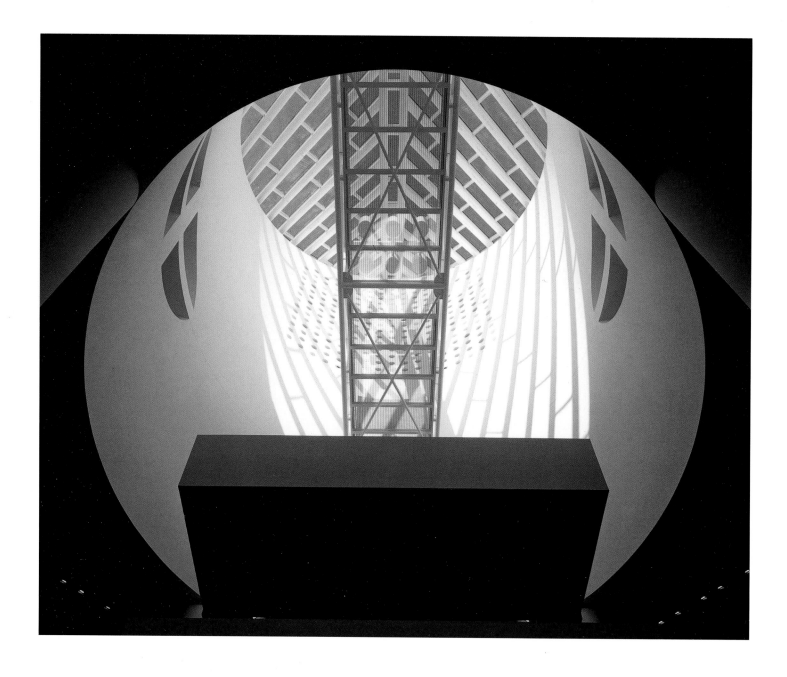

Above and overleaf:

The atrium skylight and thirty-eight-foot-long steel bow-string truss bridge spanning the turret. Visitors crossing the bridge from the fifth-floor galleries exit the tower by descending one of two curving staircases that encircle the tower and emerge onto the fourth-floor lobby. Finishing elements in the tower include decorative openings that allow visitors mounting the curving stairs to look into the turret, and small, circular apertures on the tower's east side that serve both a functional and decorative purpose. The skylight mullions radiate from a central axis, mimicking the shape of a leaf, a continuation of the architect's use of this motif. Seen on top of the bridge is one of six up-lights for use at night, when the turret becomes a beacon on the city skyline.

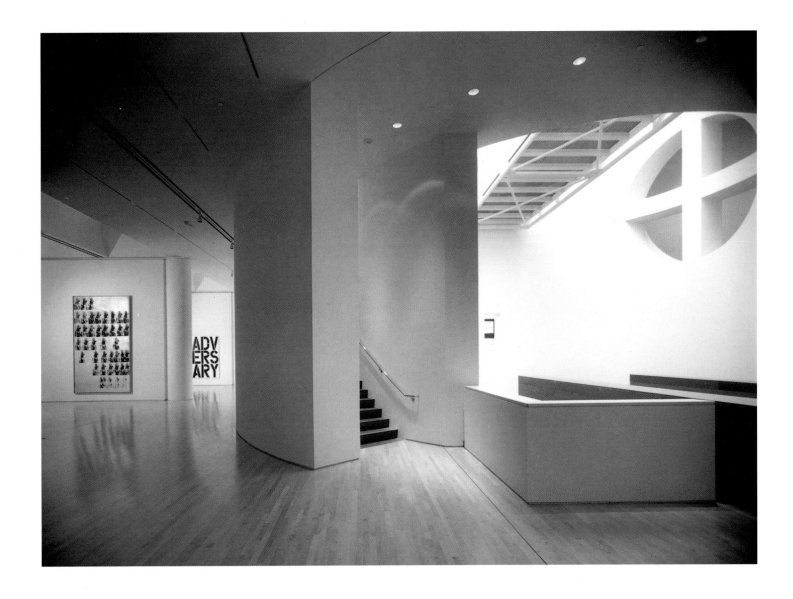

Above and right:

Views of the fourth-floor galleries, turret bridge, and one of the two staircases that enclose the turret. The hardwood floors throughout the building are maple.

Opposite:

The third-floor lobby, looking out onto the central atrium, features custom light fixtures and intricate slatted maple paneling on the ceiling. The intimate gallery spaces on this level were specially designed with low ceilings and modulated light for the display of photographs and works on paper.

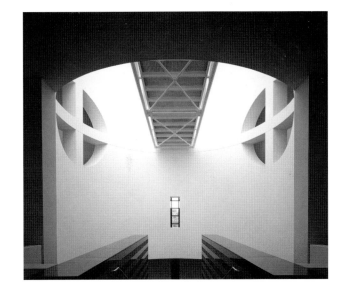

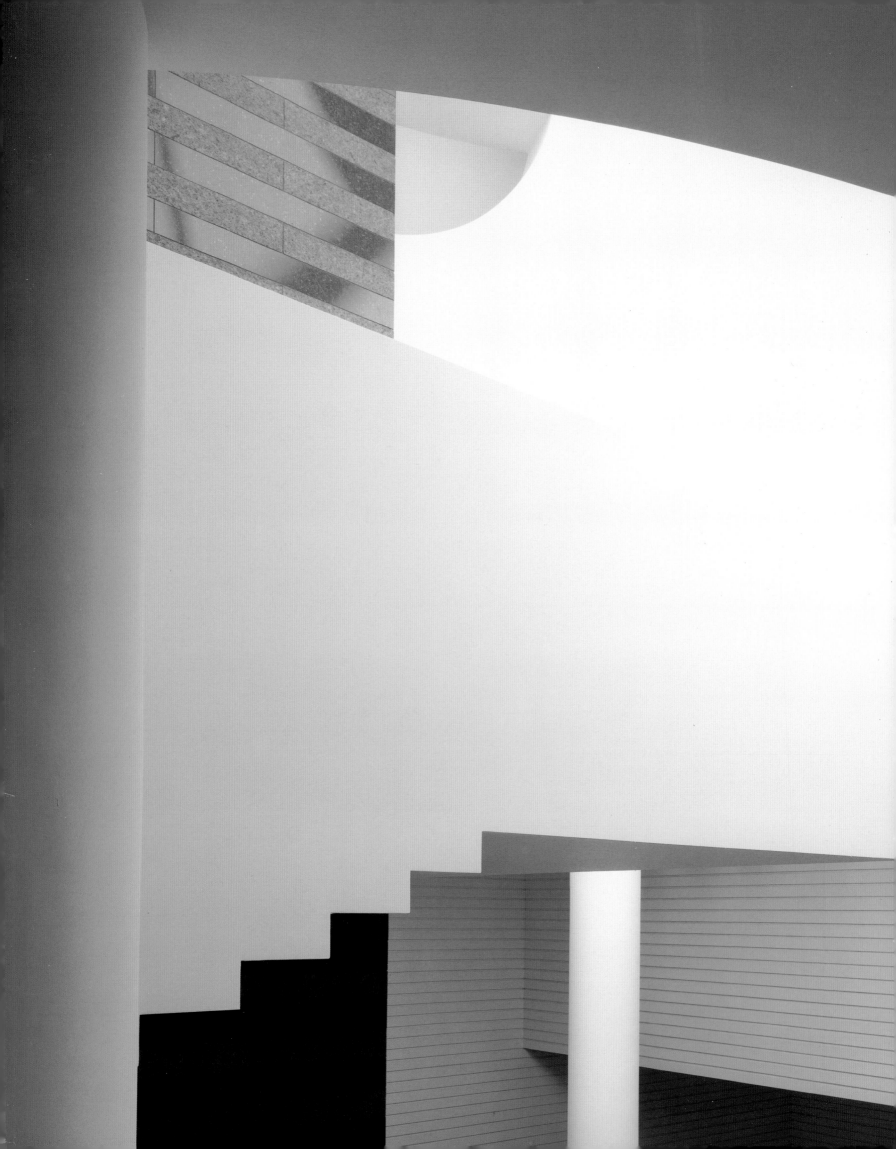

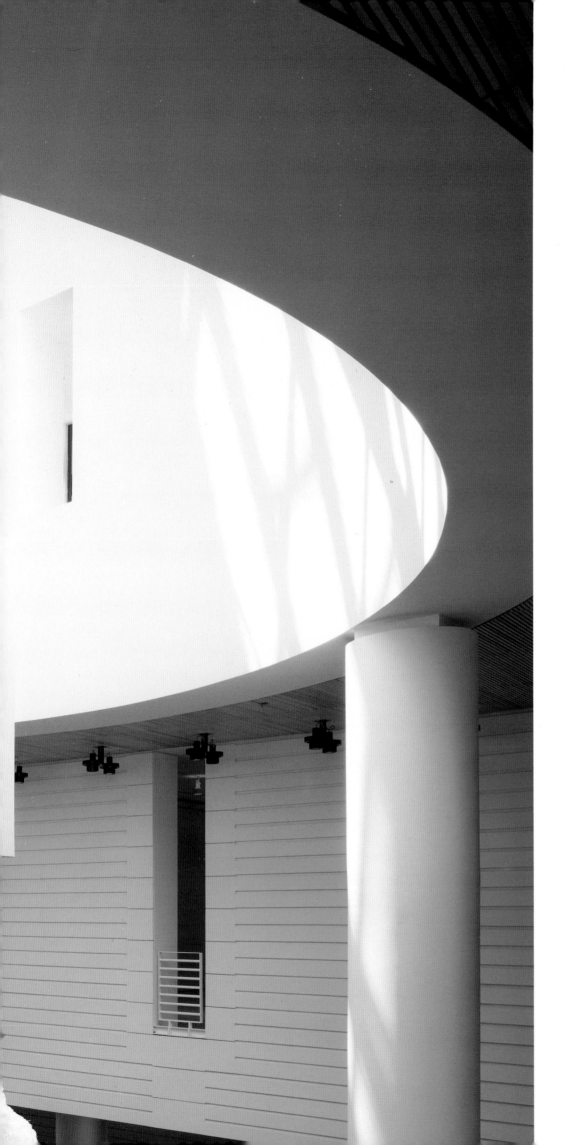

In museums, the real challenge is to discover that perfect balance where the architecture and art enrich one another. —MARIO BOTTA

The contrasting geometries of curves and angles, highlighted by subtle finishing details, make this building itself a work of art. Botta's design takes full advantage of the axial, classic symmetry of the structure centered around the atrium. This effect resonates throughout the building in such details as the narrow vertical openings that enable visitors to look out from the galleries on both the third and fourth floors to gain perspective on the atrium.

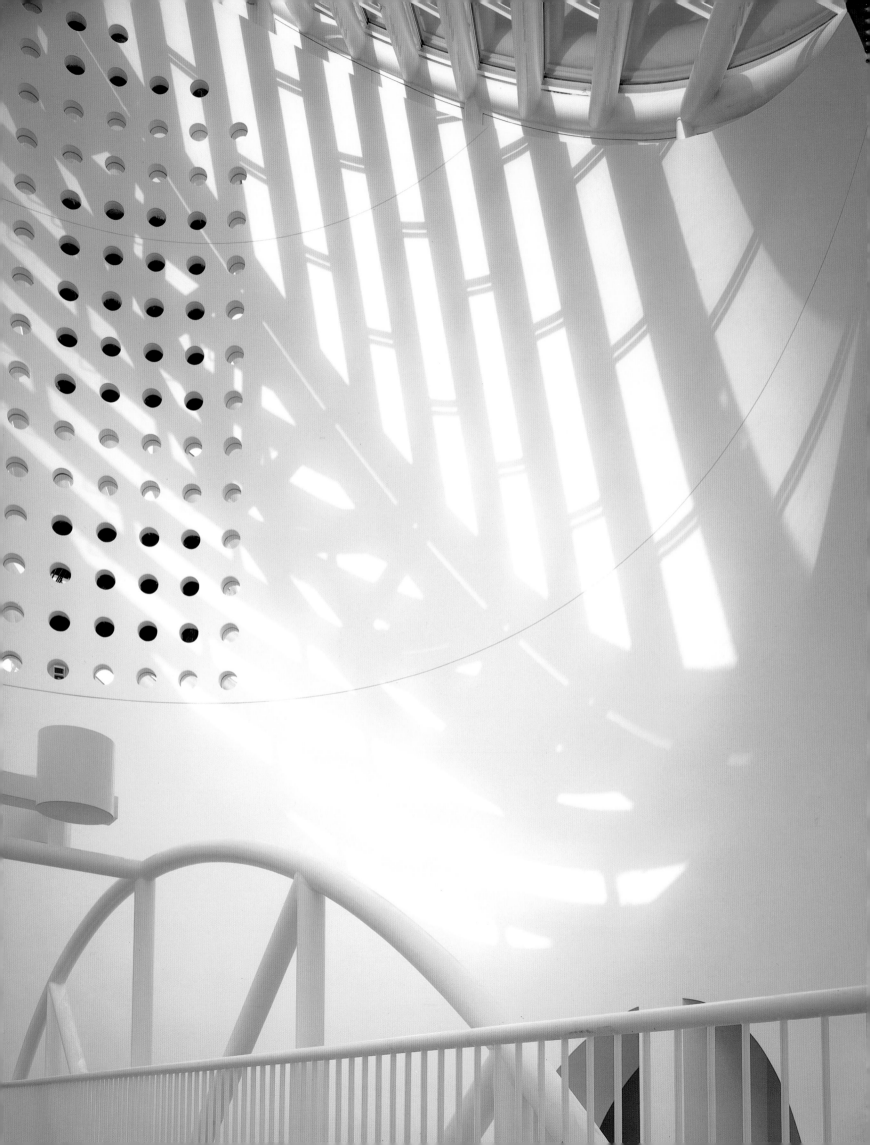

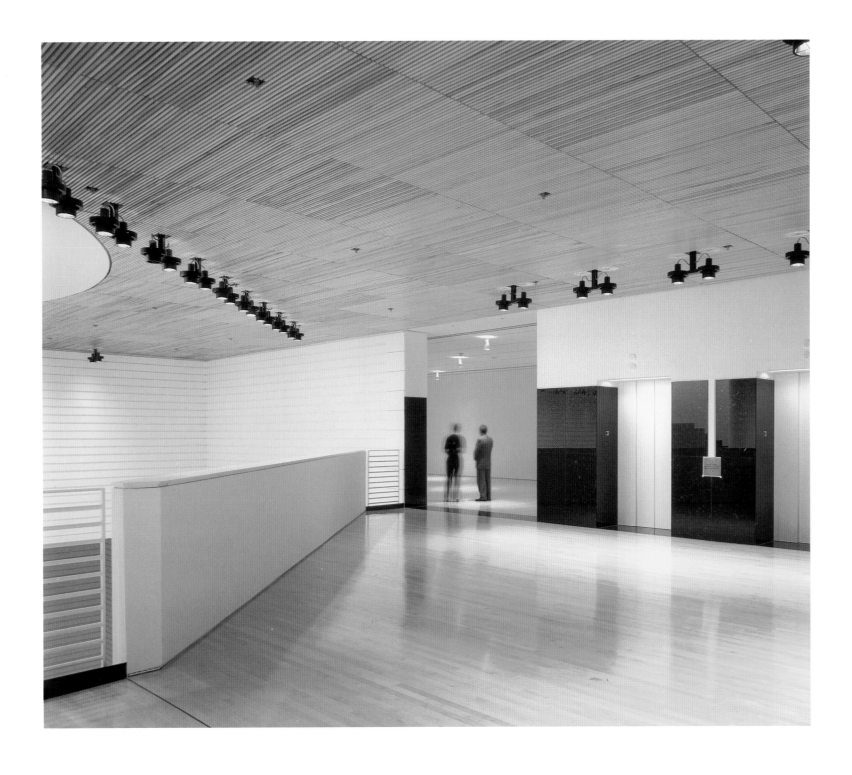

In a body of work that ranges from private residences in the Swiss Alps to urban projects in Europe and Asia, Mario Botta has, at mid-career, distinguished himself internationally as one of the preeminent figures in the architecture world. ❖ A leading proponent of the modernist tradition, Botta challenges the functionalism of the International Style that dominated from the 1920s to the middle decades of the century, pursuing instead an architectural expression more responsive to humanist concerns. As Botta remarked in an interview published in 1986, his appropriation of the principles of such modernist masters as Alvar Aalto, Le Corbusier, and Louis I. Kahn reflects "the hope that the new means available to architects—advanced techniques, new materials, industrialization—would provide more satisfactory answers to the problems of twentieth-century man and help create better living conditions."❖ Perceptible in his designs, too, is the architect's affinity for the northern Italian architecture of his birthplace, the southern Swiss canton of Ticino, as well as for classical elements. Indeed, Botta's distinctive buildings present powerful façades distinguished by monumental geometric forms, axial symmetries, and the use of more traditional materials such as brick and stone. Botta's signature style also includes his artful incorporation of striated finishes and his use of natural light, which serves at once to illuminate interior spaces and define exterior surfaces.❖ Born in 1943 in Medrisio, Switzerland, Botta has practiced architecture since age fifteen. He studied under Carlo Scarpa at the Istituto Universitario di Architettura in Venice in the late 1960s, and as a young architect worked for both Le Corbusier and Kahn. Since establishing his own practice in Lugano, Switzerland, in 1970, Botta has been honored with numerous architectural awards and was the subject of the survey exhibition *Mario Botta,* organized by The Museum of Modern Art, New York, in 1986. Other notable projects by Botta include the Malraux Cultural Center in Chambéry, France, the Bank of Gotthard in Lugano, a public library in Villeurbanne, France, a cathedral in Evry, France, a modern art gallery in Tokyo, and the soon to be built Tinguely Museum in Basel.

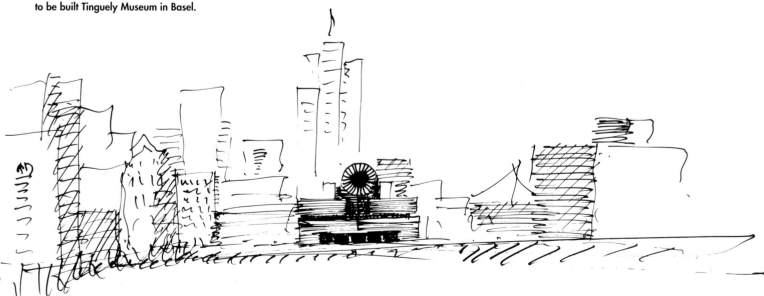

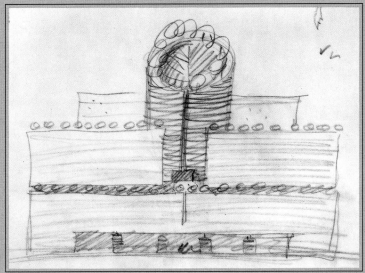

1

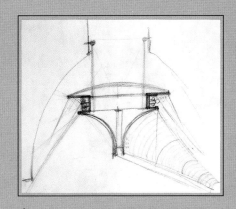

2

Mario Botta's drawings—from the technical to the whimsical—reveal the design process that culminated in this unique structure.

1. This early sketch shows one of the initial design features— a crown of trees haloing the central turret—that was eventually reconfigured. 2. A cross-section of one of the skylights designed to flood the galleries with natural light. Light enters through glass panels on the roof and is filtered by an aluminum grating. It then passes through a translucent plastic lens and washes down the plastered vaults of the ceiling.
3. This side elevation shows each floor stepped back from the previous one to allow for natural light in the gallery spaces, as well as the architect's own imaginative rendering of light entering the atrium.

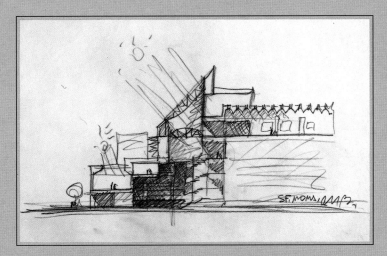

3

4. This lively sketch hints at Botta's aim—to make the turret a "living, breathing cylinder" that enlivens all parts of the Museum and provides a unifying point of reference.

Opposite:
Its stepped-back brick façade integrates the new Museum into the South-of-Market streetscape, while the central turret creates a distinctive and recognizable profile, a new cultural landmark for San Francisco.

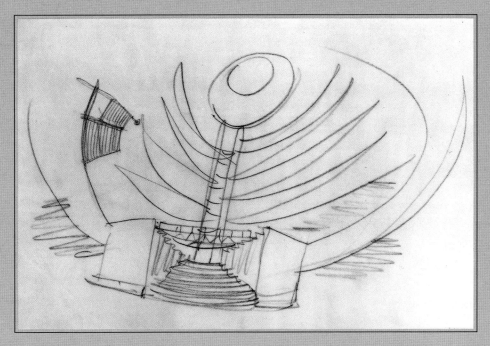

4

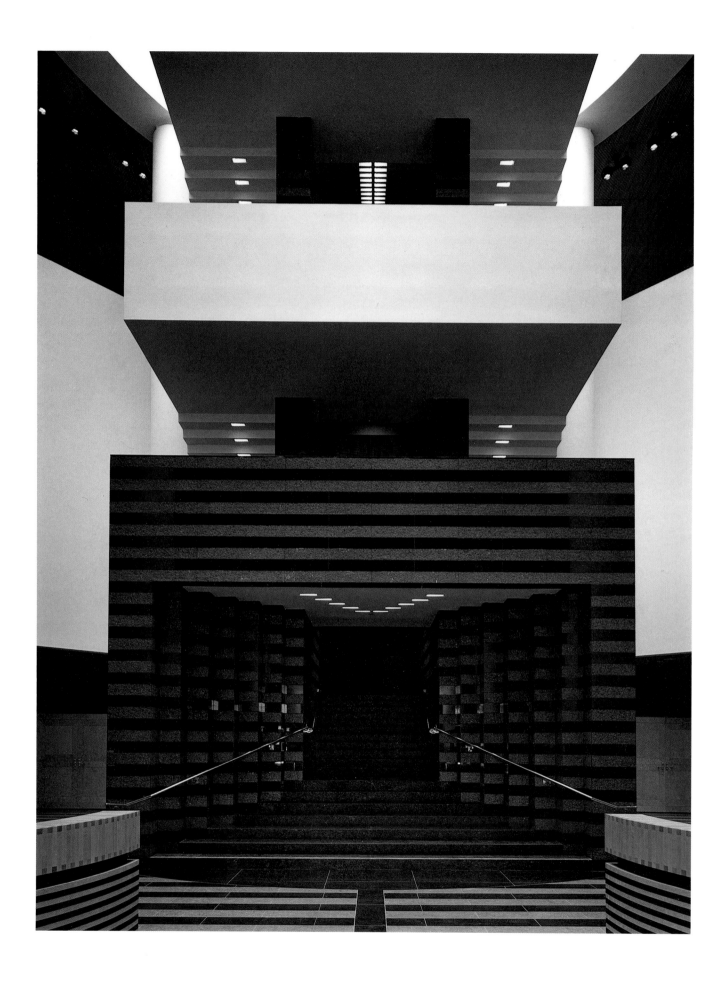

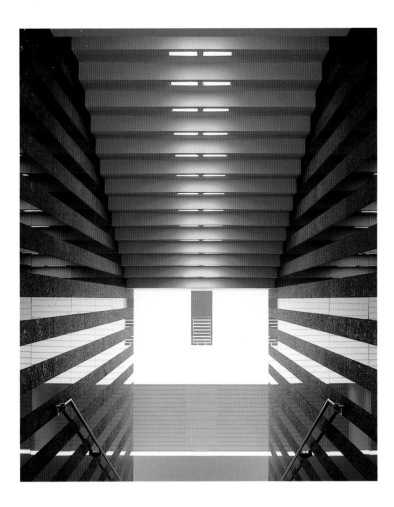

Clockwise from left:

The massive central staircase, described by Botta as "the tower in the village piazza," ascends from the atrium to three floors of galleries. Detailing on the staircase includes contrasting bands of granite—like the atrium floor—and stepped, recessed lighting that adds to the dramatic contrast between the light-filled atrium and the more subdued stairway passages. Landings on each level offer visitors the opportunity to gain perspective on the atrium below.

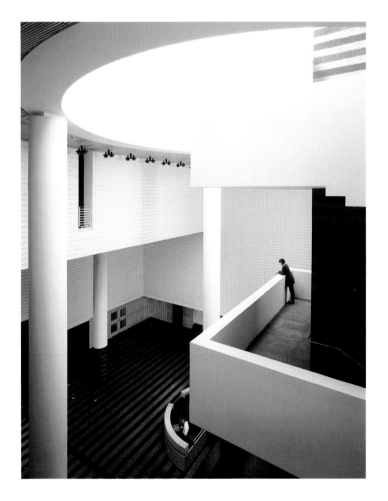

Right:

The second-floor galleries. This elegant enfilade is part of a series of thirteen galleries dedicated to the Museum's painting and sculpture collection which traces the history of twentieth-century art. Also on this level are galleries for architecture and design.

Opposite:

The fourth-floor galleries. With their eighteen-foot ceilings, these galleries are ideally suited for the display of large-scale contemporary art. Also on this level are media arts galleries. Equipped with a support-hanging grid, independent lighting, a control room, and a high concentration of electrical and audio outlets, these galleries offer a completely flexible environment for installations including film, video, and electronic and time-based media.

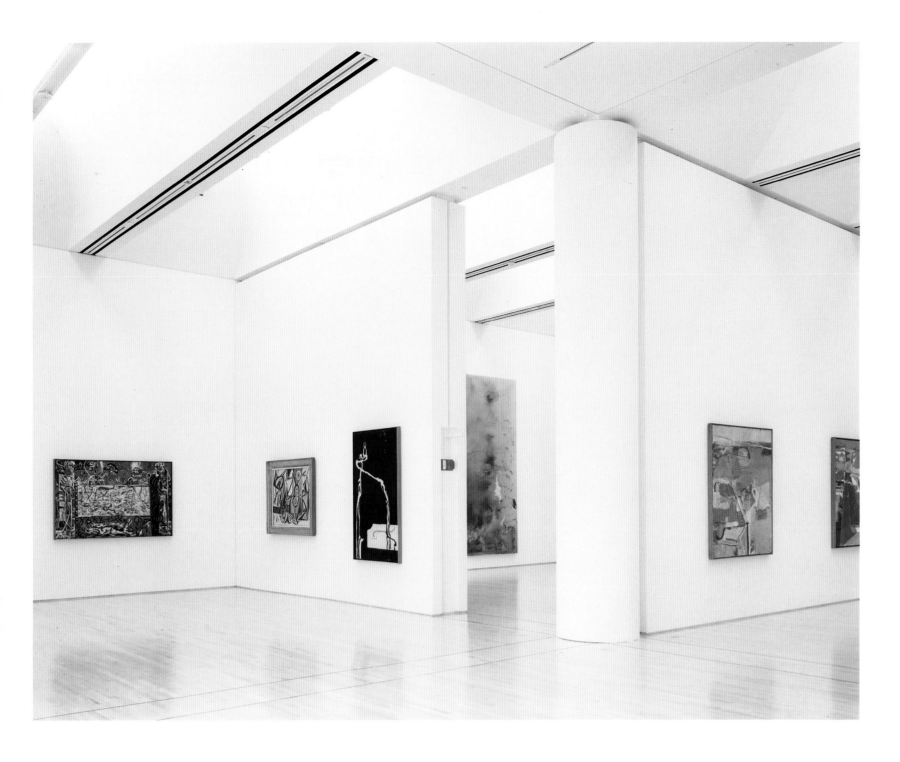

Fourth-floor skylight detail.

Natural light is a specific element tied to a geographic location. I like the thought that the artworks on display will be viewed through the 'real light' of the city. With filters and veils, you can control and modulate light through skylights, thereby offering optimum conditions while also leaving the walls completely available as expository surfaces. – MARIO BOTTA

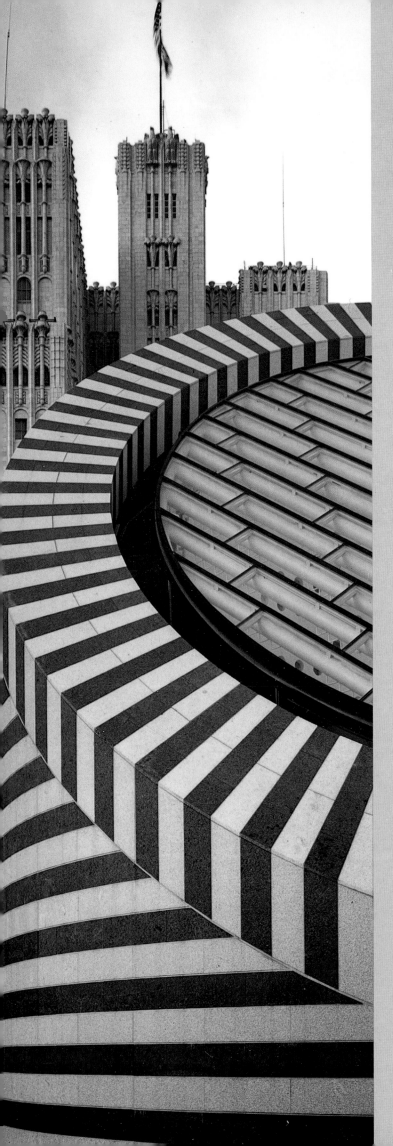

Location	151 Third Street, San Francisco, California
	The new facility is situated in the vibrant South-of-Market neighborhood between Mission and Howard Streets, adjacent to Moscone Center, directly across from the Center for the Arts at Yerba Buena Gardens, and within walking distance of the Financial District and the shops, hotels, and art galleries of Union Square.
Project Owner	San Francisco Museum of Modern Art, a member-supported, privately funded museum incorporated in the state of California.
Design Architect	Mario Botta Architetto, Lugano, Switzerland
Architect of Record	Hellmuth, Obata & Kassabaum, Inc., San Francisco, California
Project Manager	Bechtel International Company, San Francisco, California
General Contractor	Swinerton & Walberg Company, San Francisco, California
Site Footprint	60,000 square feet
Museum Size	225,000 square feet

Space Usage

Exhibition galleries	50,000
Theater (299 seats)	6,200
Classrooms and studios	3,000
Library	3,800
Conservation Laboratory	3,000
Art Study/Handling/Storage	15,000
MuseumStore	3,500
Multi-use event space	4,200
Atrium	5,500
MuseumCafe	2,500
Offices	22,500
Private parking	15,000

Climate Control System	The building has a centralized, state-of-the-art climate control system that will provide temperature and humidity controls for the preservation of artworks.
Food Purveyor to MuseumCafe	Real Restaurants

1ST FLOOR

Admissions, visitor services, coat check; education classrooms and multimedia laboratory; theater; special events space; MuseumCafe; MuseumStore.

2ND FLOOR

Permanent collection galleries for painting and sculpture, and architecture/design; educational resource room; offices.

3RD FLOOR

Permanent collection galleries for photography and works on paper; temporary exhibition galleries; offices.

4TH FLOOR

Permanent collection galleries for media arts and contemporary art; temporary exhibition galleries; outdoor sculpture terrace; conservation lab; offices.

5TH FLOOR

Galleries for temporary exhibitions in all media; access to turret bridge.

LOWER LEVEL

Library; graphic study center; education lecture room; art storage, handling, and receiving space.

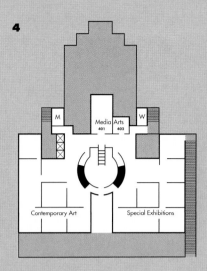

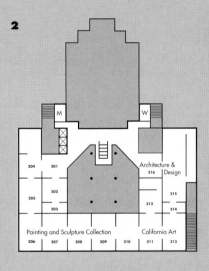

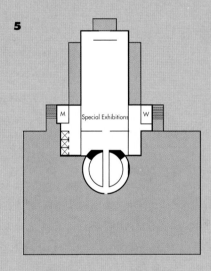

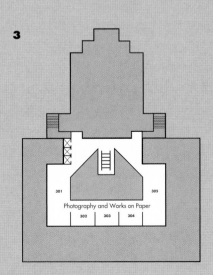

Above:

This 299-seat theater offers state-of-the-art acoustics for lectures, symposia, and musical perfomances, as well as projection facilities for film, large-screen video, and slide presentations. The walls are finished in concrete masonery with every third coursing rotated to allow for the absorption of sound by a concealed acoustical backing. The result is an uncommonly handsome fusion of form and function.

Below:

Also located on the ground floor with a sweeping view of the East Garden fountain at Yerba Buena Gardens, MuseumStore's 3,500-square-foot space is elegantly appointed with Nordic icebirch, sculptural lighting fixtures, and innovative display and interactive areas.

Opposite:

The special events space adjoins the atrium on the ground floor via a pair of sliding panels of Nordic ice-birch that allow for configuring the room for both intimate and large-scale activities. Elegant design details—including the slatted maple ceiling, custom barrel vaults, and lighting fixtures designed by Botta—make it the ideal setting for both public and private art openings, parties, receptions, and meetings.

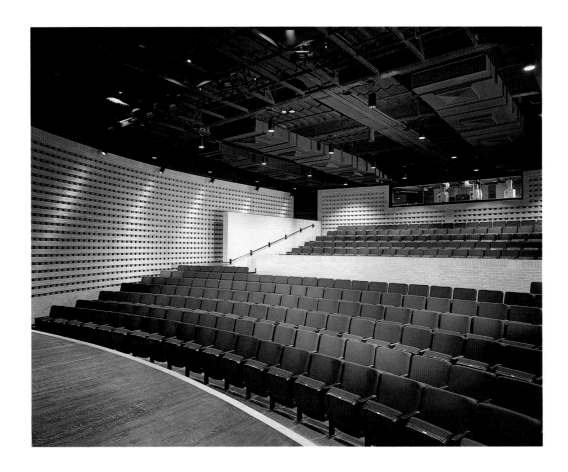

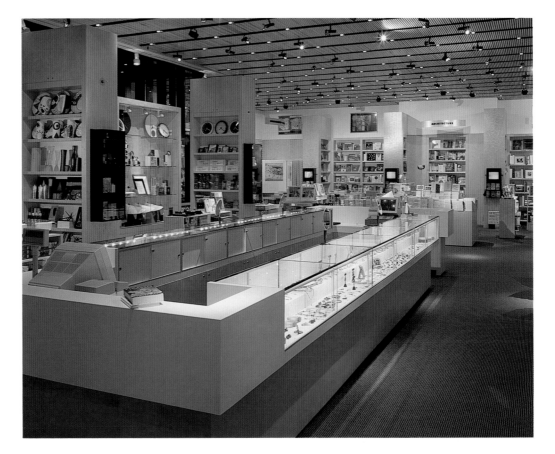

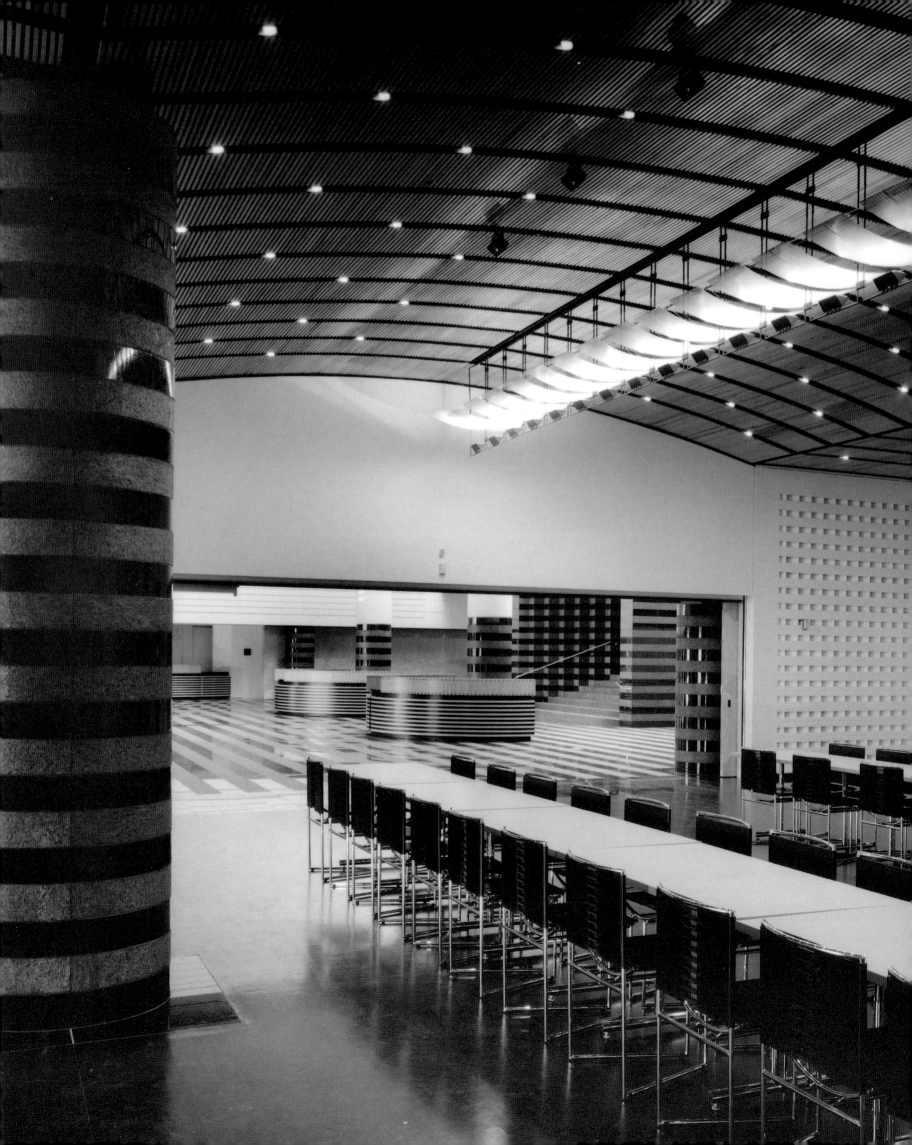

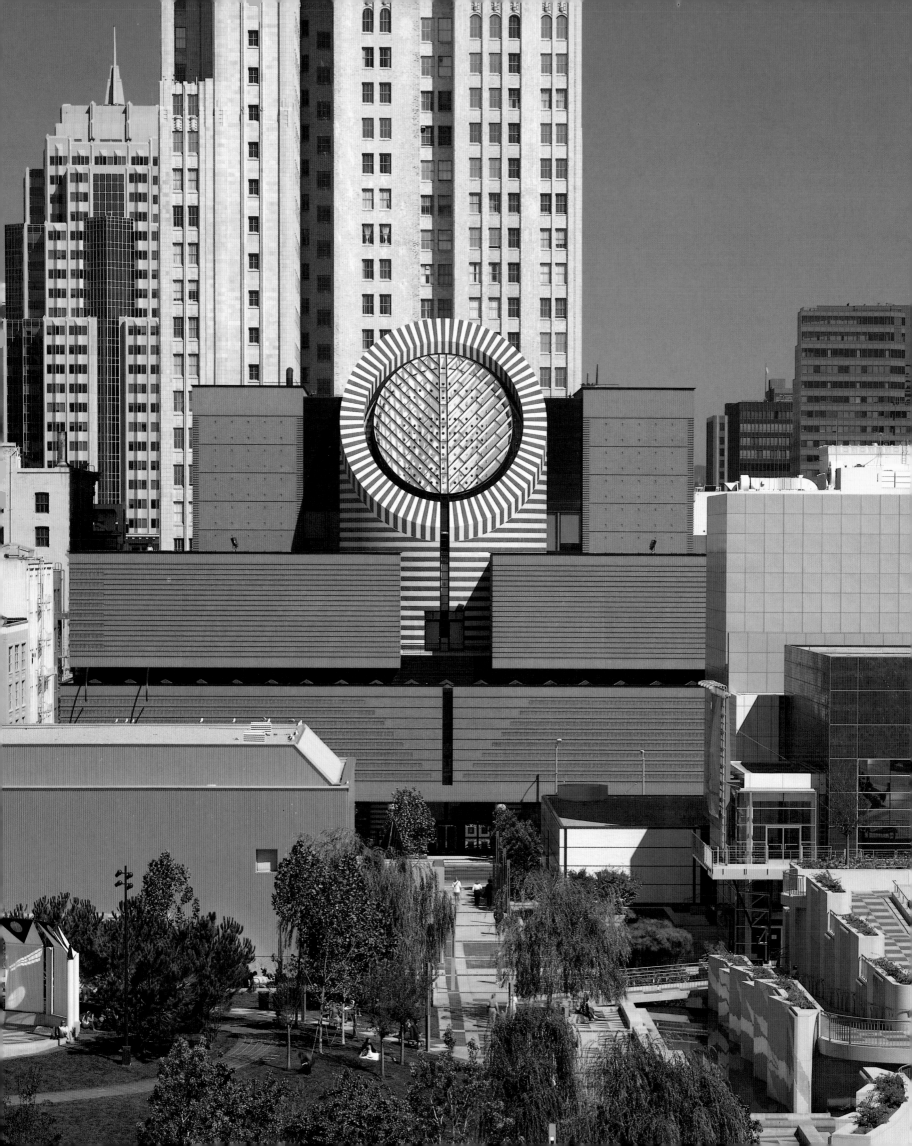

Opposite:

The Museum, as seen from Yerba Buena Gardens. In the foreground are the Center for the Arts buildings—the visual arts galleries, designed by Fumihiko Maki (left), and the performing arts theater, designed by James Stewart Polshek (right).

Below:

This north elevation illustrates distinctly detailed pattern and texture in the brick cladding of the façade, another Botta trademark. The massing of the building's profile is broken by the insertion of short columns that articulate the volume of the fourth floor.

Building from the ground up:
Construction of the War Memorial
Veterans Building, ca. 1931 (left),
and the partially completed
steel skeleton of the new Museum,
February 1993

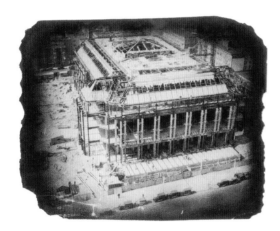 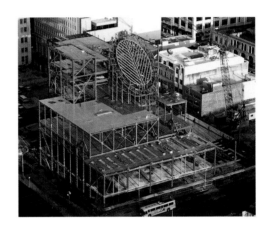

When the San Francisco Museum of Arts [sic] on the fourth floor of the Veterans' building opens tonight, sixty-three years of hope and

1935

activity on the part of San Francisco's leading art patrons will come to fruition. It is the city's best appointed art gallery. It is San Francisco's only museum easy of access from all quarters. And, as pointed out in these columns before, it takes its place alongside the opera house and the public library to complete the trinity of music, literature and art in our Civic Center. —ALFRED FRANKENSTEIN, *SAN FRANCISCO CHRONICLE*, JANUARY 18, 1935

But the most eagerly awaited event is the January, 1995, opening of the [San Francisco] Museum of Modern Art. The modern museum's

1995

new building, designed by Swiss architect Mario Botta, already looms large and impressive. From all appearances, the gray stone and red brick structure seems certain to be a new landmark for San Francisco....At a time when many museum building projects have been cut back or scrapped, the [San Francisco] Museum of Modern Art is an astonishing success story. —SUZANNE MUCHNIC, *LOS ANGELES TIMES*, FEBRUARY 5, 1994

60 YEARS

Separated by exactly sixty years, these two events—perhaps the San Francisco Museum of Modern Art's greatest achievements— are extraordinary benchmarks in the history of contemporary art in America. When the San Francisco Museum of Art, as it was originally called, opened on January 18, 1935, it became the second institution in the nation after The Museum of Modern Art, New York, committed to fostering an understanding of the new, experimental, and often controversial in international modern art. This event irrevocably launched San Francisco into the fast-paced world of contemporary art, as the new museum ushered in the latest ideas and developments from the art capitals of the East Coast and of Europe and helped raise the entire standard of artistic activity in the western United States.

Sixty years later, SFMOMA is once again at the pinnacle of the nation's cultural landscape with the construction of the largest new American art museum of the decade. The second largest single structure in the United States devoted to modern art, the heroic, modernist building designed by Swiss architect Mario Botta, is an extraordinary work in its own right, providing SFMOMA with a state-of-the-art home for its growing collection of seventeen thousand artworks and San Francisco with an important new architectural landmark.

Yet beneath the contemporary composition of steel, glass, brick, and polished stone lies the foundation of a venerable institution whose roots trace back to 1871, when a coalition of Bay Area artists established the San Francisco Art Association "for the promotion and encouragement of art in the community."[1] Toward this end, in 1874 the Association founded the School of Design,[2] the first school devoted to the visual arts in the western United States. Six years later the Association began its series of annual exhibitions, and in 1916 took over the Palace of Fine Arts, a grand Beaux-Arts structure originally designed for the art exhibitions of the sweeping 1915 Panama-Pacific International Exposition. In 1921 the San Francisco Museum of Art was incorporated as a nonprofit institution.

Two years later, however, the San Francisco Art Association embarked on a new drive to find a more suitable home for their artistic endeavors. Earlier, in 1918, this dedicated group had merged interests with the Musical Association of San Francisco to construct both a performing arts hall and an art museum complex, slated as "a War Memorial symbolic of the Arts of Peace,"[3] in the Civic Center. By 1925, maintenance and funding problems had forced the Museum to close its Palace facility, infusing the War Memorial campaign with a new sense of urgency. In 1927, after a series of insufficiently successful fund-raising efforts, the two cultural groups, now joined by a number of veterans' organizations, passed a four-million-dollar bond issue securing the necessary funds for the construction of two buildings—an opera house and a structure to house the Museum and veterans groups— and a memorial court. The twin granite Beaux-Arts structures

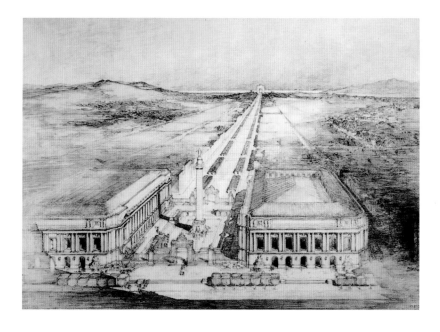

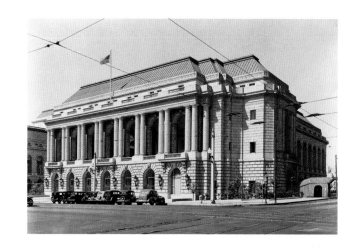

Clockwise from above:
A 1926 sketch of the
proposed War Memorial
Veterans Building, at right,
and Opera House.

The Museum, shortly
after it opened in 1935.
The entrance was originally
located on McAllister Street.

The Museum's modern,
skylit galleries showcase the
1940 exhibition *Picasso:
Forty Years of His Art.*

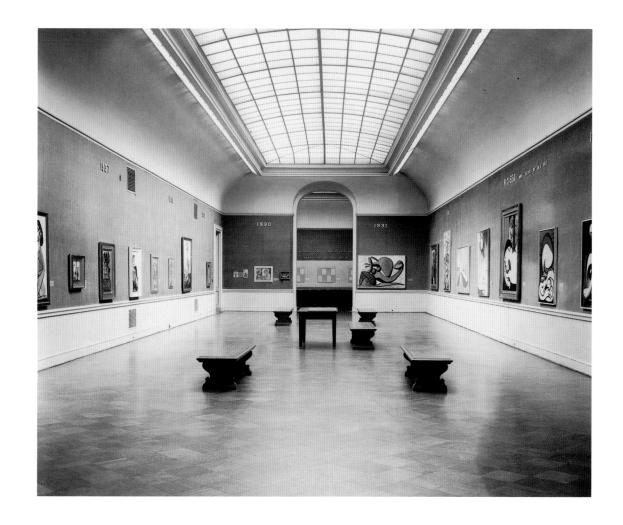

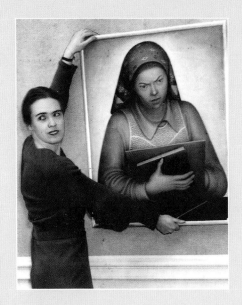

GRACE McCANN MORLEY 1900–1985

"Art is an inseparable and essential part of human life."

Spanning more than six decades, the career of Grace L. McCann Morley represents a lifetime of devotion and contribution to the visual arts. As SFMOMA's dynamic leader from 1935 to 1958, she transformed a fledgling museum into one of the nation's leading institutions in the collection and presentation of contemporary art. Morley was also a legendary figure in the international art community, renowned for her museological principles and ideals that continue to guide museum professionals throughout the world even today. ❖ Born in Berkeley, California, in 1900, Morley was an ambitious, yet sensitive scholar with bachelor's and master's degrees from the University of California and a doctorate from the University of Paris. She began her career as a college instructor of French and art, and went on serve as chief curator of the Cincinnati Art Museum from 1930 to 1933. In 1934 she was appointed to serve as SFMOMA's founding curator, and several months later was named director of the institution. ❖ While Morley led SFMOMA's rich and varied artistic program for twenty-three years, in the early 1940s she also became deeply involved in museum projects of an international scope. In a series of leaves of absence from the Museum, Morley prepared exchange exhibitions with South American museums, became the first head of the Museum Division of the United Nations Educational, Social and Cultural Organization (UNESCO), helped establish the International Council of Museums (ICOM), and founded *Museum*, the first publication to outline basic museum principles and practices for both developed and developing nations. ❖ After stepping down as SFMOMA's director in 1958, Morley tirelessly pursued her international vision. She was named director of the National Museum of New Delhi in 1960, and in 1968 founded ICOM's regional agency in Asia to assist museums of emerging countries to better present and preserve the objects of their cultural heritages. After retiring from ICOM in 1978, Morley continued to travel throughout Asia, observing, lecturing, and advising. When she died in January 1985 in New Delhi, she had been preparing to return to San Francisco to join in the fiftieth anniversary celebration of the museum that she had helped found. ❖ Grace McCann Morley pictured at left with founding President William W. Crocker, and at right preparing for the Museum's inaugural exhibitions of January 1935.

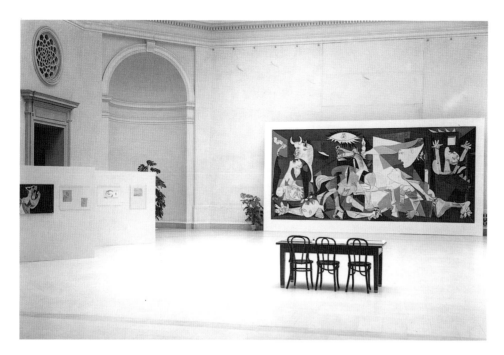

Pablo Picasso's masterpiece *Guernica,*
on view in the Museum's rotunda in 1939.

were completed in the fall of 1932 and in October 1934, the appointments of the Museum's trustees—among them such leading citizens as banker William W. Crocker, architect Timothy L. Pflueger, insurance broker Albert M. Bender, businessman William L. Gerstle, and civic leader Charles Kendrick—and first curator, Dr. Grace McCann Morley, were announced, with the galleries slated to open shortly after the new year.

Assembled in a matter of weeks by Morley—whose title was soon changed from curator to director—the Museum's inaugural exhibitions included the Art Association's Fifty-fifth Annual Exhibition, French impressionist and post-impressionist painting, Chinese art, Old Master drawings, and Gothic tapestries, reflecting not only a diversity of subject matter but also a far-reaching historical survey of art. However, it was the Museum's second exhibition—the prestigious *1934 Carnegie International,* which featured both up-to-the-minute European trends and a broad selection of American developments—that set forth the institution's contemporary direction.

With this mandate, the Museum embarked on a fast-paced course of adventurous artistic programming, averaging seventy to eighty shows annually and presenting such groundbreaking exhibitions as *Cubism and Abstract Art* (1936) and *Fantastic Art, Dada, and Surrealism* (1937), both organized by The Museum of Modern Art, New York, and the survey of the oeuvre of Paul Cézanne (1937), organized by Morley. By its fifth anniversary in

1940, the Museum had attracted a steady and devoted group of supporters—from a growing membership and an annual attendance of approximately 130,000 visitors to an energetic volunteer Women's Board and an active Board of Trustees—all of whom were hungry for the latest impulses and inspirations of the art world.

Despite the sharp curtailment of activity during the war years, including the Museum's relocation to a downtown location for several months in 1945 when Allied representatives took over the galleries to negotiate the formation of the United Nations, the Museum continued to break new ground through the 1940s and 1950s with the presentation of work by contemporary local, national, and international artists. Morley's vision led the Museum to present the first solo museum exhibitions of the work of Arshile Gorky (1941), Clyfford Still (1943), Jackson Pollock (1945), Mark Rothko (1946), and Robert Motherwell (1946), heralding the radical breakthroughs of American Abstract Expressionism in postwar art. Distinguished among the larger surveys were *Picasso: Forty Years of His Art* (1940), the landmark exhibition from The Museum of Modern Art, New York, that complemented the Museum's presentation the previous year of the Spanish artist's masterpiece *Guernica;* the 1952 blockbuster, *The Art of Henri Matisse,* also organized by the New York museum; and the *Raoul Dufy Memorial Exhibition,* which was co-organized by the San Francisco Museum of Art and the Los

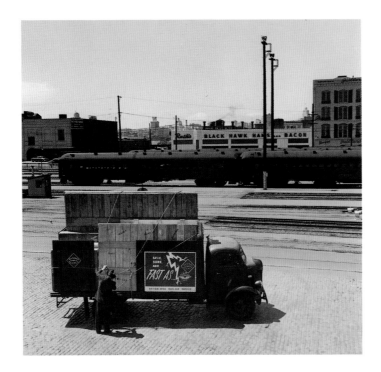

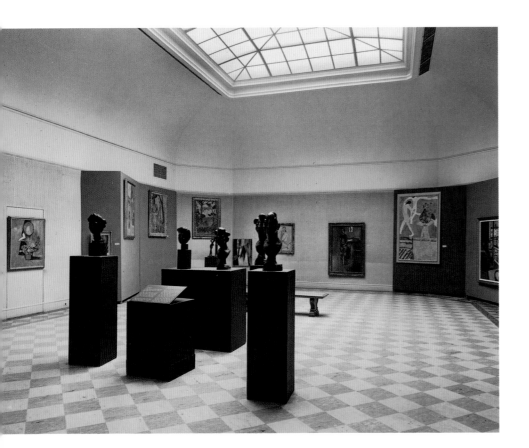

Matisse at the Museum:

Works for the 1952 exhibition
The Art of Henri Matisse await transport
from the train station to the Museum,
while San Francisco city buses sport
advertisements for the show. At left, the
works are shown installed in the
Museum galleries.

Angeles County Museum in 1954. Closer to home, exhibitions of the work of Bay Area artists David Park, Elmer Bischoff, and Hassel Smith were also presented to demonstrate the artistic developments of the region during this time.

During Morley's tenure, the Museum also witnessed the extraordinary growth of its collection through both major donations and astute purchases. Initiated by the gift of Trustee Albert M. Bender (pages 44 and 74) of thirty-six works one week after the Museum opened in 1935, the permanent collection was augmented during the 1940s by the acquisition of key individual works including Arshile Gorky's *Enigmatic Combat, Braünlich* (Brownish) by Vasily Kandinsky, Mark Rothko's *Slow Swirl by the Edge of the Sea*,[4] an untitled painting by Clyfford Still, Max Ernst's *La Famille nombreuse* (The Numerous Family), Klee's *Fast getroffen* (Nearly Hit), and Pollock's seminal *Guardians of the Secret* (pages 46 and 82). In 1950, the San Francisco Museum of Art celebrated not only its fifteenth birthday, but the bequest of the outstanding Harriet Lane Levy Collection, including important works by Matisse and Picasso.

While the Museum embarked on an active program in painting and sculpture, Morley also directed the institution to become one of the first to recognize photography as a fine-art form. Work by prominent photographers was exhibited on a regular basis, and the growing collection of photography greatly benefitted from Trustee Albert M. Bender's 1941 bequest of twenty-six fine works by Ansel Adams, Brett and Edward Weston, Imogen Cunningham, and others, and the addition of sixty-eight photographic works by Alfred Stieglitz in 1952.

While the Museum had conducted lectures, courses, and tours since its inception, a major grant from the Carnegie Corporation of New York allowed the institution to establish a comprehensive series of outreach activities in 1937. The vital education program that would grow from the Carnegie's philanthropy was in fact only one of a number of important ancillary services that would expand the scope of the Museum's activities. In 1946 two new innovative programs, Art in Cinema (page 52) and the Rental Gallery, in which works by local artists were made available to the public for rental and sale, were introduced, the latter being the first of its kind in the country.

After twenty-three years of service, Dr. Morley relinquished her duties as director in 1958, bringing to a close a prominent chapter in the history of the Museum (page 40). Morley's

legacy—the definition of a mission and building a collection of over three thousand objects, a larger constituency of visitors, and a membership of 4,600—was inherited by George D. Culler, who was appointed the Museum's second director in 1958.

Under his leadership, the institution advanced its collections through several landmark gifts and the establishment in 1961 of the T.B. Walker Foundation Fund that provided a vital resource for acquisitions. In 1963, the photography collection welcomed the addition of the Henry Swift Collection, eighty-five prints by original members of the f.64 group.

GEORGE CULLER

The Museum, which celebrated its twenty-fifth anniversary in 1960, continued to balance both historical developments and contemporary concerns as it entered the new decade. Highlights of the artistic program during this era included such major exhibitions as *The Art of Assemblage* (1962) and *The Last Works of Henri Matisse: Large Cut*

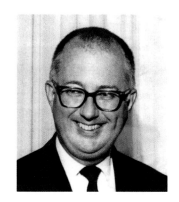

GERALD NORDLAND

Gouaches (1962). During Culler's tenure, the discipline of architectural design also received special attention as Museum audiences were exposed to the innovations of Richard Neutra (1959), Le Corbusier (1960), Pier Luigi Nervi (1961), and Eric Mendelsohn (1963).

Culler was succeeded as director by Gerald Nordland in 1966. While the Museum continued to host major exhibitions originating at other institutions—*Alberto Giacometti* (1966), *The Machine as Seen at the End of the Mechanical Age* (1969), a comprehensive Paul Klee retrospective (1967), and *Franz Kline* (1969)—Nordland set out to increase the number of shows organized by his own staff. Under his direction, the Museum assembled such notable exhibitions as *Six Artists from New York* (1966), *Paste-ups by Jess* (1968), *Joan Brown* (1971), and *Unitary Forms: Minimal Sculpture by Carl Andre, Don Judd, John McCracken, Tony Smith* (1970).

Growth of the collection under Nordland's directorship was marked by such notable transactions as the purchase of Robert Motherwell's *Wall Painting No. 10* in 1967, which prompted the

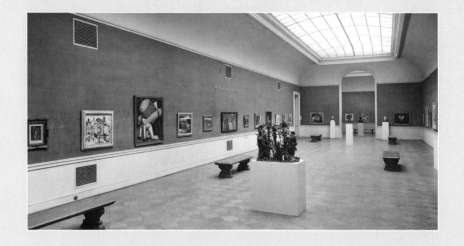

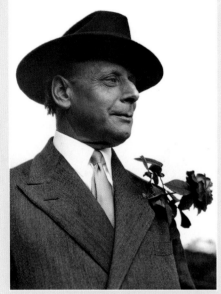

ALBERT M. BENDER, PATRON OF THE ARTS

Visitors of museums and libraries throughout the San Francisco Bay Area may be familiar with the seemingly ubiquitous "Albert M. Bender Room," "Albert M. Bender Collection," and "Gift of Albert M. Bender" credit line. Exactly who was this individual, whose name is synonymous with munificence at such institutions as SFMOMA, the California Palace of the Legion of Honor, the San Francisco Public Library, and the libraries of the University of California, Leland Stanford Jr. University, and the San Francisco Art Institute, to cite only a few? ❖ Born in Dublin in 1866, Albert Maurice Bender arrived in San Francisco at age thirteen with hopes of a brighter future. He began his career as a clerk for his uncle's insurance business, and by the early 1890s had established himself as one of the city's leading insurance brokers. ❖ Far-reaching yet personal, Bender's interest in the arts was kindled by his cousin, artist Anne Bremer, and he soon began supporting the school where she studied, the circle of aspiring artists to which she belonged, and the museums that inspired them. In addition, his patronage of the literary world included the establishment of both a library in his cousin's name at the San Francisco Art Institute and a rare book collection at Mills College. ❖ It was the San Francisco Museum of Modern Art, however, that may have benefited the most from Bender's largess. In 1935 he single-handedly formed the core of the Museum's collection with his first gift of thirty-six works that included Diego Rivera's masterpiece *The Flower Carrier* (page 74). Bender's gift in the following year included Frida Kahlo's double portrait of herself and Rivera (page 72), painted expressly for Bender, their longtime friend and supporter. Bender's donation of one thousand dollars in 1936 enabled the institution to establish its first art-purchase fund, and each December, from 1936 to 1954, the Museum mounted an exhibition commemorating his many generous benefactions—in all, over 1,100 artworks—that continued until his death in 1941. SFMOMA's Albert M. Bender Collection, representing his gifts and bequest, as well as the objects purchased through his financial support, is a testament to the vital involvement and singular vision of one of the Museum's most devoted trustees. ❖ At left, Ansel Adams' portrait, *Albert Bender, San Francisco*, ca. 1928; San Francisco Museum of Modern Art, Gift of Alfred Fromm, Otto Meyer and Louis Petei; the Museum's tenth-anniversary exhibition, *Growth of Museum Collections: 1935–1945*, featured a number of Bender's gifts, including Diego Rivera's *The Flower Carrier*.

artist to gift over twenty drawings in 1967 and two paintings in 1969. In 1972, Harry W. and Mary Margaret Anderson presented Robert Rauschenberg's *Collection* (page 88) and Jasper Johns' *Land's End* (page 90), two pivotal works that formed the foundation for the Museum's holdings of American Pop art. Also that year, Philip Guston's abstract *For M.* and Richard Diebenkorn's *Ocean Park #54* were added to the collection. The Motherwell acquisitions were included, along with the Museum's entire holdings of paintings, sculptures, and watercolors, in the institution's first catalogue of the painting and sculpture collection, published in 1970.

The year 1969 marked the initiation of the Museum's collection of California ceramic sculpture. In addition, Curator John Humphrey began placing greater emphasis on the Museum's photogaphy program and between 1966 and 1973 added works by Ansel Adams, Berenice Abbott, Wynn Bullock, Harry Callahan, Aaron Siskind, and Edward Weston, among others, to the Museum's increasingly important collection of photography.

By the late 1960s, the Museum had well outgrown its limited quarters on the fourth floor of the War Memorial Veterans Building. In 1970, after gaining additional space on the third floor, the Museum embarked on a major two-year architectural reconstruction and expansion program that yielded new fourth floor galleries, a new library, a cafe, a fully equipped art conservation laboratory, and offices on the third floor.[5]

Nordland's departure from the Museum in 1972 led to the appointment of Henry T. Hopkins, formerly head of the Fort Worth Art Museum, as director in 1974. Sensitive to the high level of contemporary art activity in the Los Angeles area, where he had served on the curatorial staff of the Los Angeles County Museum of Art in the 1960s, Hopkins sought to establish the Museum as the West Coast's premier museum of twentieth-century art through a carefully calculated plan of accelerated activity and programmatic expansion. Among his first accomplishments were to rename the institution the San Francisco Museum of Modern Art in 1975 to more accurately reflect the identity already established during its earliest years, and to create new gallery space on the third floor of the Veterans Building. In addition, the scope of the exhibition program was expanded to not only emphasize painting, sculpture, photography, and architecture and design, but also experimental forms related to performance, Conceptualism, and the media arts.

SFMOMA distinguished itself late in the decade by being the only museum in the nation to present both *Robert Rauschenberg* (1977) and *Jasper Johns* (1978). The Museum, under the direction of Curator Suzanne Foley, examined other developments in postwar American art, in particular the conceptualist movement that emerged in the late 1960s, with presentations of the work of Sol LeWitt, Christo, Howard Fried, and Tom Marioni, as well as Foley's 1979 survey *Space/Time/Sound— 1970s: A Decade in the Bay Area.* At the same time, the Museum presented shows that explored the twentieth-century's newest form of artistic expression, the media arts. An installation of slide-projection works by Jim Melchert and the exhibition *Southland Video Anthology,* both in 1975, were followed by a sound installation by Vito Acconci in 1978, integrating the regular presentation of videotapes and media works into the Museum's exhibition program.

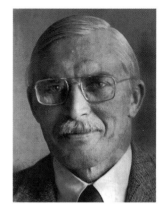

HENRY HOPKINS

The new decade of the 1980s opened with the Museum's pivotal retrospective of the work of abstract and figurative expressionist Philip Guston, organized to critical acclaim by Hopkins and circulated internationally. The Museum continued its exploration of different aspects of the history of twentieth-century art by giving the West Coast presentations of such major exhibitions as *Expressionism: A German Intuition, 1905–1920* (1981), co-organized by SFMOMA and the Solomon R. Guggenheim Museum; *Edward Hopper: The Art and the Artist* (1981); *Kandinsky in Munich: 1896–1914* (1982); and *Diego Rivera: The Cubist Years* (1984).

The appointment of Van Deren Coke as director of photography in 1979 and the establishment of a distinct Department of Photography in 1980 signaled SFMOMA's formal recognition of the importance of the medium in its overall artistic program. While the Museum had collected and exhibited photography since 1935, Coke launched the new department on an unprecedented pace of activity, with exhibitions of historical and contemporary photography accounting for approximately one-third of SFMOMA's total exhibition schedule. The landmark *Avant-Garde Photography in Germany: 1919–1939,* presented at SFMOMA in 1980, was subsequently circulated on a prestigious two-year tour throughout the United States and Europe.

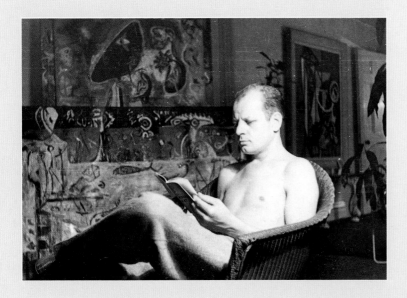

JACKSON POLLOCK

Surrounded by the myths and legends that remain inextricable from the ascendancy of American Abstract Expressionism, Jackson Pollock (1912–1956) is arguably this country's greatest painter. The abstract expressionist revolution triggered by his radical "drip" paintings of 1947–50 brought the United States to the forefront of artistic innovation and blasted the art world with raw emotionalism and heroic gestures. ❖ Yet when the San Francisco Museum of Art secured the presentation of Pollock's first solo museum exhibition in 1945, he was a relatively unknown painter, struggling to reconcile his artistic identity with his turbulent personal life. His work from the early 1940s—reflecting a variety of interests including Surrealism, automatism, Jungian imagery, and Native American art—had caught the eye of prominent gallery owner Peggy Guggenheim, who signed him on in 1943, as well as Museum Director Grace McCann Morley. "Pollock is an important new personality whose work deserves to be better known," asserted Morley in 1944,[1] and it was this conviction that led not only to the 1945 exhibition but also to the Museum's purchase of his seminal masterpiece *Guardians of the Secret* (page 82) shortly thereafter. ❖ Acquainting herself with Pollock's oeuvre over several visits to New York, Morley had favored *Guardians of the Secret* and even included the work in an earlier exhibition, *Abstract and Surrealist Art in the United States*, that she had organized in 1944. "It is *Guardians of the Secret* which I have come to find more and more satisfactory as I learn better to understand Pollock's way of expression," Morley wrote Guggenheim in 1945, seeking to add to the Museum's collection "the work of a man so original."[2] The acquisition of Pollock's remarkable painting testifies to a director's acute eye for art and the gamble she took to bring a pivotal work in the history of postwar American art—as time would later tell—to the collection of the San Francisco Museum of Modern Art. ❖ Jackson Pollock in his studio on East 8th Street in New York City in 1943. In the lower left is the unfinished painting *Guardians of the Secret*.

1. From a letter dated August 19, 1944, to Robert Tyler Davis, director of the Portland Art Museum.

2. Both quotes from Grace McCann Morley's letter dated September 6, 1945, to Peggy Guggenheim.

Similarly, the Museum's longstanding interest in the disciplines of architecture and design led to the establishment of an official Department of Architecture and Design in 1983. In its inaugural year, the department presented *Issey Miyake Spectacle: Body Works,* featuring the avant-garde fashion creations of this Japanese design innovator.

The accelerated exhibition program under Hopkins' administration was paralleled by an equally spectacular leap in collecting activity. In this arena, Hopkins may be best remembered for securing Clyfford Still's extraordinary gift in 1975 of twenty-eight monumental canvases, making the Museum, along with the Albright-Knox Art Gallery in Buffalo, New York, the first public institutions to own a substantial and representative collection of the abstract pioneer's work. In addition, the purchase of the monumental triptych *Red Sea; The Swell; Blue Light* (page 118) by Philip Guston in 1978 inspired the artist's subsequent presentation of four additional paintings, and SFMOMA's in-depth holdings of works by individual artists were augmented by gifts of work by Josef Albers, Frank Stella, and Richard Diebenkorn. In addition, the acquisition of single key works widened the scope of the collection and enhanced in particular the representation of Color Field painting, second-generation Abstract Expressionism, and the contemporary art of California.

Under Van Deren Coke's curatorial leadership, the Museum's collection of photography was brought into sharper focus with the addition of both singular works and groups of prints representing an individual artist or distinct theme. Coke's 1980 German photography exhibition prompted the acquisition of a core group of prints from the interwar era. In addition, photographs new to the collection by such pioneers as Man Ray, Ilse Bing, and Robert Frank balanced the addition of the work of contemporary artists such as Robert Adams, Larry Clark, Robert Mapplethorpe, and Joel-Peter Witkin.

It was the institution's fiftieth anniversary in 1985 that provided the occasion for the Museum to present the full breadth of its permanent collection. Taking over all the galleries, *The 20th Century: The San Francisco Museum of Modern Art Collection* comprised approximately six hundred works dating from 1900 to 1984, reflecting the special character and particular strengths of the Museum's holdings, as well as some fifty promised gifts to the collection. The year-long celebration also included special

exhibitions and public programs, and the publication of a comprehensive catalogue of the painting and sculpture collection.

In 1986, after twelve years of leadership, Hopkins departed the Museum to head the Frederick R. Weisman Foundation in Los Angeles, and Dr. John R. Lane, formerly director of The Carnegie Museum of Art in Pittsburgh, was named the Museum's fifth director in 1987. Lane, whose list of accomplishments included spearheading the critically acclaimed triennial Carnegie International exhibition in 1985 and scholarly work in the field of American Modernism, brought to SFMOMA a distinct vision for the heightened role it should play in the cultural life of the San Francisco Bay Area and beyond. Reaffirming its mission to "collect, preserve, exhibit, and interpret the art of the twentieth century," the Museum embarked on an exciting new era of growth and consolidation, one that would become visible in the quality and importance of additions to the permanent collection and in the depth and vitality of its exhibitions.

Playing an instrumental role in Lane's program of expansion was Graham W.J. Beal, who served as Elise S. Haas chief curator from 1984 to 1989. During his tenure, Beal originated several major exhibitions and also contributed to SFMOMA's *New Work* series. In addition, he assisted Lane in the establishment of five distinct curatorial spheres by creating a separate Department of Painting and Sculpture and adding the Department of Media Arts to those already existing for photography, architecture and design, and education. In 1987, Sandra S. Phillips joined the staff as curator of photography, succeeding Curator Emeritus Van Deren Coke in leading the Museum's program in photography, and Paolo Polledri was named SFMOMA's first curator of architecture and design, serving in this post until 1994. Robert R. Riley was appointed curator of media arts in 1988, and John Caldwell arrived the following year to serve as curator of painting and sculpture. In 1993, Gary Garrels was appointed Elise S. Haas chief curator and curator of painting of sculpture, after the death of Caldwell earlier that year.

Under Lane's direction, the expanded curatorial division undertook an accelerated special exhibitions schedule, both organizing and hosting important traveling shows. Curator of Painting and Sculpture John Caldwell's program assumed a strong contemporary international focus with the organization of such landmark exhibitions as *Sigmar Polke* (1990), *Luciano Fabro*

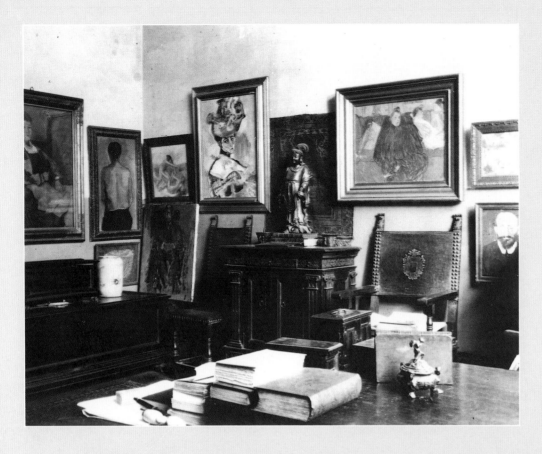

THE SARAH AND MICHAEL STEIN MEMORIAL COLLECTION

In 1935, when expatriates Sarah and Michael Stein returned from Paris to live in the San Francisco Bay Area, they brought home with them a collection that is now part of modern art lore. Indeed, the Steins, together with Michael's siblings Gertrude and Leo, had shared the adventure of collecting modern art in Paris for some thirty years, becoming the most influential patrons of the art of the early twentieth century to go to Europe from the Bay Area. ❖ While Gertrude and Leo favored such artists as Picasso and Cézanne, the work of Henri Matisse captured the fancy and, ultimately, the devoted patronage of Sarah and Michael. Shortly after the Salon d'Automne of 1905, where Matisse's *Femme au chapeau* sensationalized the art world, Sarah and Michael were introduced to the artist at his studio, for it was the Stein family who had boldly stepped forward to purchase the scandalous painting. A warm friendship ensued between Matisse and the couple, particularly Sarah, in whom the artist found an enthusiastic supporter and trusted confidante. ❖ By the early 1910s, the couple owned works representing every period of Matisse's early development, but they dispersed most of the collection after the first world war. Their collecting activity waned through the 1920s, and in 1935, they moved back to California, bringing only a few works with them. Sarah, who was widowed in 1938, sold off what was left of the collection before her own death in 1953. ❖ In 1955, Elise S. Haas, a trustee of the San Francisco Museum of Art, established the Sarah and Michael Stein Memorial Collection at the Museum in honor of her close friends. Haas herself had purchased a number of objects from Sarah, and it was her gift of Matisse's *Portrait of Sarah Stein*, along with Nathan Cummings' benefaction of *Portrait of Michael Stein*, that inaugurated the effort to reunite works from the Steins' legendary collection. Matisse, too, paid tribute to his old friends, sending two fine drawings as his personal contribution with the explanation that "though they seem different, [they] are sure by their qualities to be in perfect harmony with the works of the Stein Collection that may be brought together in the Museum." In 1990, these works were reunited with others that were originally part of the Steins' collection, including *Femme au chapeau*, when Elise S. Haas bequeathed her entire collection of modern art to the Msueum (**pages 56 and 58**). ❖ The studio of Leo and Gertrude Stein at 27 rue de Fleurus, Paris, 1906; *Femme au chapeau* is the fourth painting from the left.

Shin Takamatsu, presented in 1993, introduced SFMOMA audiences to the work of one of today's leading Japanese architects.

(1992), and *Jeff Koons* (1992), and also introduced to SFMOMA audiences the recent accomplishments of both young and established artists—among them, Matthew Barney, Martin Kippenberger, Sherrie Levine, and Christopher Wool—through the Museum's *New Work* series. Curator of Photography Sandra S. Phillips made her mark early in her tenure by organizing *A Body of Work: Photographs by John Coplans,* and subsequently initiated a number of major exhibitions that achieved wide recognition and critical acclaim, including *A History of Photography,* a four-part series celebrating the 150th anniversary of the invention of photography (1989); *An Uncertain Grace: The Photographs of Sebastião Salgado* (1990); *Helen Levitt* (1991); *Wright Morris: Origin of a Species* (1992); and *Dorothea Lange: American Photographs* (1994). Under Paolo Polledri's curatorship, the Department of Architecture and Design concentrated on California and the Pacific region, and originated such major shows as *Visionary San Francisco* (1990), *Shin Takamatsu* (1993), and *The Color of Elements: The Architecture of Mark Mack* (1993). In addition, the Museum's impact in the growing field of media arts took a leap forward with Curator Robert R. Riley's organization of such original exhibitions as *Bay Area Media* (1990), *The Projected Image* (1991), and *Thresholds and Enclosures: Television as Sculpture in Works by Vito Acconci, Gretchen Bender, Dara Birnbaum, Peter Campus, Dan Graham, and Julia Scher* (1993).

To complement the Museum's revitalized exhibition schedule, Lane also oversaw the expansion of the Department of Education for the development and implementation of a wide range of interpretive and outreach activities, including initiatives in the new area of interactive educational technologies. John S. Weber was appointed curator of education and public programs in 1993 to lead this effort. In addition, an ambitious agenda for the publication of scholarly catalogues was initiated to enrich the overall artistic program.

Similarly, the SFMOMA permanent collection flourished with the establishment of the Accessions Committee Fund in 1987, giving the Museum for the first time a significant art acquisition budget on which it could count. While purchases in all media—painting, sculpture, installation work, photography, architecture, design, and the media arts—emphasized contemporary works by international, national, and Bay Area artists, it was through the generosity of SFMOMA's donor community that the representation of early Modernism in the collection was enriched. One of the great gifts in the Museum's history was the bequest of Elise Stern Haas in 1991—some thirty works by many of the leading artists of the modern era—that gave SFMOMA its most renowned painting, *Femme au chapeau,* by Henri Matisse. Other bequests provided such major works as Matisse's 1938 painting *La Conversation* and Georges Braque's *Violin and Candlestick* from

The 1992 exhibition *Luciano Fabro* (above) and *Sigmar Polke*, in 1990, explored the work of two of Europe's most influential contemporary artists.

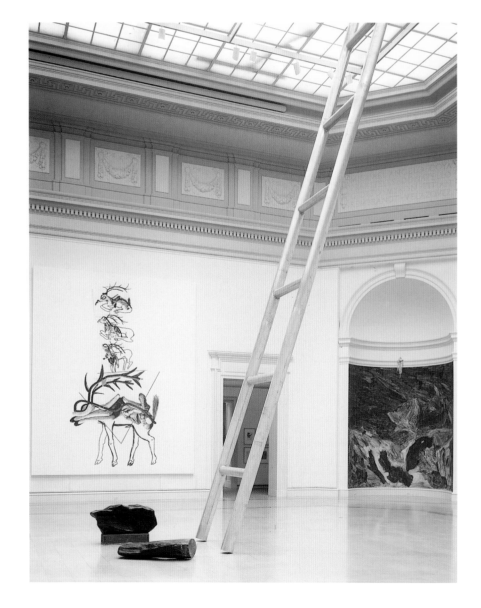

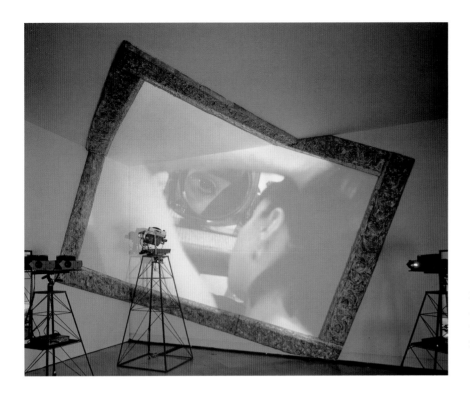

Covering new terrain:
Dorit Cypis' installation
X-Rayed (Altered) joined seven other
technologically innovative works
in the 1991 media arts exhibition
The Projected Image.

1910, while SFMOMA welcomed Dr. Carl Djerassi's ongoing and promised gift of his entire collection of approximately one hundred works by Paul Klee in 1985; and Harry W. and Mary Margaret Anderson's 1992 benefaction of seven works related to American Pop art.

Lane's mandate for SFMOMA to be a vital cultural force—from the San Francisco region to the global arena—included not only restructuring the staff and enlarging the scope of the Museum's artistic and interpretive programs, but also finding a new home for the institution. As the fiftieth anniversary exhibition in 1985 had made exceedingly apparent, the Museum, by virtue of its permanent collection alone, had outgrown the Civic Center quarters it had occupied since 1935. In 1987, both Lane and the Board of Trustees, headed by Chairman Brooks Walker, Jr., agreed that San Francisco needed a museum of twentieth-century art of truly international stature, one that could mount superior exhibitions while also exhibiting and aggressively expanding its important permanent collection of modern and contemporary art. After careful study of its future needs and considerable discussion with the Redevelopment Agency of the City and County of San Francisco, SFMOMA announced in July 1988 its plans to construct a new facility in Yerba Buena Gardens, the Agency's eighty-seven-acre mixed-use project adjacent to the Moscone Convention Center.

Celebrated Swiss architect Mario Botta was the unanimous choice of the Trustees' Architect Selection Committee, which visited his office in Lugano and surveyed a number of his completed projects throughout Europe. In September 1990, Botta unveiled his critically acclaimed design for a 225,000-square-foot modernist monument that would serve as SFMOMA's future home. The new building doubled the gallery space of the War Memorial Veterans Building while providing a generous array of program and public facilities.

Botta's design concept promised a distinguished architectural and cultural landmark for the whole San Francisco Bay region. The building's construction, initiated in April 1992 by a rousing groundbreaking ceremony, was completed in the summer of 1994. Particularly noteworthy was the $85-million New Museum Campaign launched by SFMOMA's Board of Trustees—an ambitious endeavor to secure $60 million for the new museum's construction and $25 million for an operating endowment—in time for the grand opening celebration on January 18, 1995, exactly sixty years after SFMOMA opened in the War Memorial Veterans Building on Van Ness Avenue.

The repository of a collection of seventeen thousand artworks that provide a rich context for many artistic and educational programs, the San Francisco Museum of Modern Art today is a cultural institution of international significance. Reflecting the collecting activities of five directors over sixty years, the SFMOMA permanent collection embraces the entire

ART IN CINEMA

When the San Francisco Museum of Art officially established its popular Art in Cinema program in 1946, it had already been exploring the motion picture as an art form for ten years. Indeed, since 1936, when the film library of The Museum of Modern Art, New York, made its important collection of cinematic work available, films of artistic, technical, and historical importance represented an integral part of the San Francisco Museum of Art's commitment to and presentation of "the 'growing edge' of creative living art."[1] ❖ Art in Cinema's inaugural year featured ten programs that aimed to bring Museum audiences up to date on the rich developments and hybrid aspects of the then-fifty-year-old film tradition. Focusing in particular on the avant-garde movement that flourished in Europe in the 1920s, topics ranged from "The French Avantgarde" and "The Animated Film as an Art Form" to "Experiments in the Fantastic and the Macabre" and "Poetry in Cinema." The publication accompanying the first series included scholarly essays by such prominent artistic and literary figures as Henry Miller, Man Ray, Hans Richter, Luis Buñuel, and Oskar Fischinger. ❖ Led by its visionary founding director, Frank Stauffacher, Art in Cinema operated as a separate, self-supporting activity within the Museum's framework, presenting annually two seasons of four to six programs each to a large and discriminating audience. It was discontinued in 1978 due to financial difficulties, and soon thereafter the rotunda gallery, which had been adapted into a theater for film screenings, was restored to its original grandeur as a sculpture court. ❖ Today, almost fifty years after Art in Cinema's initial founding, SFMOMA renews its commitment to exploring the infinite manifestations of film as a medium of artistic expression. The Museum's revitalized film program, presented under the direction of the Department of Media Arts and its curator, Robert R. Riley, will once again highlight innovative and experiemental filmmaking, serving as a venture to commemorate the centenary of the motion picture and to celebrate its bright future. ❖ The Museum's rotunda was filled to capacity with this October 30, 1953, program of the Art in Cinema series.

1. Grace L. McCann Morley, "Foreword," in *Art in Cinema*, ed. Frank Stauffacher (San Francisco: San Francisco Museum of Art, 1947), 1.

SFMOMA's final exhibition before permanently closing its Civic Center doors in September 1994, *Dorothea Lange: American Photographs* featured the photographer's documentary work from the 1930s to the 1950s.

span of twentieth-century art and is highlighted by early modernist works, an internationally renowned collection of photography, important holdings of media and time-based works, architecture and design objects related to California and the Pacific Rim, and a distinguished selection of work by contemporary regional, national, and international artists. Equally significant, however, may be the fact that this important resource is now presented in a singular achievement of museum architecture. Furthermore, the Museum boasts one of the most vital exhibition programs in the nation, presenting an ambitious schedule of shows organized by the SFMOMA curatorial staff, paired with a growing and committed education program.

When the San Francisco Museum of Modern Art was established in 1935, it became a pioneering force for the development of contemporary art in San Francisco and played an influential role in making the region the cultural stronghold of the western United States. Today, the San Francisco Bay Area has a new museum, one that honors the artistic heritage of the region and is worthy of a major metropolitan center that attracts visitors from all over the world. As it has done throughout its distinguished history, the new SFMOMA looks forward to contributing to the cultural richness and artistic vitality of the Bay Area into the twenty-first century, for the vision of its first director,

Grace McCann Morley, remains unchanged: "A museum of contemporary art must lead the way, it must explore, it must endeavor to reach out into the new fields of art as they develop, it must try to assure a firm foundation of understanding for the new of yesterday that has become the accepted of today and will be the tradition of tomorrow."[6]

1. San Francisco Art Association, *The California School of Design, San Francisco Institute of Art* (San Francisco: San Francisco Art Association, 1912), 5.

2. The school, which was located in various locations including the former Nob Hill mansion of Mark Hopkins, found a permanent home on Russian Hill in 1926, renaming itself the California School of Fine Arts. In 1961 the San Francisco Art Association and school merged under the name of the San Francisco Art Institute.

3. Moses Lasky, *History of the San Francisco Museum of Art and Analysis of its Relation to the City and County of San Francisco*, a document prepared for the Board of Trustees of the San Francisco Museum of Art in 1961. See p. 1.

4. A work of highly sentimental value to Rothko, the 1944 painting was exchanged in 1962 for a 1960 untitled work at the request of the artist.

5. The $2.25-million cost, adjusted for the dollar's 1994 value, is $8.25 million. Half of the funds raised were allocated to the reconstruction and half were allocated to the already established endowment fund to maintain additional operations and services.

6. From a memo from Dr. Morley to the Museum's Board of Trustees, dated March 17, 1958.

Janet C. Bishop
Andrew W. Mellon Foundation
Assistant Curator of Painting and Sculpture
1992–present

Gary Garrels
Elise S. Haas Chief Curator and
Curator of Painting and Sculpture
1993–present

Douglas R. Nickel
Assisant Curator of Photography
1993–present

Sandra S. Phillips
Curator of Photography
1987–present

Paolo Polledri
Curator of Architecture and Design
1987–1994

Robert R. Riley
Curator of Media Arts
1988–present

J. William Shank
Chief Conservator
1991–present

John S. Weber
Curator of Education and Public Programs
1993–present

INTO THE GALLERIES

Collection Highlights

FEMME AU CHAPEAU
(Woman with the Hat), 1905
oil on canvas
31¾ x 23½ in. (80.6 x 59.7 cm)
Bequest of Elise S. Haas, 91.161

• French, 1869–1954

HENRI MATISSE

Henri Matisse's early portrait *Femme au chapeau* is principal among the highlights of the Elise S. Haas Collection, bequeathed to the Museum in 1990. The Haas collection includes thirty-seven paintings, sculptures, and works on paper by many of the most important modernist artists—Brancusi, Picasso, Juan Gris, Henry Moore, Marsden Hartley, and Georgia O'Keeffe, among others—as well as a number of significant works by Matisse. Together these objects comprise one of the most important gifts to the Museum in its sixty-year history.

Matisse completed *Femme au chapeau* in the fall of 1905 in Paris, where it was first exhibited in the Salon d'Automne, the great annual exhibition of contemporary art. The work marked the artist's most adventuresome break with the traditions of French painting, and it drew the most attention in the exhibition and the most outrage from the critics, who characterized it as one of the "wild beasts," thus christening the movement "Fauvism."[1] Without question, the painting stands as one of the landmarks in the development of modernism, and in turn set off a chain reaction leading in the successive radical innovations of the early twentieth century, from the Cubism of Picasso and Braque to Italian Futurism and German Expressionism, as well as the increasingly experimental works of Matisse himself. Happily for this museum, the importance and quality of *Femme au chapeau* was recognized at the time by the expatriate Stein family from the Bay Area, who acquired it for their collection. In the early 1950s it was purchased from them by the Haas family.

The painting presents a half-length portrait of the artist's wife, Amélie, who is seated in a chair with her body and head turned to meet the gaze of the artist—and of the viewer. What were radical and repugnant characteristics at the time it was first presented are in fact many of the same qualities that continue to make the painting so powerful and engaging today—the loose, rich, sensual brushwork; the high-keyed, luxuriant color; and the mysterious, preoccupied pose of the model who appears to look out directly but actually stares past in complete self-absorption. As John Elderfield, in his essay for the recent Matisse retrospective at The Museum of Modern Art in New York, has observed, "It is an aloofness at once serene and disquieting, both sensual and cold, not seen elsewhere in modern painting."[2] And, as John Klein noted in his recent essay on the painting, "…the breaches of decorum committed by *Femme au chapeau* were not limited to conventions of technique in painting. Social and personal values were also under fire in this portrait…."[3] The style of the painting and the psychology of the portrait equally contribute to this work's important break with nineteenth-century sensibilities. The presence of this painting in SFMOMA's collection underlines the Museum's mission to be alert to new and critical challenges of aesthetic and artistic convention, to be both a laboratory for the new and a repository of past achievements. – GG

Matisse re-used a previously painted canvas for *Femme au chapeau*, a fact evidenced by the thick brushwork that does not conform to the composition of the portrait. X-radiographs of the painting unfortunately yield little information about the earlier image; the extent to which the colors of the painting beneath may have influenced Matisse's palette on this first Fauve portrait remains a mystery. –JWS

1. The most recent and in-depth discussion of this painting is by John Klein: "When Worlds Collide: Matisse's *Femme au chapeau* and the Politics of the Portrait," in *Matisse and Other Modern Masters: The Elise S. Haas Collection* (San Francisco: San Francisco Museum of Modern Art, 1993): 7–18.

2. John Elderfield, *Henri Matisse: Retrospective* (New York: The Museum of Modern Art, 1992), 41.

3. Klein, p. 8.

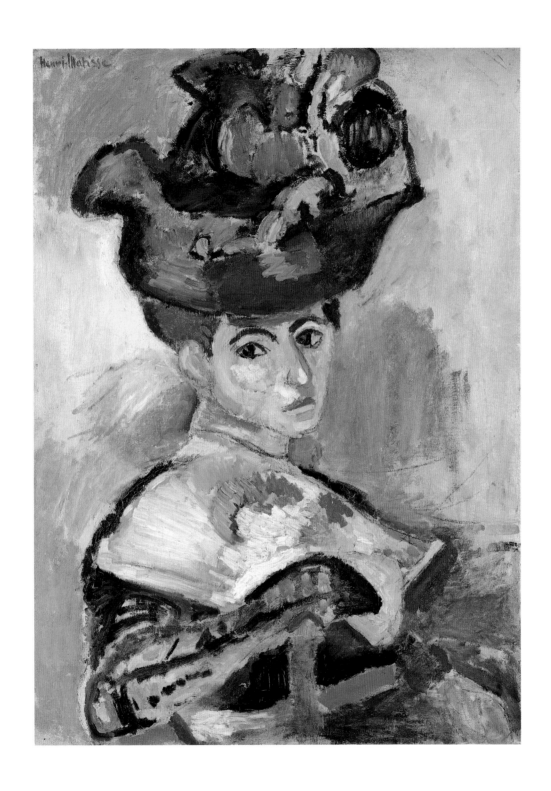

If Matisse's portrait of his wife, *Femme au chapeau*, announced the birth of Fauvism at the Salon d'Automne in 1905, the movement reached its apex with his monumental landscape of the following year, *Le Bonheur de vivre*, now in the Barnes Foundation collection. In terms of subject—carefree figures basking in the splendor of the outdoors—the painting was not unusual; it represents, in fact, a sophisticated synthesis of traditions of subject and formal composition ranging from prehistoric cave painting to Ingres' *L'Age d'or* (The Golden Age) of 1862.[1] Yet despite its presentation of a well-established theme, *Le Bonheur de vivre*'s monumental scale, heated palette, and oddly cartoon-like treatment of its figures made it *the* radical painting that Picasso must have wished to surpass when he made a seminal work of his own—*Les Demoiselles d'Avignon* (The Young Ladies of Avignon)—the following year.[2]

Before arriving at the final composition of *Le Bonheur de vivre*, Matisse completed several studies for the work: a landscape without figures painted in the summer of 1905 at Collioure; pen and ink sketches more fully detailing the composition and individual figures; and *Esquisse pour "Le Bonheur de vivre,"* the final (known) oil sketch, probably made in Paris after the Salon d'Automne in the fall or winter of 1905–6. The scale, in particular, is unique to the final version (*Le Bonheur de vivre* is over four times as large as the esquisse), yet the *Esquisse pour "Le Bonheur de vivre"* anticipates the painting in several important ways. Though the esquisse was, for the most part, executed with loose, neo-impressionist broken brush strokes, one can also see hints of Matisse's interest in the broad, flat, Gauguinesque areas of color in the upper-right portion. Furthermore, Matisse had already begun to enclose areas of color by line to articulate the figures. It is in this final oil sketch, too, that both the palette and the arrangement of all of the major figures were determined, including the barely perceptible ring of dancers in the background—the very first appearance of a motif that would become a favorite of the artist. — JCB

HENRI MATISSE

ESQUISSE POUR "LE BONHEUR DE VIVRE"
(Sketch for "The Joy of Living"), 1905–6
oil on canvas
16 x 21½ in. (40.6 x 54.6 cm)
Bequest of Elise S. Haas, 91.160

• French, 1869–1954

1. See John Elderfield, *Henri Matisse: A Retrospective* (New York: The Museum of Modern Art, 1992), 54.

2. See Pierre Daix, *Picasso: The Cubist Years, 1907–1916* (Boston: New York Graphic Society, 1979), 16.

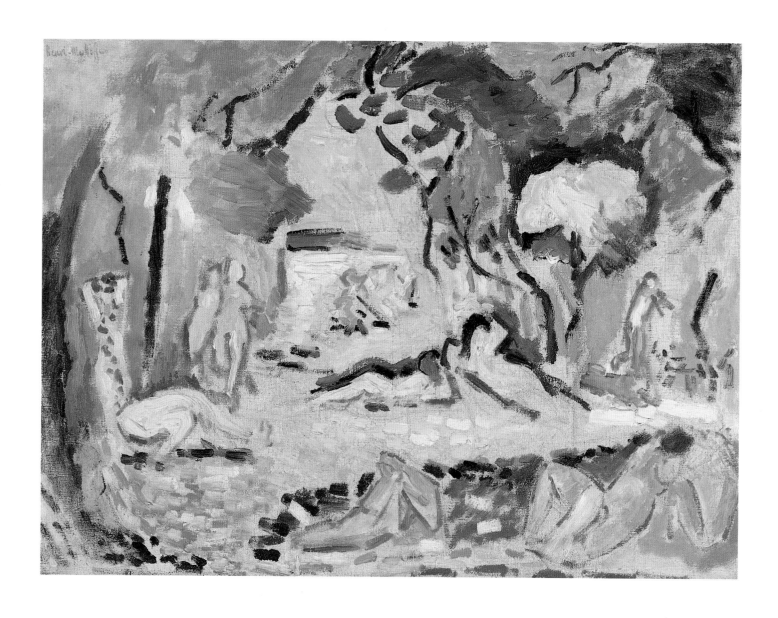

The evolution of Cubism is entirely dependent upon a several-year period of mutual exploration by Georges Braque and Pablo Picasso that entered its most intense phase in the fall of 1909 in Paris, after Braque returned from summer holiday at La Roche Guyon and Le Havre, and Picasso from the Portuguese island of Horta. Braque's *Violin and Candlestick*, made during this period when the works of the two artists became virtually indistinguishable, represents the height of the resulting style of Analytic Cubism—an approach to painting that the artists developed to reconcile the placement of three-dimensional objects on a two-dimensional picture plane without the traditional use of Renaissance perspective, light, and shadow.

In *Violin and Candlestick*, familiar still-life props, some clear and some ambiguous, appear clustered at the center of a shallow, grid-like armature. The canvas bears the vestiges of dabbed, neo-impressionist brushwork. The palette, however, bears no resemblance to the sun-drenched ones of Braque's immediate predecessors, but is typical of the subdued color scheme that he and Picasso favored at the time, in this case white, yellow ochre, brown, gray, and black—hues that are relatively unsusceptible to modulation and alteration by light. Through the selective use of *passage*, a painterly technique borrowed from Cézanne, Braque tends toward a unification of object and arena by both opening up and covering over the boundaries of the black-outlined objects. Form and ground are further locked together as the volumes in the still life are transformed to accommodate their multiple surfaces on a flat plane, thereby allowing the viewer to see more of any given object than would be possible from a single vantage point. The base of the candlestick in the center, for instance, tilts up in the rear, appearing parallel to the canvas (and thereby echoing the shape of the violin). By forging a new visual vocabulary for the articulation of space, form, and volume, Braque and Picasso took immeasurable strides toward freeing painting from the conventions of traditional representation. – JCB

GEORGES BRAQUE

VIOLIN AND CANDLESTICK, 1910
oil on canvas
24 x 19¾ in. (61 x 50.2 cm)
Gift of Rita B. Schreiber in loving memory
of her husband, Taft Schreiber, 89.78

• French, 1882–1963

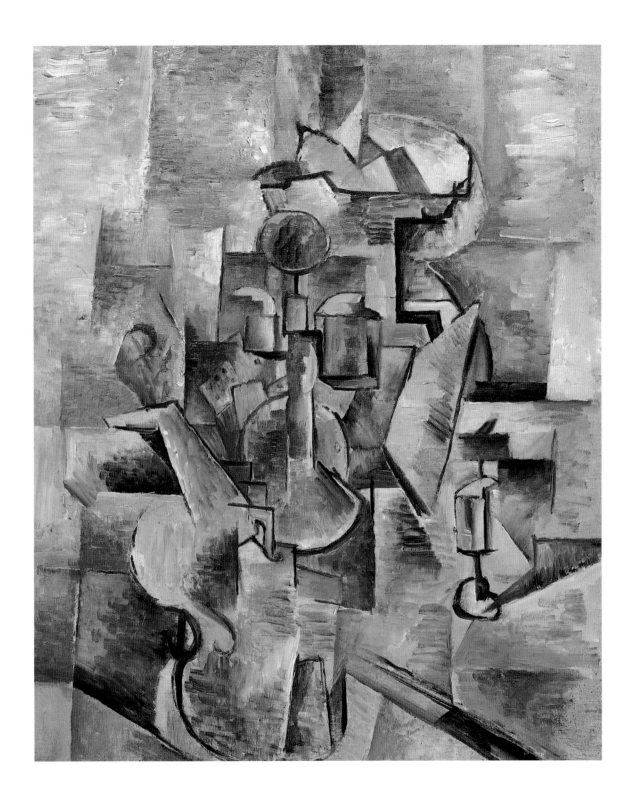

The eve of 1911 brought the fortuitous meeting of Franz Marc and Vasily Kandinsky. As the new year advanced, so too did the artistic kinship of the young German artist and his new Russian friend and mentor, an alliance that resulted in the founding of a new segment of German Expressionism, *Der Blaue*

Reiter (The Blue Rider). Referencing in its name the two painters' well-established interests in both color and the subject of the horse, *Der Blaue Reiter* was not a movement or a school per se, but rather a shifting group of artists with a shared concern for spiritual harmony within the natural world.

The first exhibition staged by *Der Blaue Reiter* took place at Munich's Moderne Galerie Thannhauser in December 1911. The show consisted of paintings by an international roster of artists invited to participate by Marc and Kandinsky, including Bavaria-based painters Albert Bloch and Gabriele Münter, the composer Arnold Schönberg from Berlin, August Macke from Bonn, and Elizabeth Epstein, Henri Rousseau, and Robert Delaunay from Paris. Hanging next to a painting of the Eiffel Tower by Delaunay was Marc's canvas, known then as *Landschaft* (Landscape).[1] This work took as its subject a region of upper Bavaria that boasted the Pioneer Path, a treacherous mountain trail hiked by Marc that may have served the artist as a metaphor for the difficult journey of life.[2]

In September 1912, Marc went to Paris to visit Delaunay, whose interests in luminous color and structure informed by cubist abstraction were of great interest to the German artist. Late in that year, after returning to Germany, Marc painted over *Landschaft* and retitled it *Gebirge* (Mountains). During this second session with the painting, he added dark lines that accentuate the prismlike nature of the icy mountains. Marc painted in a bright orange sun that peeks over the hills at the very top of the composition, recalling such forms that were so central to Delaunay's imagery, and he activated the lower left quadrant of the painting with a virtual kaleidoscope of colors. The result is an important transitional painting that has become crucial to understanding the work of an artist whose career was cut short in 1916 by his death at the Battle of Verdun at the age of thirty-six. — JCB

GEBIRGE (formerly *Landschaft*)
(Mountains [formerly Landscape]), 1911–12
oil on canvas
51½ x 39¾ in. (130.8 x 101 cm)
Gift of the Women's Board and Friends of the Museum,
51.4095

• German, 1880–1916

1. See photograph by Gabriele Münter in Peter-Klaus Schuster, et. al., *Delaunay und Deutschland* (Cologne: Dumont Buchverlag, 1985) 217, fig. 8.

2. The interpretation is Klaus Lankheit's. See Mark Rosenthal, *Franz Marc* (Munich: Prestel Verlag, 1989), 27.

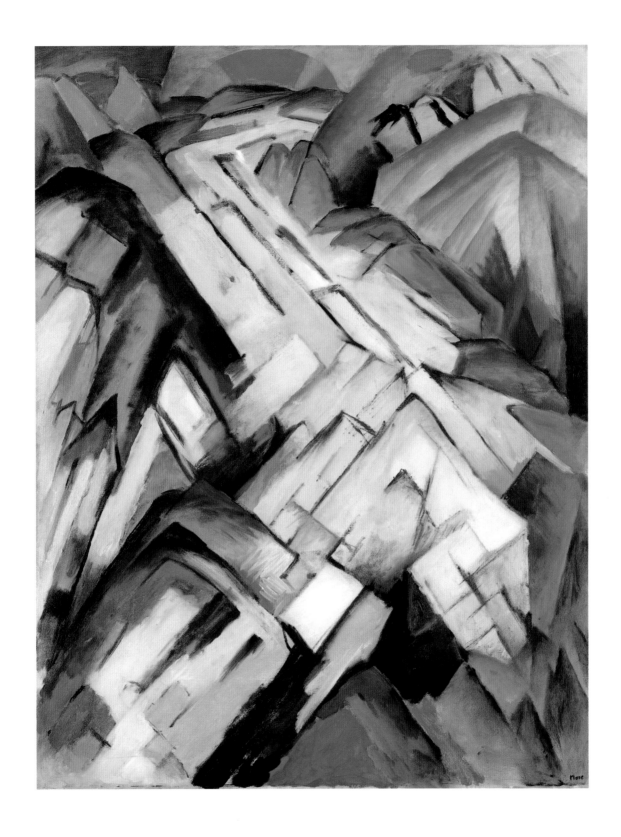

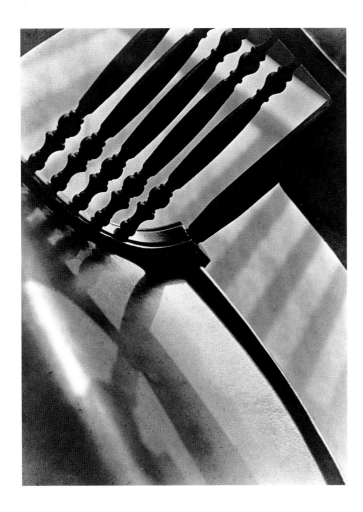

CHAIR ABSTRACT, TWIN LAKES,
CONNECTICUT, 1916
palladium print, 13 x 9¹¹/₁₆ in. (33 x 24.6 cm)
Purchase, 84.15

• *Paul Strand* American, 1890–1976

Photographic modernism in America arose during the First World War as a synthesis of the Pictorialist impulse toward design and the appearance here of cubist painting. At the Armory Show in 1913 and at Alfred Stieglitz's "291" Gallery, young photographers beheld the arrival of Cézanne, Matisse, Picasso, and Duchamp, European artists who had turned their backs on the tradition of representational painting and undertaken experiments into the very nature of representation and vision. How time and three-dimensional matter might be analyzed and rendered as a static, two-dimensional image was the cubists' primary concern, but it was also the concern of any serious person who had ever picked up a camera, and so it is not surprising that a fruitful cross-fertilization of modern painting and photography came to pass in the first decades of this century.

Paul Strand was Stieglitz's protégé in the period 1915–1921. In the summer of 1916, on a visit to Twin Lakes, Connecticut, Strand began a series of exercises intended to test the plastic organizational properties of photography against those of painting. He wanted to learn "how you build a picture, what a picture consists of, how shapes are related to each other, how spaces are filled, how the whole must have a kind of unity."[1] *Chair Abstract* was one of the results, a vertiginous image that takes a piece of porch furniture as the occasion for radical compositional experimentation. By moving in close and tilting his camera forty-five degrees off-level, Strand defamiliarizes his subject, transforming it into faceted planes and repeating lines and forms. The entire picture surface is activated; the tight cropping throws the viewer's relationship to represented space into question. Not long after

making his chair picture, Strand gave up this kind of abstraction and returned to the politically motivated, humanistic portrait and landscape work for which he is best known, having quite absorbed the lessons this self-imposed assignment in design could bestow.

Ralph Steiner came to his abstract composition by a different route. As a student at the Clarence White School of Photography in New York in the early twenties, he gravitated toward the teachings of Arthur Wesley Dow, whose influential book *Composition* demonstrated how principles of Japanese art could be applied to modern design. Steiner's final project for the Clarence White School was *The Beater and the Pan,* a unique, handmade book featuring eight elegant photographic studies. Like Strand, Steiner begins with everyday objects, but he transforms them into arrangements of light and shade by approximating the flattened perspective of Japanese prints. Steiner emphasizes shadows more than Strand, befitting his desire for abstract harmonies independent of subject and meaning. That the following decade found both Steiner and Strand working as documentary photographers and filmmakers is not altogether surprising; for each, design became prerequisite to meaningful social expression. Their two career paths eventually crossed in the late 1930s at Frontier Films, an independent, antifascist filmmaking company, where they collaboratively brought their pre-Depression, modernist sensibilities to bear on themes of importance to their native land. – DRN

1. Paul Strand, *Paul Strand: Sixty Years of Photographs* (Millerton, N.Y.: Aperture, 1976), 19.

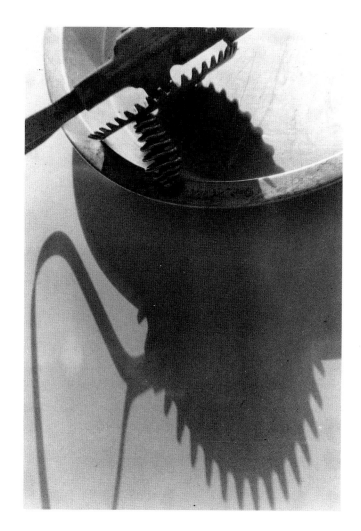

UNTITLED
(from the unique, handmade book
The Beater and the Pan), 1921–22
gelatin silver print
4¹¹⁄₁₆ x 3³⁄₁₆ in. (11.9 x 8.1 cm)
Purchase, 83.109.2

• *Ralph Steiner* American, 1899–1986

Formerly we used to represent things visible on earth, things we either liked to look at or would have liked to see. Today we reveal the reality that is behind visible things, thus expressing the belief that the visible world is merely an isolated case in relation to the universe and that there are many more other, latent realities. Things appear to assume a broader and more diversified meaning, often seemingly contradicting the rational experience of yesterday. There is a striving to emphasize the essential character of the accidental. PAUL KLEE, 1920[1]

PAUL KLEE

Paul Klee's *Rotes Haus* is one of nearly one hundred paintings, drawings and prints that have been either donated or promised to the Museum by Carl Djerassi and the Djerassi Art Trust. Together these works form the basis for the Paul Klee Study Center and constitute one of the Museum's primary areas of strength, encompassing pieces from throughout Klee's career and in all the media in which he worked.

Throughout most of his artistic career, Klee worked in Germany, leaving only in 1933 when dismissed from his teaching post in Düsseldorf by the National Socialist regime. Along with Vasily Kandinsky, Gabriele Münter, Franz Marc, and August Macke, Klee was a member of *Der Blaue Reiter* (The Blue Rider), the group of Expressionists active in Munich from 1911 to the outbreak of the First World War.

Made during the period in the 1920s that Klee and his friend Kandinsky were on the faculty of the Bauhaus, Weimar Germany's influential modernist design school, *Rotes Haus* is a brilliant example of Klee's tendency to straddle a border between purely geometric forms and cartoon-like, cryptic, but recognizable imagery. Echoing its title, rudimentary architecture is suggested by red forms recalling a wall, a roof, and a portal, situated in a middle ground also occupied by a geometric, tree-like form. *Rotes Haus* was painted shortly after the artist returned from a journey to Egypt, and its warm palette may reflect the deep impact the trip made on Klee. In a letter written in Egypt, the artist observed, "What is civilization, good or bad, compared with this water, this sky, this light?"[2]

Certainly, the abstract character of *Rotes Haus* and the intense, nearly monochromatic color create an impression that evades easy description, and the natural world that so impressed Klee in Egypt may account for the elemental quality of *Rotes Haus*. As Klee's most famous dictum says, "Art does not reproduce the visible; rather it makes visible."[3] And in this spirit it is unnecessary to seek a precise interpretation of *Rotes Haus*. What is essential is its overall sense of organization and the intuitive, mysterious nature of the scene unfolding within Klee's intimate landscape. – JW

ROTES HAUS (Red House), 1929
oil on canvas mounted on cardboard
10 x 10⅞ in. (25.4 x 27.6 cm)
Gift of the Djerassi Art Trust, 92.261

• German, b. Switzerland, 1879–1940

1. Paul Klee, "Creative Credo," reprinted in Herschel B. Chipp, ed., *Theories of Modern Art: A Sourcebook by Artists and Critics* (Berkeley: U.C. Press, 1968), 182.

2. Paul Klee, as quoted in Donna Graves, *Pattern & Process: Nature and Architecture in the Work of Paul Klee* (San Francisco: San Francisco Museum of Modern Art, 1987), 19.

3. Paul Klee, "Creative Credo," 182.

At first glance, Surrealism and photography would seem to make strange bedfellows. The former, an art movement springing from Dada irrationalism and Freud's descriptions of the subconscious mind, might initially appear to have little to profit from the latter, a medium so rooted in the visible,

MAN RAY • JOHN GUTMANN

material world. Yet Surrealism took to photography with a vengeance in the 1930s, as French, German, British, and American artists embraced the camera as a means for proposing psychological emblems and exploring the strangeness of everyday life. Photography imbued Surrealism with the authority of the actual, making concrete the stuff of dreams and fantasy.

Man Ray, an American living in France between the wars, was one of the pioneers of surrealist photography. His *Self-Portrait* from 1933 is a smorgasbord of Freudian iconography. Here a cast of the artist's face is positioned near plaster hands (in French *main*, pronounced "man"); one of these hands holds a bulb (a source of "rays"); the other hand is attached to an arm and set before Man Ray's photograph of glass tears (*larmes*). The mathematical toy on the left mirrors the *bilboquet* game on the right—controlled geometry is contrasted with the element of chance, a central tenet of Man Ray's Duchampian aesthetic. We are thus presented with an inventory from the artist's psychic universe—hands and eyes, originals and copies, emotion and reason, words and images—given meaning through surrealist metonymy.

John Gutmann's *Memory* favors a less cerebral approach to its subject. Using the simplest of pictorial means, Gutmann offers us an image resonant with suggestion. Freud proposed the eye as a site of displaced castration anxiety: Luis Buñuel's surrealist film *Un Chien andalou*, for example, uses this fear to great advantage. Gutmann's isolated eye does too: it is veiled, though hardly protected, and his title implies that in this case we are meant to understand eyesight figuratively. We look out upon the world and back upon ourselves through a veil, the veil of memory, as it were. Here vision is held to be mediated—by fashion accessories, by repression, by the technique of photography itself. Like Man Ray, Gutmann seeks to explore the ways in which the world of appearances masks a world of deeper significance, the realm between the real and the invisible that Freud called the uncanny. – DRN

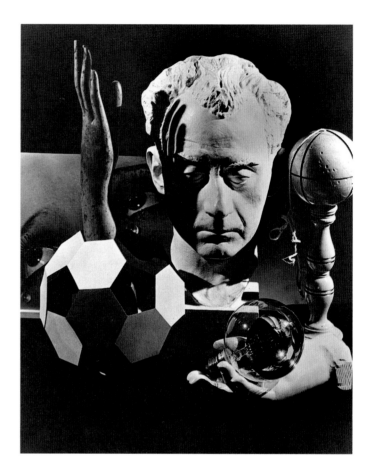

Opposite:

UNTITLED
(SELF-PORTRAIT CAST IN PLASTER
WITH MANNEQUIN HANDS,
ANGULAR BALL AND LIGHT BULB), 1933
gelatin silver print, 11⁹⁄₁₆ x 9¹⁄₁₆ in.
(29.3 x 23 cm)
Helen Crocker Russell and William H. and
Ethel W. Crocker Family Funds
Purchase, 80.344

• *Man Ray* American, 1890–1976

Left:

MEMORY, 1939
gelatin silver print
8 x 10 in. (25.4 x 20.3 cm)
Gift of Jeffrey Fraenkel, 90.87

• *John Gutmann* American, b. Germany, 1905

69

Like many of those who participated either directly or from afar in the Harlem Renaissance of African American arts, San Francisco–based sculptor Sargent Johnson's central focus was the issue of racial identity. As he commented in 1935, it was his wish "to show the natural beauty and dignity" in African Americans for African Americans, stressing the importance of his subject as a central part of his audience.[1]

By the time that he made *Forever Free*—one of nine sculptural works in the Museum's permanent collection—Johnson's carved masks, busts, and full-length figures had achieved national acclaim through the traveling exhibitions in the twenties and thirties of the Harmon Foundation in New York, which was committed to fostering the creative efforts of African Americans. With *Forever Free*, Johnson synthesized his interests in a sculpture that is relatively simple in form yet far-reaching in its implications. The subject is stylized, in the tradition of African carving, representing not a unique individual but the generalized physical and personality traits that Johnson saw as particular to black Americans—a "characteristic lip, bearing, and manner."[2] The artist started by carving a block of redwood into a dense, contained form, using line sparingly to articulate the figures of the children, the mother's swirled hair, and the details of her clothing—the buttons, hem- and neckline of her rather Puritanical attire. He then covered the form with gesso and cloth before applying broad areas of pigment to achieve smooth, lustrous surfaces of black, white, and coppery brown.

The sculpture's archetypal maternal subject stands with the timeless conviction of its title, which both references the history of African American enslavement in the United States and asserts the enduring freedom of the race with which Johnson identified completely (he was of African American, European, and Native American descent). The strong, columnar figure with broad, squared shoulders is firmly rooted in the present, but her upward-tilted head—both reflective and looking toward the future—engages some distant horizon. Her especially lengthy arms protect and nurture the not-yet-fully formed children that are incised about her skirts, symbols of the generations to come. — JCB

FOREVER FREE, 1933
wood with lacquer on cloth
36 x 11½ x 9½ in. (91.5 x 29.2 x 24.2 cm)
Gift of Mrs. E.D. Lederman, 52.4695

• American, 1888–1967

1. "San Francisco Artists," *San Francisco Chronicle*, October 6, 1935, D–3.
2. Ibid.

In November 1930, Frida Kahlo and Diego Rivera came to San Francisco, where Rivera had been commissioned to execute murals at the San Francisco Stock Exchange and the California School of Fine Arts. During the months that followed, the two artists lived in sculptor Ralph Stackpole's studio on the 700 block of Montgomery Street. Kahlo painted a number of portraits during her stay, among them this image of herself and her husband of one and a half years, which she painted for their longtime supporter, Albert Bender. It was through Bender's extraordinary patronage to the Museum in its early years—from its inception in 1935 until his death in 1941—that its permanent holdings grew by some 1,100 objects, including an important core of work by Mexican modernists.

Kahlo's painting is a less formal version of a conventional colonial wedding portrait executed in a shallow, deceptively neutral setting. Rivera is shown in a European-style suit with monogrammed belt buckle, blue work shirt, and massive boots, his identity intact as the painter whose right hand—with brushes for fingers—clutches his palette (his attribute), as his gaze confronts the outside world. Kahlo, however, is presented not as an artist but as a loyal companion, offering her hand to her husband and tilting her head—with its very private, inward-focused expression—toward her life's partner. She is bedizened, as was her usual preference, in traditional Mexican costume, in this case entirely in red and green—from her polka-dotted hair ribbon to her tiny flowered slippers. The dove over Kahlo's head holds in its bill a banderole offering an inscription (in Spanish) that reads: "Here you see us, me Frieda Kahlo, with my beloved husband Diego Rivera. I painted these portraits in the beautiful city of San Francisco, California, for our friend Mr. Albert Bender, and it was in the month of April in the year 1931."[1] — JCB

1. Sometime in the early 1930s, after this painting was made, Kahlo (whose father was a native of Baden-Baden, Germany) changed the spelling of her first name from "Frieda" to the less Germanic "Frida."

FRIDA KAHLO

The uncertainty of the twenty-three-year-old artist is evident in the frequent pentimenti throughout Kahlo's composition. Besides minor changes on the figures (the couple's clasped hands and Rivera's nose, for instance), a rectangle at top center, between the couple, was probably the original site of the inscription that is now visible on the banner above the artist's self-portrait. In addition to these formal changes, Kahlo also reworked the colors significantly. Microscopic examination of the painting reveals that her green dress was originally pink, with blue decoration at the gathers in the pleats of the skirt. Kahlo's shoes were also originally pink, or she may have first painted herself in stocking feet. –JWS

FRIEDA AND DIEGO RIVERA, 1931
oil on canvas
39⅜ x 31 in. (100 x 78.7 cm)
Albert M. Bender Collection,
Gift of Albert M. Bender, 36.6061

• Mexican, 1907–1954

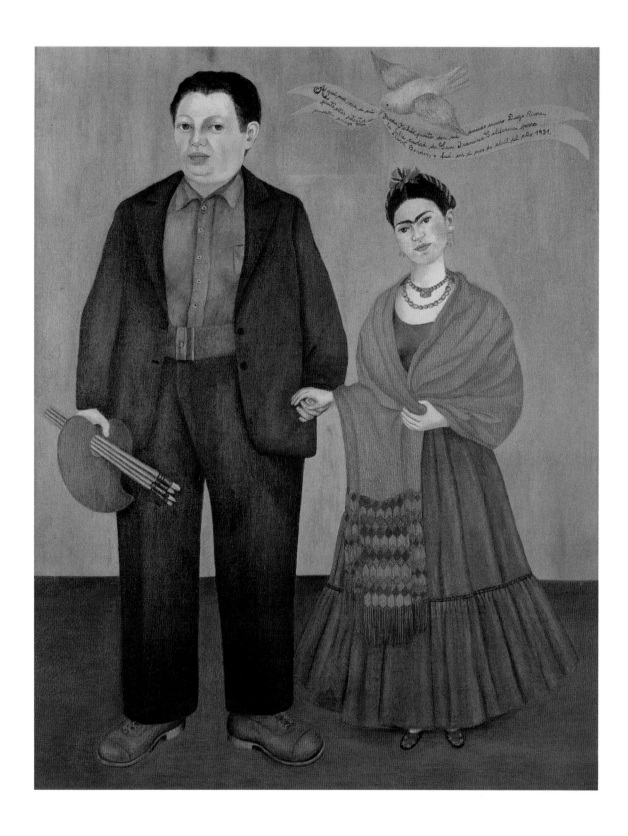

THE FLOWER CARRIER
(formerly *The Flower Vendor*), 1935
oil and tempera on Masonite
48 x 47¾ in. (121.9 x 121.3 cm)
Albert M. Bender Collection, Gift of Albert M. Bender
in memory of Caroline Walter, 35.4516

• Mexican, 1886–1957

Diego Rivera's *The Flower Carrier* is widely acknowledged as one of the finest works on panel by the great Mexican muralist. It was

DIEGO RIVERA

purchased for the new San Francisco Museum of Art by Rivera's San Francisco friend and patron Albert M. Bender in 1935, at the height of the artist's career. In his letter to the painter, Bender asked that Rivera himself select "a representation of your work at its finest and best."[1] Rivera's choice was one of his largest paintings of the mid-1930s, a rhythmically powerful image of Mexican peasants carrying a basket of flowers. *The Flower Carrier* is painted in oil and tempera on Masonite with a white undercoat of gesso. As Bender noted, it has "something of the same feeling as [the] frescoes"[2] that had brought Rivera to the pinnacle of international renown and had earned him commissions for murals in San Francisco, Detroit, and New York. Indeed, the artist's 1931 exhibition at The Museum of Modern Art in New York had outdrawn the Matisse exhibition of the previous year.

Rivera's career reveals an astonishing assimilation of the traditions of European Renaissance painting and the most radical developments of his era. As a young artist he moved from Guanajuato, Mexico, to Spain in 1907 and continued on to Paris, where he eventually established a considerable reputation as a cubist painter. He lived in Paris until 1920, traveling briefly to Mexico in 1910 at the outset of the Mexican Revolution. On a trip to Italy in 1920–21, he was deeply impressed by the Florentine fresco cycles of Giotto and Cimabue. Returning to postrevolutionary Mexico in 1921, Rivera was commissioned by the new government to execute a series of magnificent wall paintings telling the story of the Mexican Revolution in historical and symbolic form. The resulting works melded these various influences into a style and thematic program that distinguishes Rivera as one of the singular artists of his time.

The Flower Carrier is one of many images Rivera made of peasants, and in it his sympathetic respect for manual labor is apparent, echoing his Marxist political convictions. As with many of the artist's images of Mexican agricultural workers, the subjects of *The Flower Carrier* are weighed down by a heavy burden, yet painted with a sculptural solidity that lends them a monumental dignity. Both figures are shown close to the earth, as the flower carrier kneels to allow the woman to secure an immense basket of blossoms on his back. Given the highly symbolic and politically articulated nature of Rivera's oeuvre, a fairly specific interpretation of *The Flower Carrier* seems justified. Clearly, the generalized features of the two *campesinos* present them as idealized representatives of their class, working together and in harmony with the natural world. Although presented virtually as beasts of burden, they labor—like Rivera himself—to bring beauty to others, as embodied by the flowers that are the focus of their work. — JW

1. Albert Bender, in a letter to Diego Rivera dated March 29, 1935, in the director's files of the San Francisco Museum of Modern Art.

2. Albert Bender, in a letter to Mrs. Walter Siple dated September 25, 1935, in the director's files of the San Francisco Museum of Modern Art.

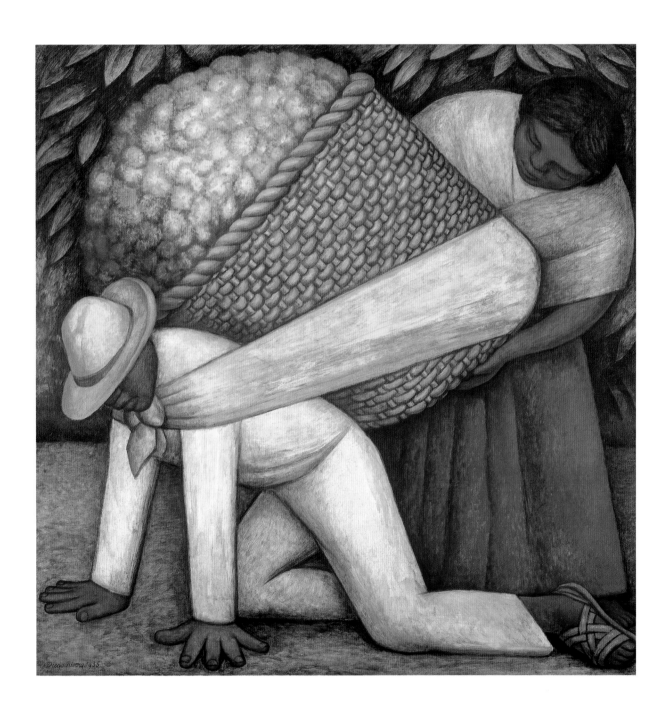

The paintings of Georgia O'Keeffe are among the most beloved and celebrated works by an American artist of the twentieth century. For seventy years, from the time her first paintings were shown in 1916 until her death in 1986, she has been acknowledged for the uniqueness of her vision, in which abstraction and representation are skillfully balanced and blended. As one of the great contributors to the development of modernism in America, she long was associated with its foremost champion, the photographer Alfred Stieglitz, to whom she was married from 1924 until his death in 1945.

The most consistent source for her vision was the natural world, especially the landscape of New Mexico. First visiting Taos in the summer of 1929, O'Keeffe returned every summer after that, and in 1940 purchased Ghost Ranch, near the small village of Abiquiu, where she settled permanently after Stieglitz's death. O'Keeffe often went hiking and camping, and one of her favorite places she called the "Black Place." About this landscape she wrote, "having seen it, I had to go back to paint—even in the heat of midsummer. It became one of my favorite places to work. The Black Place is about one hundred and fifty miles from Ghost Ranch and as you come over the hill it looks like a mile of elephants—gray hills all the same size with almost white sand at their feet."[1]

In *Black Place I,* her first painting of this subject, O'Keeffe treats the landscape in an exceptionally sensuous manner, almost like the backside of a human torso, complete with rippling flesh and deep, pocketed vertebrae. Near the top of the painting, emerging out of the subtle, muted earth tones of gray, black, and mauve, a hint of living, green vegetation emerges. This work wonderfully complements her more austere and iconic paintings of animal pelvis bones and sky from the same period, showing the expressive range of her work, which included more tender and personal subjects as well as severe and bold images. – GG

GEORGIA O'KEEFFE

BLACK PLACE I, 1944
oil on canvas
26 x 10⅛ in. (66 x 76.6 cm)
Gift of Charlotte Mack, 54.3536

• American, 1887–1986

1. Georgia O'Keeffe, as quoted in *Georgia O'Keeffe* (New York: Viking Press, 1976), n.p.

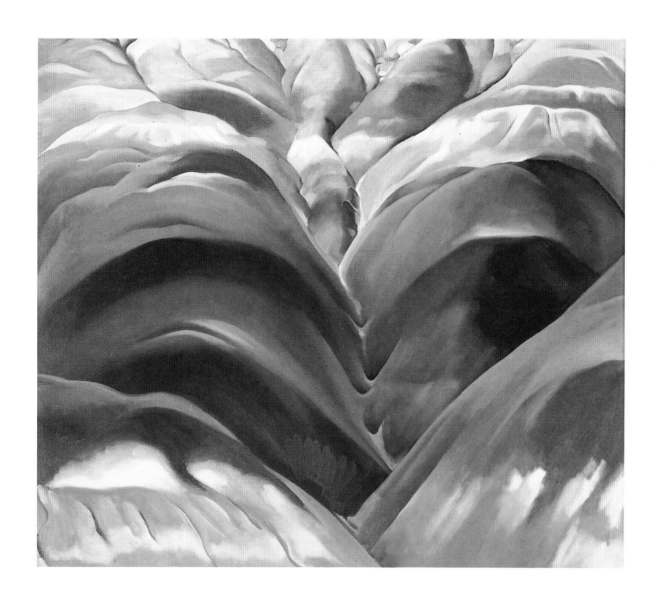

In 1952 Georgia O'Keeffe offered San Francisco Museum of Art director Grace Morley sixty-seven photographs by O'Keeffe's late husband, Alfred Stieglitz, in a special deal—she would donate forty-two prints if the Museum would purchase twenty-five others at $100 each. Dr. Morley did some scrambling and, with the help of local supporters, managed to raise the necessary funds. As one of a select group of institutions nationwide that were presented with this original Stieglitz material, the Museum now houses one of the great collections of work by this important twentieth-century artist.

GEORGIA O'KEEFFE, 1921
gelatin silver chloride print
9⅝ x 7⅝ in. (24.5 x 19.4 cm)
Gift of Georgia O'Keeffe,
Alfred Stieglitz Collection, 52.1816

• American, 1865–1946

"I am at last photographing again," Stieglitz wrote his friend Sadakichi Hartmann in 1919. "It is a series of about 100 pictures of one person —heads & ears—toes—hands—torsos."[1] The person was O'Keeffe, twenty-three years his junior, with whom he had been living in a Fifty-ninth-Street studio in New York since the previous year, and who would become his wife five years later. Stieglitz and O'Keeffe were both tremendous talents; both were independent and headstrong by nature. Their relationship was intense, by turns inordinately close and manifestly competitive. Stieglitz was thrilled with O'Keeffe's autonomy, but also frightened by it: he was, after all, raised a Victorian, and only modern by force of will. His extended portrait of O'Keeffe reveals this duality of perception: far from being a catalogue of body parts, the series proposes isolated corporeal details as symbolically charged surrogates for Stieglitz's various and complicated feelings about his companion. In this sense, they are as much a portrait of Stieglitz as of O'Keeffe.

SFMOMA's 1921 photograph of O'Keeffe's neck is a case in point. Cropped and relegated to the periphery of the image are the face and hands—those elements most insistently expressive and individual in other pictures from the series. O'Keeffe's hands—which to Stieglitz stood for her formidable creative powers, but also, by implication, her ability to support herself financially—are here truncated, reduced to claws whose sole function is to point toward the protruding neck muscle that dominates the composition. The neck is, physiologically, a vulnerable feature of one's anatomy, and O'Keeffe's twisted pose renders her throat all the more exposed—a dynamic triangle of taut, unprotected flesh and sinew, simultaneously powerful and defenseless, erotic and clinical. Stieglitz aspired to make photographs that were equivalent to his emotional response to a subject; few of his portraits inventory his complicated disposition towards O'Keeffe as economically as this. – DRN

1. Alfred Stieglitz, in a letter to Sadakichi Hartmann dated April 27, 1919, as quoted in Sarah Greenough and Juan Hamilton, *Alfred Stieglitz Photographs and Writings* (Washington, D.C.: National Gallery of Art, 1983), 205.

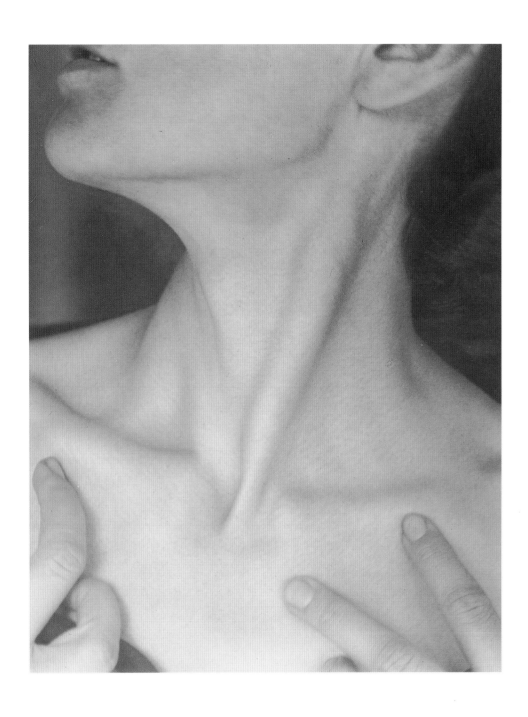

These three photographs were all made at approximately the same time, a moment when there was a shadow cast over many people's lives, a pall originating in the economic crisis of the Great Depression, compounded by the attendant social anxieties and political unrest, and, in some artistic circles, the advent of Surrealism.

Of the three photographers, Dorothea Lange was the most politically committed. J. R. Butler, her subject here, was an organizer for the Southern Tenant Farmers' Union, a radical interracial organization that fought for the rights of the common agricultural laborer against the more conservative political and social interests of the large corporate farmers, the inheritors of the plantation system. Lange was married at this time to the Berkeley social scientist Paul Taylor, himself an ardent defender of the rights of small farmers and the benefits to society of small farm life. Lange's view of Butler is that of a spiritual leader: his wide eyes energize his whole being while his hunched posture and his hair standing in tufts emphasize his intense concern for moral principle. Without the fountain pens in his shirt pocket he could almost pass for an early church father.

Walker Evans' little girl, by contrast, is an almost frightening picture. In her face we see an awful premonition, a contradiction to the accepted notions of what childhood should be: an anxious augury of distraught old age.

Evans' photographs are not commonly so psychological. In his book *American Photographs,* most of the pictures are of humble and worn—but beautiful—architecture. When people are present, they are most often seen from a distance or asleep. Very few of Evans' pictures were made spontaneously, as was this one; usually he explored with the large view camera, a more meditative instrument, but this one was most likely made with a small, hand-held camera, which enhances the quality of momentary apparition.

This little girl, so disarmingly troubled, was probably photographed on one of Evans' trips to the South, perhaps in one of the rural coal-mining communities of West Virginia. Like Lange's picture, it was undoubtedly made while he worked for the government. Unlike the portrait of Butler, however, Evans' child does not carry a social message, but rather a more personal disquiet, even a social distance from the subject.

While Evans and Lange are concerned with the psychology of the people they photograph, Henri Cartier-Bresson depicts a more impersonal, but perhaps more pervasive sense of uneasiness in his *Seville, Spain,* 1932. Cartier-Bresson was a painter as well as an early friend of the surrealists, a group of poets and painters interested in describing the potency of the irrational and its marvelous presence in everyday life. What instrument but the camera could be at once more natural and challenging for an artist with an almost athletic sense of the poetry of the moment?

Of the two children in this picture, the one on the right is in such deep shadow that we can hardly distinguish his features and, though the light touches him glowingly, there is a sense of profound stillness. The other child is a cropped blur, captured only for a moment. Yet what seems most interesting is not the children themselves, but the space between them. The portentous shadows and the deep cleft into an unseen distance are rather like the strange and disquieting distances in Giorgio de Chirico's paintings. The walls are decorated with the kind of ancient patina that so interested the surrealists (including Brassaï), and there is even a curiously Miróesque design on the pavement. Rather than render portraits of people in his photography, Cartier-Bresson conveys the strangeness and mysteriousness of the world at large, which seems closer to a description of his own state of being at that moment. — SSP

Above left:
J.R. BUTLER, PRESIDENT OF THE
SOUTHERN TENANT FARMERS' UNION,
MEMPHIS, TENNESSEE, JUNE 1938
gelatin silver print
9¹⁵⁄₁₆ x 7¹⁵⁄₁₆ in. (25.2 x 20.2 cm)
Purchased through a gift of
The Robert Mapplethorpe Foundation and
Accession Committe Funds, 93.42

• *Dorothea Lange* American, 1895–1966

Above right:
UNTITLED, 1935
gelatin silver print
8 x 9¹⁵⁄₁₆ in. (20.3 x 25.2 cm)
Accessions Committee Fund and
Members of Foto Forum, 93.92

• *Walker Evans* American, 1903–1975

Below:
SEVILLE, SPAIN, 1932
gelatin silver print
9 x 13½ in. (22.9 x 34.3 cm)
Purchase, 88.367

• *Henri Cartier-Bresson* French, b. 1908

Jackson Pollock is best known for the large-scale, purely abstract paintings that he began to make in the late 1940s and that were characterized by intricately overlapping skeins of paint, poured and dripped onto the canvas. Capturing the attention of the mass media in the 1950s, these works came to epitomize the Abstract Expressionist movement, and Pollock has been taken as the movement's most mythic figure, symbolizing America's romantic notions of personal freedom. Born in 1912 in Cody, Wyoming, and raised in California, Pollock's biography readily lends itself to our desire for over-simplified pioneering heroes.

GUARDIANS OF THE SECRET, 1943
oil on canvas
48⅜ x 75⅜ in. (122.9 x 191.5 cm)
Albert M. Bender Collection, Albert M. Bender
Bequest Fund Purchase, 45.1308

• American, 1912–1956

In fact, the true stature of Pollock's art stems from a complex synthesis of diverse influences and sources that he melded in his work. Moving to New York in the early 1930s, he studied with Thomas Hart Benton, the foremost regionalist painter of the time, who was a strong mentor to the young artist. He also was influenced by the Mexican muralists, especially David Alfaro Siquieros. By the mid-thirties he had become deeply interested in modernism, particularly the work of Pablo Picasso and Joan Miró, and soon was enmeshed as well in the pervasive influence of Surrealism. By the end of the decade, Pollock was immersed in psychoanalysis by a Jungian therapist and was making drawings inspired by unconscious archetypes as elaborated in Jung's understanding of the human mind and spirit.

Guardians of the Secret represents Pollock's first mature body of work, which remains among his most complex and powerful achievements. Here the tension between figuration and abstraction is held in taut balance. The central, rectilinear panel teems with energy, foreshadowing the later abstract canvases. On either side of the canvas sentinel figures stand alert, and at the bottom a watchful dog crouches, so that symmetry and balance anchor the threatening and explosive secret energy at the center, which must symbolize the hidden forces of the unconscious. Far removed from the American frontier, this painting more readily evokes the tensions of the Mediterranean and Greek classicism, between the balance of Apollo and the frenzy of Dionysus.

Completed in 1943, the painting was exhibited that year in Pollock's first solo exhibition, held at Peggy Guggenheim's Art of This Century gallery in New York, the pivotal link between European modernism and the American avant-garde. In 1945, Guardians of the Secret was shown at SFMOMA in Pollock's first one-person museum exhibition, immediately after which it was acquired for the Museum's collection. — GG

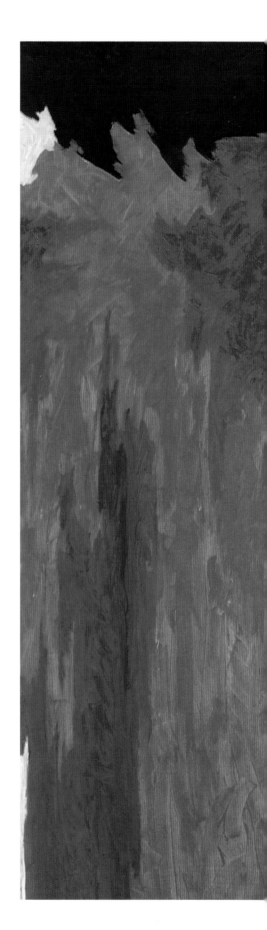

UNTITLED (PH-968), 1951-52
oil on canvas
113⅜ x 156 in. (288 x 396.2 cm)
Gift of the artist, 75.30

• American, 1904–1980

One of the most extraordinary holdings of this museum are thirty paintings by the American abstract painter Clyfford Still, dating from the mid-1930s through the mid-1970s. Twenty-eight of these works were given to the Museum by the artist in 1975, joining two works already in the collection,

CLYFFORD STILL

gifts of Peggy Guggenheim and Mr. and Mrs. Harry W. Anderson. The first museum exhibition of Still's paintings was presented by SFMOMA in 1943, and from 1946 to 1950 he taught at the California School of Fine Arts, now the San Francisco Art Institute, where his influence was far reaching. One gallery of the Museum is permanently dedicated to the presentation of a selection of Still's painting.

Untitled (PH-968), 1951-52, is a superb example of Still's work. He purposely did not title his paintings in order to avoid any external association, but designated them by the year in which they were painted. The PH designation (a number issued when all of his paintings were photographed) is now used for purposes of identification. Unlike most artists, Still ground his own pigments, then mixed them with boiled linseed oil in order to enhance their ability to catch light. The paint was then applied using both a palette knife and a brush, often in multiple layers, which created rich variations between glossy and matte finishes. The deep colors evoke sensations of earth and blood; the surfaces, gestures, and shapes suggest primordial, natural forces and landscapes.

While often associated with Abstract Expressionism, Still claimed to have developed his work independently, rejecting any influence of European precedents or associations with other artists. Instead, he relied on the primacy of personal experience and the study and distillation of his own painting. As disciplined with himself as he was with others, Still strongly believed in the autonomy of one's own experience, and described his artistic process as a solitary ethical journey. He explained his paintings "as a sequence of diary entries that, taken together, would form a unity and perhaps a synthesis. They were meant as examples of peace and independence and as a protection from external, decadent, and corrupting influences."[1] — GG

1. Clyfford Still, as quoted in Thomas Kellein, "Approaching the Art of Clyfford Still," in *Clyfford Still, 1904–1980: The Buffalo and San Francisco Collections* (Munich: Prestel-Verlag, 1992).

85

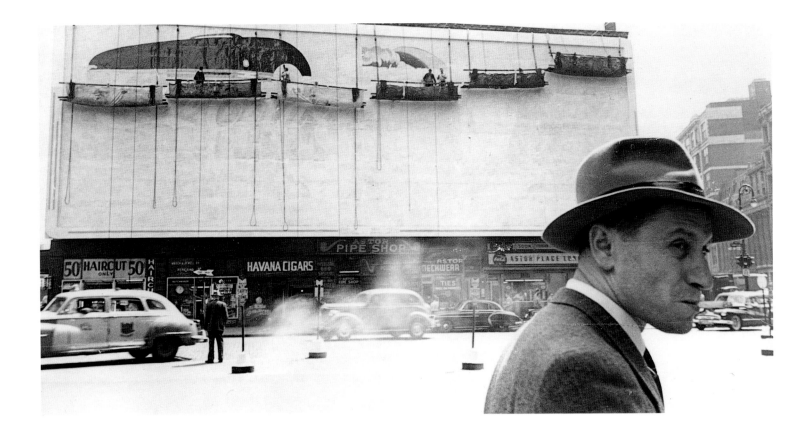

The concept of stylistic influence becomes especially slippery when
applied to the medium of photography, where style itself is often an
impartible collusion of form and sub-
ject, of intention and happenstance.

What does it mean for a photographer to claim the influence of oth-
ers? Can such effects be described without recourse to the typically
reductive genealogical approaches of art history?

Both Robert Frank and Daido Moriyama began their careers far
from the recognized geographical centers of photographic activity.
Frank, Swiss by birth, once stated that his teachers were Bill Brandt
and Walker Evans, whose work he knew first through their published
photographic books. His late 1940s *Astor Place* would seem to bear out
this assertion, for it reveals not only the sense of gritty immediacy we
usually associate with Brandt, but also the unmistakable semiotic
gamesmanship of Evans. Frank's picture is a meditation upon the
relationship between words, images, and reality: a man smokes a
cigarette and passes by storefronts that advertise a pipe shop and
"Havana Cigars"—shops themselves partly obscured by smoke from
the street—while billboard painters above enact the creation of a

picture that features a gigantic cigar-shaped object. This interest in the linguistic vernacular remained a part of the artist's subsequent work—it is evident throughout *The Americans*, Frank's own seminal photographic book, for example—though now in a more trenchant and visually distinct fashion.

Daido Moriyama learned photography in a similar manner. Raised in Osaka, he educated himself in photographic design by looking at foreign magazines and books, particularly those of William Klein and Robert Frank. The harsh contrast and coarse half-tone effects of cheap publishing were raised to a positive aesthetic principle in Moriyama's work: *Stray Dog, Misawa* is, by conventional standards, a bad print—grainy, out of focus, with empty black shadows and claustrophobic framing; it retains the spontaneously confrontational presentation of Klein and Frank while taking their existential street-gestalt to new levels of acerbity. Moriyama's dog is a quintessentially urban creature, like Frank's smoker, and as such occupies an untrusting world of sidelong glances, a postwar world made small and level by global communications and the ubiquity of photography. – DRN

Opposite:
ASTOR PLACE, ca. 1947–51
gelatin silver print
7⅝ x 13¼ in. (17.8 x 33.7 cm)
Accessions Committee Fund, 92.233

• *Robert Frank* American, b. Switzerland, 1924

Above:
STRAY DOG, MISAWA, 1971
gelatin silver print
7⅝ x 11¾ in. (19.4 x 29.8 cm)
Anonymous Gift, 80.320

• *Daido Moriyama* Japanese, b. 1938

Robert Rauschenberg's *Collection* is one of the first examples of the artist's "combine" paintings, a breakthrough body of work he began in the mid-1950s. As this characterization suggests, these paintings combine painted surfaces with three-dimensional found objects, fragments from newspapers and

magazines, postcards, and other scavenged imagery. Eventually, Rauschenberg began to create combines that were less paintings than sculptural assemblages with intermittent areas of paint, two-dimensional clippings, and pictures glued to the surface, plus found objects such as tires, umbrellas, suitcases, and in one celebrated instance, a stuffed sheep.

COLLECTION (formerly Untitled), 1953–54
oil, paper, fabric, and metal on wood
80 x 96 x 3½ in. (203.2 x 243.9 x 8.9 cm)
Gift of Harry W. and Mary Margaret Anderson, 72.26

• American, b. 1925

The key aspect of Rauschenberg's combines is the artist's fearless use of disparate, seemingly unrelated "real world" materials salvaged from junk heaps, mass media, and his own life, unified by his keen sense of composition into a single work that manages to be both organized and messy, arbitrary yet peculiarly logical. *Collection* is structured loosely in three horizontal bands dominated by a central stratum of newspaper clippings, comics, scraps of fabric, cheap art reproductions, and other found material. This area is painted over in a raw, splattered, and drippy fashion that seems to both mimic and mock the so-called action painting of the abstract expressionists, whose work the much younger Rauschenberg admired greatly. The bottom of the canvas consists of nine broad stripes of color, provided in part by pieces of fabric glued to the surface. The top is primarily covered by large patches of fabric and newspaper. Sitting on top of the canvas, a number of furniture fragments, bits of wood, and collaged elements rupture the boundary delineated by the wood-strip frame and emphasize the "real" nature of Rauschenberg's raw material. Together, the more abstract top and bottom strata of *Collection* compress the central, highly frenetic area into an archeological cross-section of images, scraps of text, and "painting."

As is often observed, Rauschenberg's work from the mid-1950s followed the inward-looking, psychologically charged painting of the abstract expressionists with an ecstatic infusion of objects, photographic images, and documentary fragments drawn from everyday American life. Yet Rauschenberg's work is less a rejection than simply a departure from the generation that preceded him. And although Rauschenberg may open the door for the full-blown vernacularism of Pop art in the 1960s, his own work is more psychologically nuanced, formally multifaceted, and nostalgically loaded than that of Pop artists such as Andy Warhol, Roy Lichtenstein, or Claes Oldenburg. — JW

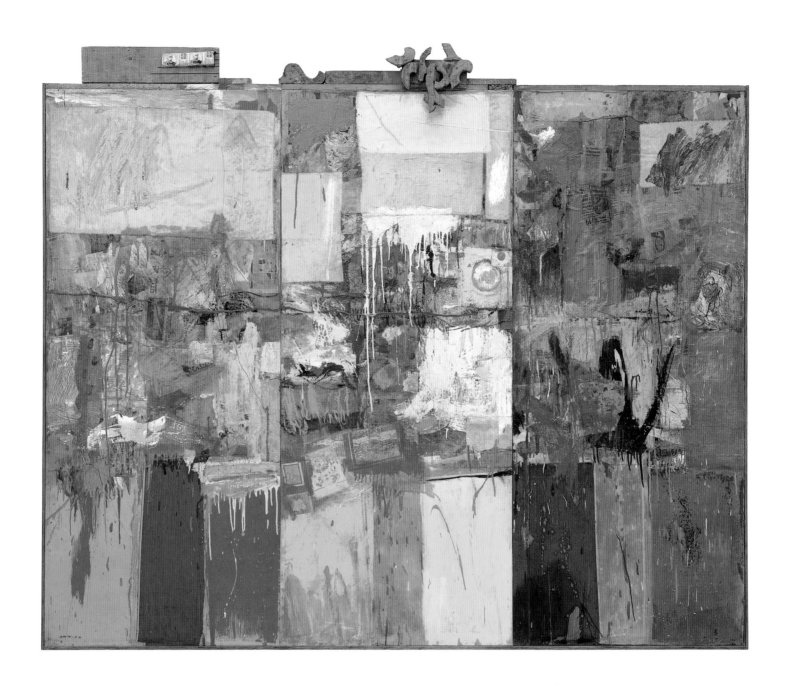

By 1963, when Jasper Johns painted *Land's End,* he had moved away from the iconic targets and flags that had been so germinal in the development of Pop art. In those works the artist had presented "things the mind already knows,"[1] whereby the artwork's composition was fully dictated by the object, leaving the artist room to investigate other levels (the subject of the work not really being the object at all). In *Land's End,* despite the use of the words red, yellow, and blue—poets' names for painters' tools—the stenciled application does little to mask their very personal and metaphoric use. Johns not only reclaims the abstract expressionists' emotional, turbulent brushwork in the painting, but his rendering of each of the three words upsets the viewer's/reader's expectations of how they "should" be: "YELLOW" is painted in blue, random letters appear to be flopping or slipping off the canvas, "RED" is duplicated by a mirror image, and the letter spacing of "BLUE" is irregular and agitated. Only the small "RED," rendered in fire-engine red atop the larger version of the same word, appears perfect and pure. The central mark on the canvas is an arm that ends with the imprint of Johns' own right hand, upwardly reaching, striving for the perfect red, gasping as a drowning figure would for the only part of the canvas with any "air"—the stained, but not painted portion, of the upper third, the area above the horizon line.

Johns called the painting *Land's End,* he has said, "because I had the sense of arriving at a point where there was no place to stand."[2] In this and other works from the same period such as *Periscope (Hart Crane)* and *Diver,* Johns appears to identify with Crane, the poet who died by drowning in 1932. The artist's hand reaches upward, but the drawn arrow points back down. He is struggling for air, but the outcome is uncertain. Everything, Johns has said, was "confused with thought" in this complex, emotionally charged canvas.[3]

Johns' *Land's End* and Robert Rauschenberg's *Collection* were two especially important gifts that Harry W. and Mary Margaret Anderson made to the San Francisco Museum of Modern Art in 1972. Twenty years later, in 1992, the Andersons supplemented these paintings with another very generous donation of seven works by other artists who were central to Pop art in the United States, including a wall relief from The Store by Claes Oldenburg, two paintings by Roy Lichtenstein, a self-portrait by Andy Warhol, and paintings by Jim Dine, Robert Indiana, and James Rosenquist. — JCB

LAND'S END, 1963
oil on canvas with stick
67 x 48¼ in. (170.2 x 122.6 cm)
Gift of Harry W. and
Mary Margaret Anderson, 72.23

• American, b. 1930

1. Jasper Johns, as quoted in Leo Steinberg, "Jasper Johns: The First Seven Years of His Art," in *Other Criteria: Confrontations with Twentieth-Century Art* (New York: Oxford University Press, 1972), 31.

2. Jasper Johns, as quoted in Michael Crichton, *Jasper Johns* (New York: Harry N. Abrams, Inc., 1977), 50.

3. Ibid.

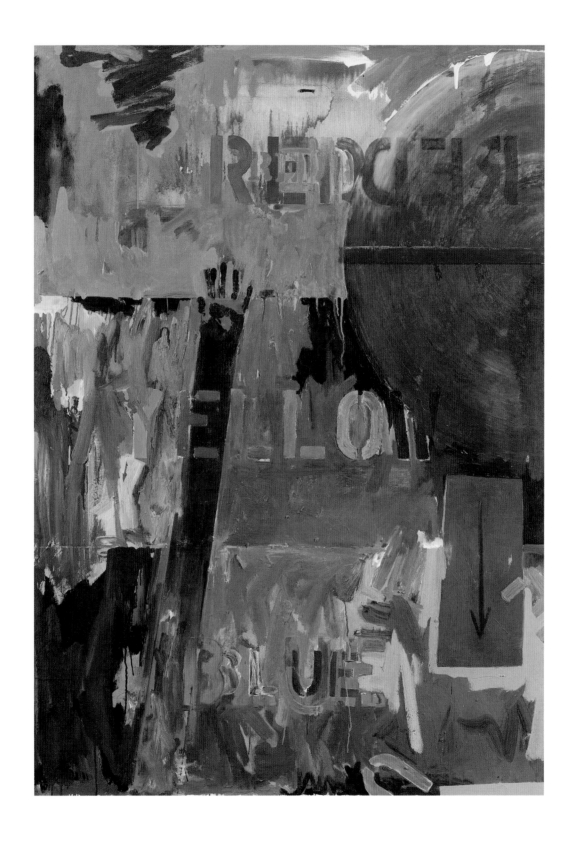

The art of Andy Warhol is among the most complex and influential bodies of work of the postwar period. Including painting, sculpture, drawings, graphics, photographs, films, videos, and extensive commercial production, an enormous number of works were produced with varying intentions and audiences over the course of Warhol's career, which began in the late 1940s and ended with his death in 1987. Without question, his paintings from the early 1960s now stand as one of the key achievements of American contemporary art. *National Velvet* is both a singular and exemplary work from this period, for it represents the artist's obsession with movie stars, his use of the serial image, and his exploration of the photo-silkscreen technique.

National Velvet shows a repeated image of the young actress Elizabeth Taylor on horseback taken from a film still of the movie of the same name. While Warhol used the same image of Marilyn Monroe repeatedly in a number of paintings, treating her as a timeless goddess, in the case of Elizabeth Taylor he used various images in different paintings, tracing her evolution as a film star. In *National Velvet,* Taylor is a young woman at the first flowering of her maturity, an image unique in Warhol's work. He covered the tall, imposing canvas, one of his largest paintings, with silver paint and then printed the rich, black images side by side in rows of varying length. The background inevitably evokes the "silver screen" moniker and emphasizes the flickering and filmic quality of the original image. Because Warhol let the natural variations of the silkscreen process dictate the outcome of the painting, each image of Taylor is different. The "first" one on the left top of the painting is almost like a photograph, while the "last" is faded and ghostly. Each image in-between has its own unique character, emphasis, and resonance.

Andy Warhol challenged the conventions of art in terms of originality, technical production, and aesthetic interpretation. His iconoclastic work of the 1960s included the use of commercial images such as Campbell soup cans; celebrity icons such as Monroe, Taylor, and Elvis Presley; and pictures of car crashes and race riots. Not surprisingly, the work of Warhol stirred the public imagination more than that of any other artist of the time because it acutely reflected the image of a nation and society possessing a new-found power, and captured its allure and vulnerability. Thirty years after their introduction, Warhol's early works retain the vivid originality and seductive power of their first impression, and also convey artistic subtlety, control, and beauty. — GG

NATIONAL VELVET, 1963
silkscreen ink on synthetic polymer paint on canvas
136⅜ x 83½ in. (346.4 x 212.1 cm)
Accessions Committee Fund, Albert M. Bender Fund, Tishler Trust, Victor Bergeron Fund, Members' Accessions Fund and gift of The Warhol Foundation for the Visual Arts, Inc., 93.376

• American, 1928–1987

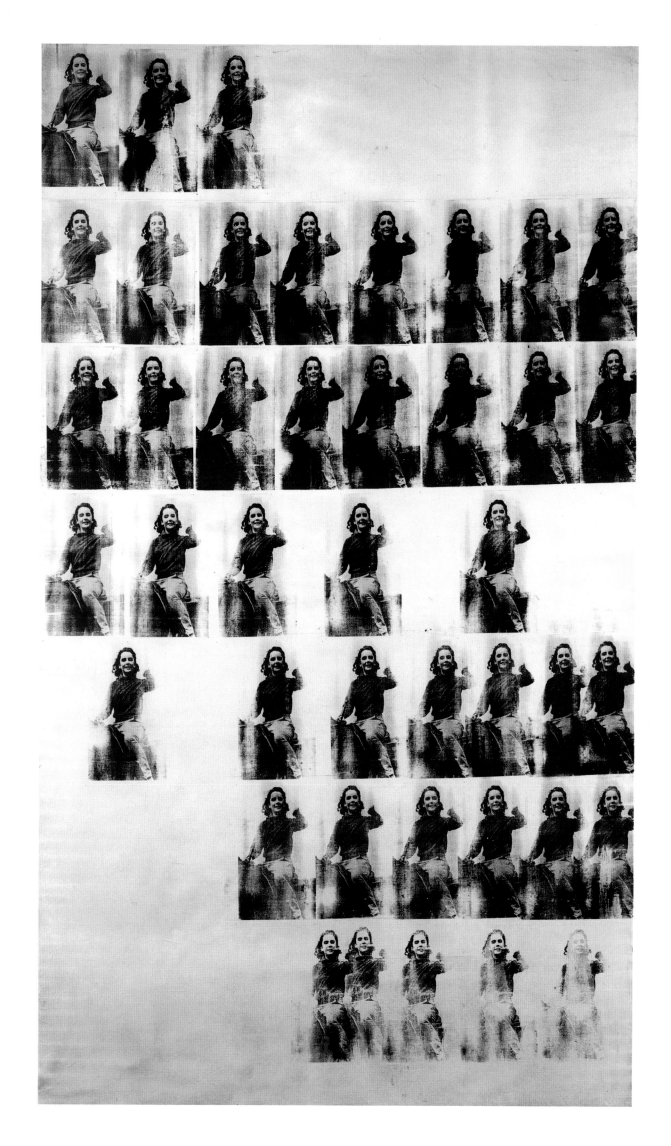

EGG GROWS, 1984–89
Installation: eight video monitors, video camera, egg, and plan
36 x 108 x 216 in. (91.4 x 274.3 x 548.6 cm)
Accessions Committee Fund: gift of Elaine McKeon, Byron Meyer, Madeleine Haas Russell, and Mr. and Mrs. Robert A. Swanson, 89.125

• American, b. Korea, 1932

Since the early 1960s, Nam June Paik has helped to shape the cultural icon of television into an

NAM JUNE PAIK

artist's medium and, in the process, has contributed greatly to the expanding definition of video art, the only medium new to twentieth-century art.

Paik considers video to be not unlike the painter's palette, a malleable material for the artist interested in establishing new expressive forms from analog or digital sources and in controlling time-based phenomena. Such technical innovations—forms of electronic synthesis that generate video effects of the artist's own creation—have enabled Paik to subject the image field of TV to his original vision.

The use of the television console—TV's "picture frame"—in a single or multiple video monitor installation provides Paik with a matrix of endless potential. In *Egg Grows,* a discrete video sculpture, Paik creates a dialogue between the real and the represented, drawing our attention to the subjective nature of the video medium. This teetering arrangement presents eight video monitors that increase in size in a left-to-right progression; to the left of the monitors a single egg is recorded by a live video camera. This image is fed into the smallest of the eight monitors to create an instantaneous representation of the egg in precise scale relationship to its source. Following the artist's plan of prescribed increases in scale, the egg "grows" incrementally to enormous proportions—from real to surreal—in a series of eight televisual pictures. Meditative in tone and minimalist in strategy, Paik's sculpture is a humorous expression of the video medium's capacity for exaggeration and affords insight into the impact of electronic communication on experience. → RR

94

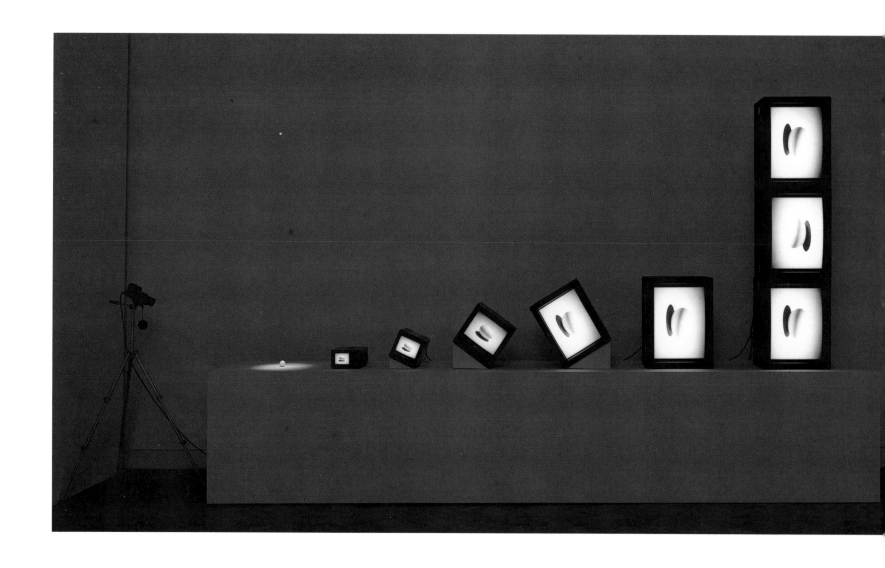

RICHARD DIEBENKORN

Between his first solo exhibition in 1948 at the California Palace of the Legion of Honor and his death in 1993, Richard Diebenkorn established himself as one of the most celebrated and respected painters in the United States. Before the age of thirty, he had earned a solid reputation as a young, West Coast abstract expressionist. But in 1955, the artist changed course dramatically. As Diebenkorn recalled in 1964, "I came right up against limitations that certain conceptions of abstract space impose. As I felt the urgency of particularizing more in my painting, I saw that this had become impossible within the abstract idiom."[1] Although he continued exhibiting abstract works, in the studio he abandoned the wholly nonrepresentational approach of his earlier paintings in favor of brushy, raw, color-saturated canvases of people, land- and cityscapes, and still-life imagery from his studio. These paintings, along with related works by Elmer Bischoff, David Park, James Weeks, and a number of younger artists who followed in their footsteps, set the tone for Bay Area Figurative Art, a movement that remains the region's most prominent contribution to American art history.

Cityscape I shows a scene of a street fronted on one side by a row of low, nondescript buildings and on the other by open fields and empty lots. The horizon line is high, and the painting features cool hues of green, blue, gray, and white, offset by the sandy patch of earth on the right and a small, inexplicable area of red to the extreme left. A strong, if somewhat vacant, sense of mood prevails. Diebenkorn's rendition of deep shadows cast by the building frontages into the street and fields dominates the center of the image.

As in the artist's other figurative works, Diebenkorn's attention appears split between the desire to recognizably depict his subject and a competing fascination with the abstractly layered application of paint and a carefully structured, modulated choreography of color and form. In creating the painting, Diebenkorn apparently based it on an existing cityscape, but left out all the buildings on the right-hand side of the street in order to create a flatter, more geometrically pronounced composition. In fact, another, even less "realistic" version of the scene exists, and within four years, Diebenkorn would return to a completely abstract mode of painting. In its asymmetrical composition, alternately translucent and opaque application of paint, and strong intersection of vertical, horizontal, and diagonal geometries, *Cityscape I* occupies a pivotal position in the artist's career. It looks back to the free-form, organic abstraction of his earliest mature work, and provides a strong foretaste of the *Ocean Park* series, Diebenkorn's third and final major body of work. – JW

1. Richard Diebenkorn, as quoted in Henry J. Seldis, "Diebenkorn: BMOC at Stanford," *Los Angeles Times*, February 2, 1964.

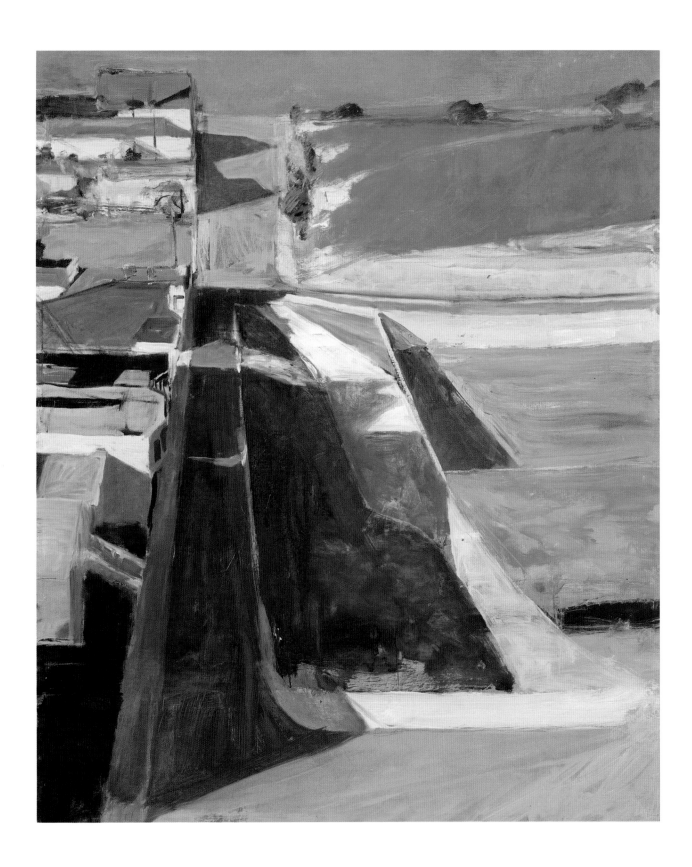

The paintings that Joan Brown was making around 1964 mark the culmination of her first body of work—the thickly painted canvases that she began as a student at the California School of Fine Arts (now the San Francisco Art Institute) in the late 1950s, and would pursue with great abandon into the mid-1960s. Brown credits Elmer Bischoff's *plein air* landscape class of the summer of 1956 for the solidification of her interest in painting, yet her subject matter in the ensuing years tended to be more personal than that of her mentors and fellow painters who were central to the Bay Area Figurative movement, especially after the birth of her and sculptor Manuel Neri's son, Noel Neri. Brown's paintings became a personal record of the immediate domestic surroundings of her Saturn Street home and studio: Noel, the pets, a coffee cup—whatever was both available and meaningful.

In *Noel in the Kitchen,* the artist's toddler son—flanked by loyal pups in profile—reaches up to the kitchen sink that is stacked with a still life of dirty dishes. Painted in a bright, primary-based palette, the painting is rich in rhythm and design, with a repetition of squares, polka-dots, and hues. The receding checkered floor abuts the vertical cabinet face and wall to reveal a new proclivity for structure in Brown's compositions, a transition toward the orderliness of her later work. The artist's paint handling, however, is still raw, almost wild. "I loved what happened when I was using the trowel, the physical exuberance of just whipping through it with a big, giant brush."[1] The right-hand dog's shoulder is the only place where the texture of the canvas itself is visible in the otherwise highly sculptural surface. Yet the thickness of the paint does not relate to the actual depth of the objects depicted. The dogs are painted relatively thinly, for instance, while the cabinet, which in real space would be behind them, very noticeably protrudes from the picture plane. – JCB

JOAN BROWN

Although Brown, in her later works, spread thin, almost brush-less, layers of acrylic paint on wooden panels, in the 1950s and 1960s, her rough-hewn technique was as aggressive as her aesthetic vision. Working with Bay City brand oil enamel paints, she layered thick globs of paint directly onto a sized, stretched (but unprimed) canvas with a trowel, and then manipulated it with wide brushes. The characteristic "wrinkling" of the thick paint appeared soon after the paintings dried. According to the artist, the layers of impasto were built up, surprisingly, less in an attempt to create texture than in a repeated alteration of the colors until the desired hue was achieved.[2] –JWS

1. Joan Brown, as quoted in Thomas Albright, *Art in the San Francisco Bay Area, 1945–1980* (Berkeley: University of California Press, 1985), 75.
2. From a conversation with the artist held on July 11, 1989.

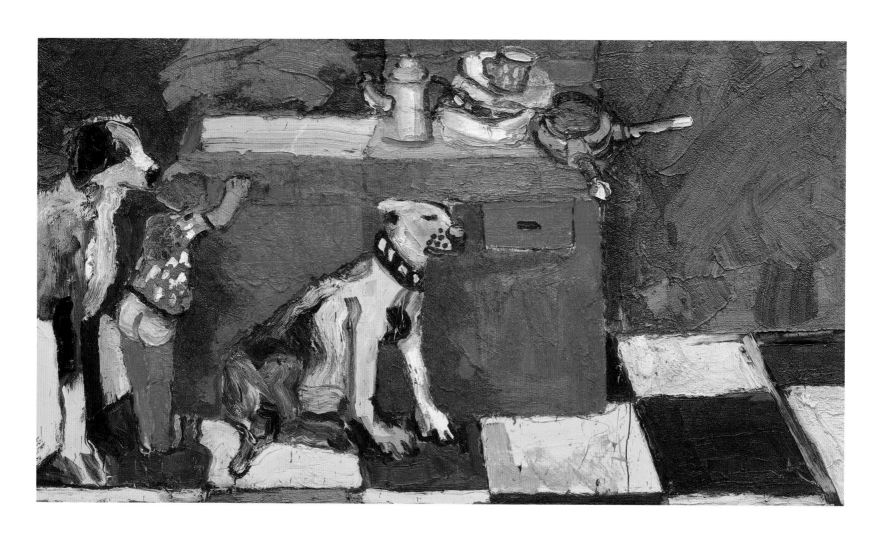

NOEL IN THE KITCHEN, ca. 1964
oil on canvas
60 x 108 in. (152.4 x 274.3 cm)
Bequest of Dale C. Crichton, 89.79

• American, 1938–1990

Looking Glass is the last major sculptural collage created by Bruce Conner, one of the San Francisco Bay Area's most important artists. Completed one year after Conner's work was shown in

New York at The Museum of Modern Art in *The Art of Assemblage*, *Looking Glass* is the largest three-dimensional collage Conner made. Following its completion, the artist abandoned three-dimensional constructions to pursue filmmaking, two-dimensional collage, and drawing.

Conner came to San Francisco in 1957, bringing with him a long-standing interest in collage and a general dissatisfaction with painting. Combined with his lack of money, this led him to experiment with discarded objects, old clothes, and junk picked up in the street or in second-hand shops, which was, as he put it, cheaper than buying paint and canvas.[1] At the same time, Conner was drawn to "funky" sculptural collage as a way to create unfamiliar objects capable of evoking a strong emotional impact by evading or contradicting most viewers' preconceptions about art. His frequent use of nylon stockings and sheer fabrics lent his work an eerie, often sexual charge, recalling skin, cobwebs, decay, and Victorian fetishism. But by 1964, Conner felt that audiences had become too comfortable with the elements of his collages and were too ready to pigeonhole his work as "assemblage" (a term he never liked), rather than experiencing each piece directly. So he abandoned this mode of work, precisely as it was bringing him acclaim and notoriety through solo exhibitions in San Francisco, New York, London, and Rome.

Looking Glass is divided roughly into two compositional and visual zones. The lower half and sides of the piece form a chaotic, scorched, and scratched collage of pictures of naked women clipped from soft-core "girlie" magazines. The upper portion is a three-dimensional tableau featuring a figure constructed from a mannequin's arms leaning on a ledge joined to a creepy, seemingly mummified "head" made from a bejeweled and veiled blowfish. The upper portion of the piece is crammed with a variety of objects, including a high-heeled shoe, heart-shaped candy boxes, a bead purse, and more pinup pictures, all swathed in layers of nylon, old lingerie, and costume jewelry.

Along with friends and fellow artists such as George Herms, Wally Hedrick, Wallace Berman, and Jay DeFeo, Conner brought an iconoclastically original, often anti-establishment, Beat generation tenor to Bay Area art of the late 1950s and early 1960s, and the scathing emotional tone of *Looking Glass* reflects this. Beneath the ghostly tableau of fake pearls and faded finery, Conner has depicted a ravaged, mass-distribution netherworld of male heterosexual desire. Both the photo-collage, with its torn and scored surface, and the central figure, choked and smothered by accoutrements of sexual display and imposed conventions of middle-class "femininity," signal the artist's apparent disdain. Far from reinforcing stereotypical views of sexuality, Conner's *Looking Glass* reveals the leeringly unoriginal underside of commercialized eros. – JW

Looking Glass has had an interesting physical history since leaving the artist's hands. Originally owned by actor Dennis Hopper, it first began to change at the collector's home in Taos, New Mexico, where desert dust blew into the assemblage, aging it prematurely. Many of the highly touchable elements have been rearranged over the years, in particular the mannequin's hands and the lingerie draped over them. Working according to Bruce Conner's recollections of the original configuration of Looking Glass, SFMOMA conservators have re-adhered broken pieces of mirror and uncovered a hidden pin-up of Marilyn Monroe. The artist also revealed an audio element hidden behind some pink underclothes: a black plastic ring that once activated the voice of a doll. When pulled, according to the artist, it said, "Let's have a party," "I like you," and "Let's be friends."[2] –JWS

1. Bruce Conner, in conversation with John S. Weber, March 1994.

2. Bruce Conner, in conversation with Graham Beal, J. William Shank, and Carol Rosset, August 15, 1986.

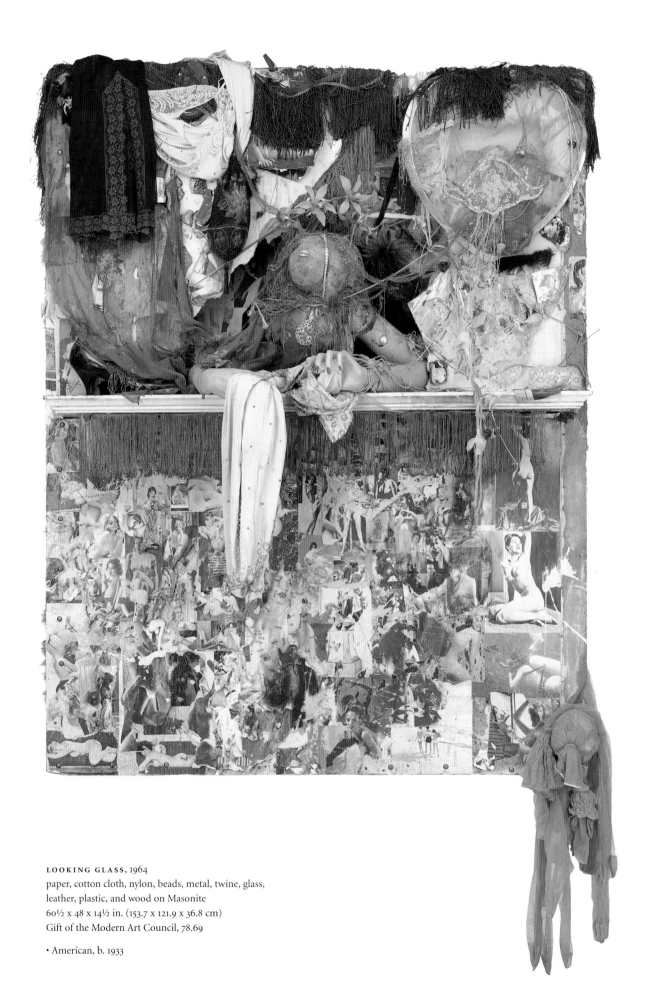

LOOKING GLASS, 1964
paper, cotton cloth, nylon, beads, metal, twine, glass,
leather, plastic, and wood on Masonite
60½ x 48 x 14½ in. (153.7 x 121.9 x 36.8 cm)
Gift of the Modern Art Council, 78.69

• American, b. 1933

RIGHT ANGLE PLUS ONE, 1969
lead antimony
plates: 48 x 48 x 1 in. (121.9 x 121.9 x 2.5 cm) each
pole: 84 in. (213.4 cm)
Purchased through a gift of the Modern Art Council,
Fund of the 80's and Board Designated Accessions
Funds, 90.104.a-d

• American, b. 1939

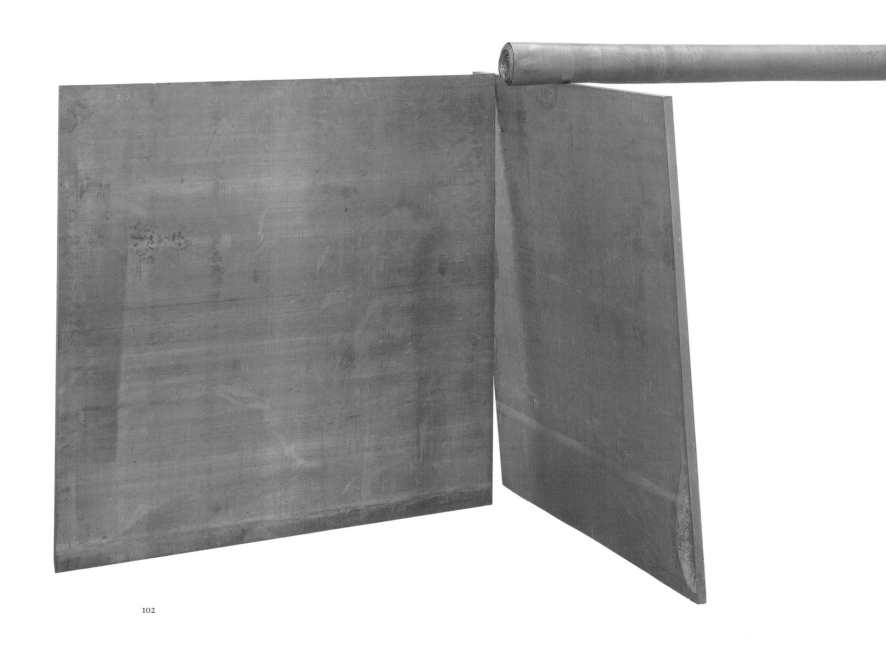

A native of San Francisco, Richard Serra was born here in 1939, studied at the University of California, Berkeley, and worked in steel mills in the East Bay to support himself. Crucial years were spent in the early 1960s at Yale University, where he completed an advanced degree in fine arts, and in New York, where he moved in 1966. Serra quickly gained a key position in the intense activity of the era, when artists were rejecting the reductive and static qualities of Minimalism in favor of a more analytical and process-oriented art that invited the viewer's critical engagement. His work contributed strongly to the emergence of sculpture as the dominant art form in the late 1960s, one of its most creative and formative periods in the twentieth century.

Right Angle Plus One comes from a series of works Serra completed in 1969 that he referred to as "prop" pieces. Made from lead or lead alloys, these works give form to the essential issues of sculpture—gravity, balance, and the intrinsic quality of the materials. Lead is notable both for its weight and malleability, and its use here accentuates the sculpture's subtle but bold exploitation, even defiance, of physical forces. The four elements of *Right Angle Plus One*—three thick lead sheets and a pole of thin rolled lead—hold each other in position by their own weight, while threatening to collapse. In addition, the dull sheen of the lead surface is sensual, both reflecting and absorbing light, beautiful and seductive, but further undermining the perception of physical stability.

This work is experienced not just in terms of space and volume but also through time as a moment of suspended equilibrium. One mentally reconstructs the act of making the work, the process of positioning the parts into place and of their set of engineered relations. Yet one also begins to imagine the chain of events if this static bond were to break. The resulting sculpture is both quiet and dramatic, eliciting fascination but also evoking a sense of danger. – GG

In the late 1960s and 1970s, art photography expanded its presence in the world of museums and galleries as an accepted way of documenting ephemeral works of art such as installations, performance pieces, site-specific sculptures, and what came to be known as earthworks: sculpture carved literally out of the land. Gordon Matta-Clark's *Conical Intersect* embodies this phenomenon. Properly speaking, *Conical Intersect* is a conceptual artwork that the artist chose to convey in multiple forms: first, in the "carving" of a cone shape into the architecture of a seventeenth-century Parisian townhouse, and second, in an extensive series of still photographs, photographic collages, and movie film shot on the site.

Made in 1975 for the Paris Biennale, *Conical Intersect* was sited in a structure slated for demolition during the building of the nearby Pompidou Center. Like other works by Matta-Clark, it has a series of alternate titles that offer punning commentary on the piece and suggest a variety of high- and lowbrow references. At its largest point, *Conical Intersect* was approximately thirteen feet across, forming a huge hole spanning part of the third and fourth floors of the townhouse. As it moved deeper into the house, the cutaway cone narrowed nearly into a point and emerged from the roof on the opposite side.

Trained as an architect, Matta-Clark was the son of the famed Surrealist painter Roberto Matta Echaurren. Where sculpture traditionally filled space, Matta-Clark approached sculpture as a way of both creating new space literally, as in the cone-shaped cutout of *Conical Intersect,* and making visible the normal construction of space in architecture. For Matta-Clark, the still photograph and movie camera were means to further explore and expand on the ideas that his architectural sculptures examined, as well as bring them to a broader audience. Photography was, for Matta-Clark, not simply documentation, but a distinct, significant aspect of a larger artistic investigation into architecture and sculpture. Frequently his photographic works took the form of elaborate collages, and he experimented extensively with photographic processes both in the camera itself and in the darkroom. In the case of *Conical Intersect,* French authorities condemned and walled up the building immediately after Matta-Clark finished it, and the artist was barely able to gain entry to document it.

Where Matta-Clark's work involves the translation of fundamentally three-dimensional, sculptural, and architectural ideas into a two-dimensional photographic context, Larry Sultan and Mike Mandel's book, *Evidence,* involves the transposition of non-art photographs into an art context. In the case of this work, what may appear to be an image documenting a somewhat typical, if intriguing, work of avant-garde sculpture is, in fact, something else entirely, and something that is all the more interesting for its mystery. Scouring more than fifty photographic archives maintained by scientific research facilities, police departments, cities, and universities, Sultan and Mandel assembled a series of images that record unfathomable activities and mysterious locations, which they published as *Evidence.* Seen together, these pictures resemble nothing so much as a collection of photographs documenting peculiar artworks, performance art activities, quirky sculptures and aesthetically charged—but unclassifiable—situations.

Deftly, *Evidence* recycles lost and forgotten photographs and retrofits them as refreshingly unself-conscious, witty works of art. Rather than shooting new photographs, Sultan and Mandel have simply mined the mother lode of vernacular images that photography inexhaustibly provides. *Evidence* testifies to the truth that photographs made for the most mundane reasons may in fact be as interesting, or more so, than those made self-consciously to perform as "art photography." – JW

Above right:
CONICAL INTERSECT, 1975
gelatin silver print
10⅝ x 15⅝ in. (27 x 39.7 cm)
Accessions Committee Fund: gift of Frances and John Bowes, Collectors Forum, Pam and Dick Kramlich, and the Modern Art Council, 92.426

• *Gordon Matta-Clark* American, 1945–1978

Below right:
UNTITLED (from the project *Evidence*), 1977
gelatin silver print
8 x 10 in. (20.3 x 25.4 cm)
Purchased through a gift of Mary and Thomas Field, Accessions Committee Fund and Foto Forum Fund, 93.43.1–44

• *Larry Sultan* American, b. 1946
• *Mike Mandel* American, b. 1950

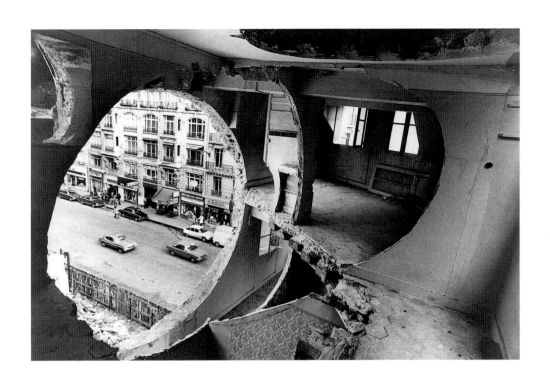

Dan Graham's ground-breaking work *Opposing Mirrors and Video Monitors on Time Delay,* in appearance a reductivist sculp-

DAN GRAHAM

ture, gives sculptural form to the television medium, using its ability to articulate and elasticize space and time to complicate the integrity of physical perception. In Graham's installation empathy for objects and the physical relationships between the viewer and the work of art are lost, but new ground is gained.

Using two video cameras and monitors, this time-lag, criss-crossing, two-channel-video installation creates temporal asymmetry in an ostensibly foursquare situation: each camera records the image in the mirror it faces, feeding the reflection to the one across the room, not the video monitor beneath it. Undermining the viewer's confidence in his or her ability to perceive reality, this video installation redefines sculpture to include time, electronic image, reflection, and movement.

With *Opposing Mirrors...* Graham introduces a new system of representation wholly removed from the traditional rendering of perspective in Renaissance art, in which the viewer faces a painting, looking forward into the "projected" space the artist contrives. In such an image, perspective is fixed and an observation point is predetermined. Through the combination of mirrored plates and corresponding video images, Graham defines a location that shifts in relationship to the viewer's position and motion. The mirror provides a view of a room—according to the viewer's position—which magnifies or reflects an image in infi-

nite regression. The added video images of the mirror's reflection and the use of a time-delay mechanism allow the viewer to see what would be, under ordinary circumstances, visually unavailable: the observed self as both subject and object as it simultaneously forms the image and describes the situation.

Graham's installation draws from minimalist strategy for the placement of raw material and overwhelms in its maximal concept. The artist announces with this work that the video medium, once imposed over actual space, describes a contemporary vision of some complexity; Dan Graham, along with Nam June Paik, Mary Lucier, Peter Campus, and Bruce Nauman, introduced the video installation, a new field of art making, in the early 1970s. *Opposing Mirrors...* is an ephemeral monument to the infinite expansion of communication media and televisual space, prefiguring much of the artist's subsequent work, including the *Homes for America* series and his recent glass observation stations called *Pavilions.* — RR

OPPOSING MIRRORS AND VIDEO MONITORS ON TIME
DELAY, 1974
Installation: two mirrors, two video monitors, two video cameras,
digital time delay mechanism, plywood, paint, and plan
30 x 30 ft. (9.1 x 9.1 m)
Gift of Dare and Themis Michos and Accessions Committee Fund:
gift of Collectors Forum, Doris and Donald G. Fisher, Evelyn and
Walter Haas, Jr., Pam and Dick Kramlich, Leanne B. Roberts,
Madeleine H. Russell, and Helen and Charles Schwab, 93.78.1-7

• American, b. 1942

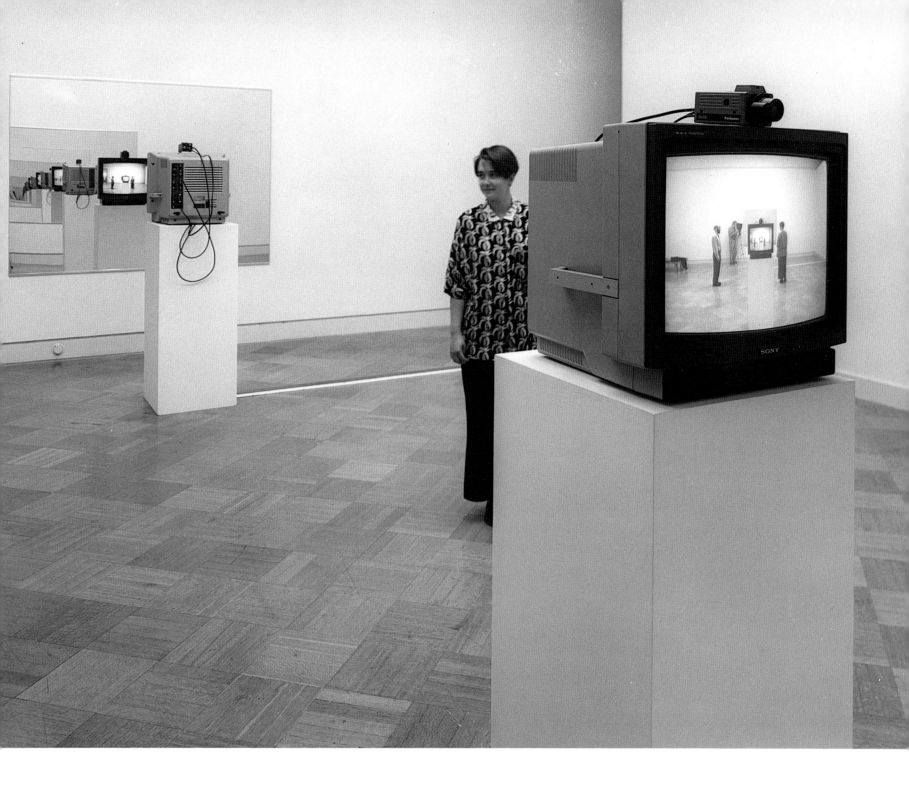

Toward the end of his life, Edward Weston became fascinated by the roots and trunks of gnarled, aged trees, just as he was drawn to the edge of the ocean to photograph the flotsam and jetsam that had washed ashore. A younger Weston was inclined to transform his subjects into monumental sculptural forms—nudes, peppers, even a toilet would achieve a quality of timeless beauty under his lens. But in the later pictures he is, as one might expect, intensely aware of the passage of time. In his image of an ancient eucalyptus, the old roots capture the earth in its bony arms, and leaves fall on eddies of earth that resemble the tidal pools of Point Lobos. The photographer seems as interested in a metaphor of rejuvenation—of the crumbling tree seeded by its own flickering small leaves—as he is in the physical massiveness of its beautiful old trunk.

Robert Adams also has a poet's sense of the anthropomorphic potential of nature. On a prospect two skinny trees are struggling to stay alive. We are reminded of the nymph Daphne, from Ovid's *Metamorphosis,* transformed into a laurel tree to escape a pursuing god, or the old couple Baucis and Philemon, so devoted to each other that they chose to be transformed into trees rather than face the death of one before the other. In Adams' picture, one figure seems almost to be tearfully wringing its hands as the other vainly, but valiantly, stretches out a few meager leaves. The mysterious romantic mist beyond is actually Los Angeles smog, revealing some of the tremendous population in the valley below, and indicating the agent of the tragic drama enacted by the two fragile trees.

Most landscape photographs have been made by men, and many of them reflect what have traditionally been male pursuits and interests: conquest; the magisterial view, as of a pioneer surveying eminent domain (a mode Ansel Adams often employed); or mapping, the objective, scientific approach, documenting activities such as the cutting of tunnels or erection of bridges or, less invasively, the measurement of layers of sediment on a

canyon wall. Ana Mendieta was a Cuban-born performance artist. Prior to her untimely death, she was married to the sculptor Carl Andre, and traveled in sophisticated New York art circles. Her interest in the pre-Hispanic cultures of Latin America motivated her to create art related to traditional Latin culture, with its special earthy reverence for the interrelatedness of death to life. Her *Silueta* photographs record her presence in the landscape: the subtle change of color and texture of the grass is the result of an application of fertilizer on the imprint left there by her body. It could be said that such a sensuous and intimate relationship of earth and artist might be best understood as female, as it suggests a collaboration with nature rather than an intervention into it or an objective documentation of it. The artist herself becomes Daphne, and the rejuvenation of the landscape a result of her activity. With Mendieta, as with Weston and Adams, the land becomes a screen for the projection of human values and desires.

— SSP

Opposite:
UNTITLED, 1945
gelatin silver print
7⅝ x 9½ in. (19.4 x 24.2 cm)
Bequest of Blanche C. Mathias, 83.62

• *Edward Weston* American, 1886–1958

Above left:
ON SIGNAL HILL, OVERLOOKING
LONG BEACH, CA, 1983
gelatin silver print
16 x 19⅞ in. (40.6 x 50.5 cm)
Accessions Committee Fund, 93.387

• *Robert Adams* American, b. 1937

Below left:
UNTITLED (from the series *Silueta*), 1978
gelatin silver print
19¹⁵⁄₁₆ x 15¹³⁄₁₆ in. (50.6 x 40.2 cm)
Accessions Committee Fund, 93.219

• *Ana Mendieta* American, b. Cuba, 1948–1985

Taking its form as a dolmen-like structure, *Dawn Burn* is a ground-breaking video installation that introduced new materials to the sculptural medium: the size and shape of the television screen itself, "real-time" or unedited video imagery, and video recording processes. Lucier's seven channels of landscape video imagery are a record of a sequence of seven sunrises over New York's East River. While Lucier videotaped the sun's gradual elevation, aligning the actual horizon with the bottom edge of the television frame, the sun's luminosity burned a spot in the picture tube as it reached its level of tolerance. This left the picture tube, and the videotapes made with it, indelibly scarred, and Lucier embraced this flaw for its lyricism and documentary quality. As the sun rose, it etched its path in the tube: the burn became a line that measured time, extending the expressive gesture of drawing, painting, and sculpture into the technology of video, and distancing the creative act from the human hand.

Dawn Burn prefigures artists' projects in video and photography from the late 1970s and 1980s that look upon the natural environment with grave concern. Lucier's placement of seven monitors that increase in size from left to right—and each marked with an additional burn from the preceding day—echoes the efflorescence of sunrise light. Ephemeral and monumental, *Dawn Burn* employs the symbolic nature of video to simultaneously explore themes of illumination, time, decay, and renewal. – RR

MARY LUCIER

Dawn Burn is the first video installation in the Museum's media arts collection to undergo conservation. The artist's original video material and sculptural plan—seven one-half-inch, open-reel videotapes, plinths, and television monitors—are now obsolete. Twenty years old, the videotape was subject to decay and irreparable loss. New conservation practices made it possible to digitally restore the original video image and transfer the signal to new archival video material for its protection and long-term presentation. –RR

DAWN BURN, 1973; videotape conservation and
digital re-master, 1993
Installation: seven-channel video and slide projection
seven video monitors, seven video laser discs, plywood,
paint, 35-mm slide, and plan
object: 98 x 45 x 54 in. (248.9 x 114 x 137.2 cm)
Accessions Committee Fund: gift of Doris and Donald
G. Fisher, Marion E. Greene, Evelyn and Walter Haas, Jr.,
and Leanne B. Roberts, 91.231

• American, b. 1944

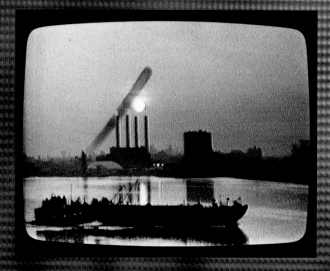

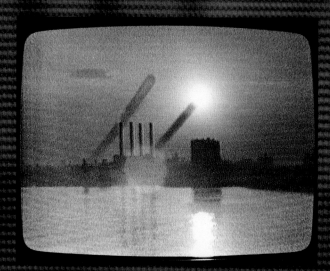

Doug Hall's three-channel video, sound, and mechanical installation *The Terrible Uncertainty of the Thing Described* takes its title from "The Passions, Clearness and Obscurity as the Effect," chapter IV in Edmund Burke's *A Philosophical Inquiry into the Origins of Our Ideas of the Sublime and Beautiful* (1757). The states of awe and revelation associated with the sublime as discussed by Burke are evoked in Hall's tumultuous vision of the landscape, expressed in steel and television technologies.

DOUG HALL

Within the darkened room of the installation, six video monitors and large-scale video projection present dramatic imagery of storms, fires, floods, and their associated sounds, in Hall's inspired confluence of the natural and the mechanical. Amalgamations of moving video images and solid forms, industrial materials, and an actual arc of lightning reflect elemental transformation in weather, echoing natural processes harnessed by heavy industry in the service of mass production.

The Terrible Uncertainty of the Thing Described dissects and places on view a situation in which the artwork's subject and object are boldly intermixed. While the representation of natural forces is partly its content, Hall's video installation also addresses the media landscape of simulation—the televisual environment—as its subject. Perceived as natural, Hall's television is an environmental presence of metamorphic potential and a pervasive cultural force. Violent weather conditions appear as concrete forces of destruction and renewal, symbolic of social erosion and emotional life.

The signifying potential of Hall's video landscape viscerally communicates a sense of cataclysm through imagery and an architectural division of space. Hall's blackened steel-mesh fence precariously tips toward the viewer, a towering row of video monitors displays images that imply cause and consequence, and an intermittent blast of undifferentiated electricity produced by a Tesla coil all construct an electronic arena of image and process that fuses the interlinked worlds of nature and technology with force. – RR

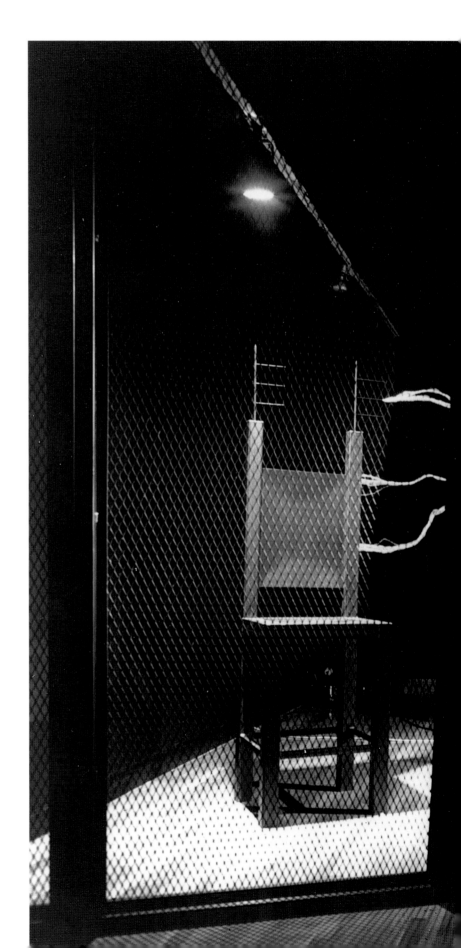

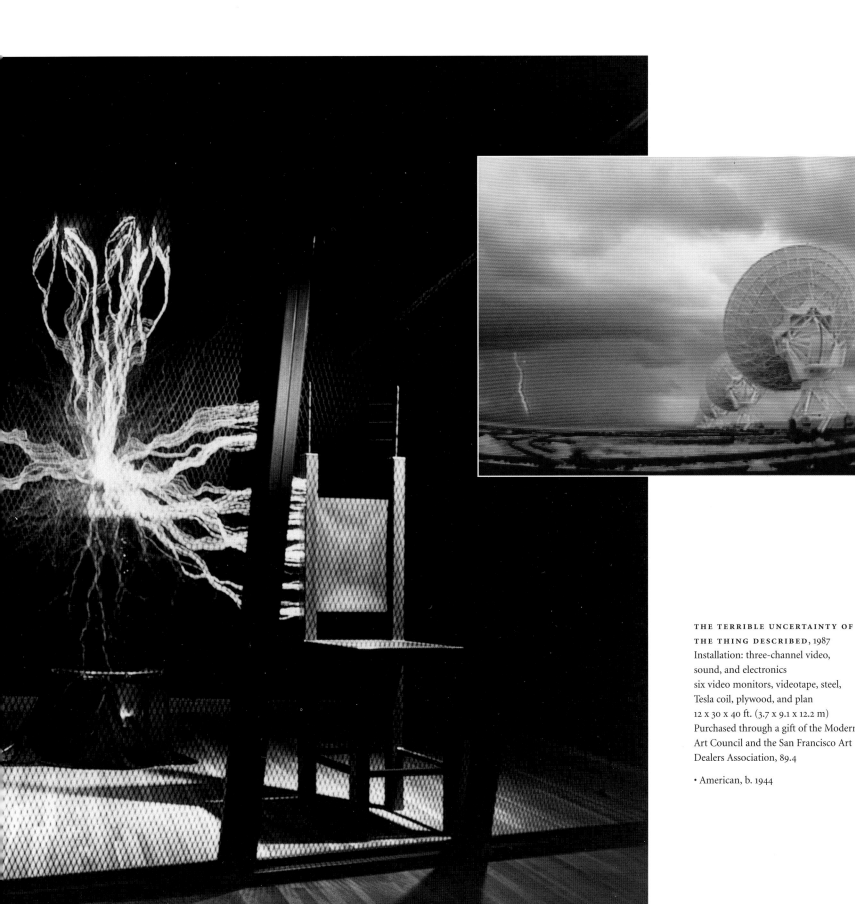

THE TERRIBLE UNCERTAINTY OF
THE THING DESCRIBED, 1987
Installation: three-channel video,
sound, and electronics
six video monitors, videotape, steel,
Tesla coil, plywood, and plan
12 x 30 x 40 ft. (3.7 x 9.1 x 12.2 m)
Purchased through a gift of the Modern
Art Council and the San Francisco Art
Dealers Association, 89.4

• American, b. 1944

Luciano Fabro has for over thirty years communicated with great strength and quietude his enduring engagement in contemporary experience as it relates to cultural history. Frequently employing humble materials and economical forms

LUCIANO FABRO

to create richly associative objects, Fabro is one of several artists who began making mature work in Italy in the 1960s that has come to be known as *arte povera,* or "poor art."

The sculpture *Demetra* takes as its subject the mythological goddess of the earth. Into each of two slabs of pinkish-gray rock, Fabro has carved one of the lips of the goddess. "Demeter is made as a figure whose mouth we see....All the rest is there," the artist has commented, "but only the mouth appears to us."[1] One thinks of Stonehenge and the mysteriousness of how such enormously heavy blocks came to rest upon one another to convey far more than they do individually. The form of the goddess' mouth, recessed as it is, emulates the concavity of female genitalia, and would appear to welcome interaction but for the barrier of a loop of steel cable that both emerges from between the lips and prevents any contact with them.

Like Dionysus, the god of the vine, Demeter was considered a kind-hearted deity, not to be feared, but cherished for her generosity of spirit in assuring the growth and harvest of crops. Despite Demeter's amicable nature, however, part of the myth is that she cannot be taken for granted, and in fact, the tale describes her refusal of human overtures to offer her sweet wine following the abduction of her daughter Persephone. Relegated to the underworld for the winter months of each year, Persephone is separated from her mother, which accounts for the accompanying chill of that season and the death of the crops. Fabro's sculpture, in turn, serves as a link between culture and nature, thus reminding the viewer of his or her responsibility to the mythological earth goddess and her domain. — JCB

1. Luciano Fabro, as quoted in Silvia Fabro, "Catalogue of the Exhibition," in John Caldwell et. al., *Luciano Fabro* (San Francisco: San Francisco Museum of Modern Art, 1992), 102.

DEMETRA (Demeter), 1987
stone and steel cable
44¾ x 79¾ x 31 in. (113.7 x 202.6 x 78.7 cm)
Gift of Robin Quist in memory of George Quist, 87.97

• Italian, b. 1936

Anselm Kiefer's *Osiris und Isis* is based loosely on the story of two primary deities of Egyptian mythology. Osiris, ruler of the lower

world and god of the sun, represented the male reproductive principle in nature and was the most widely worshipped god. His twin sister and wife, Isis, represented female fertility. Osiris was betrayed by his brother, Set, who cut his body into pieces and scattered them across the land. Isis was able to collect and bury his remains, with the exception of his phallus.

Like Kiefer's other major works, *Osiris und Isis* joins traditions of history and landscape painting with currents of contemporary conceptual art in an overwhelming visual synthesis. At the same time, it offers an intellectually layered, seemingly ironic landscape of puns, mythological references, and sly allusions to the history of art. The center of the painting is dominated by a huge pyramid recalling a Roman ruin the artist saw in Israel. At its base are a number of porcelain fragments that represent the dismembered body of Osiris and are connected by copper wire to a television circuit board placed at the apex of the pyramid. Typical of Kiefer's dramatic landscapes, the horizon line is high and the layered surface of the painting presses forward toward the viewer. In the background a pale comet crosses the dark sky.

When originally exhibited, this work was shown with a cycle of large books by Kiefer and another major painting, *Brennstäbe* (Fuel Rods). A number of shared elements link the two paintings closely with at least four of the books including *Die Geburt der Sonne* (The Birth of the Sun), *Durch den Mittelpunkt der Erde* (Through the Center of the Earth), *Spaltung* (Splitting), and *Schweres Wasser* (Heavy Water). Together these works suggest layers of wordplay and intertwined meanings that link the power, death, and resurrection of the sun god to the specter of nuclear fission. In particular, Kiefer draws an ominous parallel between the splitting of the atom and the fragmentation of Osiris. Just as the sun god is split into fourteen parts, Kiefer depicts fourteen atomic "fuel rods" in *Brennstäbe*, representing the modern technology of creation and destruction used to bring the power of the sun within the grasp of humankind. An implicit aspect of Kiefer's parallel between Osiris and nuclear power is that what is torn apart—whether for good or evil—can never be put back together.

Along with the issue of nuclear power, the central drama of *Osiris und Isis* also juxtaposes themes of family loyalty and betrayal, eros, mortality, and the reproductive forces of nature, all transposed ambivalently into a modern, technological idiom. Perhaps most crucial in unraveling *Osiris und Isis* is an examination of the vocabulary Kiefer has chosen to represent the narrative climax of this legend. The artist recasts the shattered body of Osiris as a common plumbing fixture, recalling the phallic fixture of male reproductive and erotic plumbing that his wife is unable to locate (and possibly alluding to Duchamp's famous *Fountain*). The connective tissue knitting Osiris back together again is copper wire leading to the heart of a TV—a ruthlessly logical, if uncomfortable, symbol for the metaphysical center of life in a consumer society. These elements are placed upon an immense tomb, a testimony to death and the hope for an afterlife.

In sum, *Osiris und Isis* is a bittersweet retelling of a religious myth that encompasses primary stories of power, love, conflict, loss, and redemption. The ambivalent genius of Kiefer's work is that it provokes such beguiling readings and yet transcends them in its rich physical presence and historical complexity. – JW

Although Kiefer's works are considered by many a "conservator's nightmare," *Osiris und Isis* is unusually resilient for a work of its scale and texture, primarily because of the artist's choice of materials. For instance, acrylic paint emulsions and acrylic media were used to build up the thick impasto. Such synthetic paints remain more plastic as they age than do traditional oils, which become hard—sometimes brittle—with time. Three-dimensional elements are held in place with another flexible product: silicon rubber. –JWS

OSIRIS UND ISIS (Osiris and Isis), 1985–87
oil, acrylic, emulsion, clay, porcelain, lead, copper, wire, and circuit board on canvas
150 x 220½ x 6½ in. (381 x 560.1 x 16.5 cm)
Purchased through a gift of Jean Stein by exchange, the Mrs. Paul L. Wattis Fund, and the Doris and Donald Fisher Fund, 87.34.a-b

• German, b. 1945

view foldout ➤

RED SEA; THE SWELL; BLUE LIGHT, 1975
oil on canvas
73½ x 78¾ in. (186.7 x 200 cm)
73 x 78⅛ in. (185.5 x 198.5 cm)
73 x 80½ in. (185.5 x 204.5 cm)
Purchased through the Helen Crocker Russell
and William and Ethel W. Crocker Family Funds,
the Mrs. Ferdinand C. Smith Fund, and the
Paul L. Wattis Special Fund, 78.67.a-c

• American, b. Canada, 1913–1980

This museum organized the first major retrospective of Philip Guston's work in 1980, which opened only three weeks before his

PHILIP GUSTON

death, and has an exceptionally strong collection of the artist's work representing various periods of his career.[1] One of the major figures of Abstract Expressionism, Guston took a remarkable turn in 1968 when he developed a radical new style of figurative painting, first in a series of small studies of domestic objects and, soon after, hooded figures recalling the Ku Klux Klan. From the following year until his death, Guston created a unique body of work which, in content and style, is among the most vital and original contributions to contemporary painting. Coming on the heels of Pop art, Minimalism, and Conceptual art, which dominated in the 1960s, the new direction in Guston's work had a profound influence on painters of the subsequent decade.

In the triptych *Red Sea; The Swell; Blue Light,* Guston creates a complex allegory about the condition of art and the artist. Guston, Jewish by birth, alludes to the Old Testament story of the escape of the Jews from slavery in Egypt through the parting of the Red Sea. The composition evokes the sand of the wilderness, the red waters of the sea, and the darkness of the night in which they fled to their Promised Land. The paint retains a strong sense of its material presence by resisting control and threatening to overpower and suffocate its master. The images broadly suggest the feeling of a nightmare, of being caught, of drowning, only to wake up, peering into the darkness to remember the dream and reorient oneself. By working across three panels, Guston produces an epic-like sweep to this very personal narrative. The tryptich evokes two of Guston's closely related concerns: "When you paint things they change into something else, something totally unpredictable,"[2] and that the essential subject of painting is "Freedom. That's the only possession an artist can have—freedom to do whatever you can imagine."[3]

But the seriousness is leavened by inescapable elements of humor and absurdity as in many of Guston's late paintings. Norbert Lynton, writing in 1982 about this work, observed: "Guston has the deep irony of the man constitutionally incapable of standing in awe of anyone, least of all himself, and yet fully attuned to humanity's awesome powers of creation and destruction."[4] Thus Guston converts traditional history and narrative into multiple metaphors about the struggle of the creative process and its potential both to entrap and to liberate. – GG

1. See the exhibition catalogue, *Philip Guston* (New York: George Braziller, in association with the San Francisco Museum of Modern Art, 1980).

2. Philip Guston, "Philip Guston Talking," in *Philip Guston: Paintings 1969–80* (London: The Whitechapel Art Gallery, 1982), 54.

3. Ibid, 53.

4. Ibid, 14.

Infinity Kisses is a group of 115 photographs by artist, filmmaker, and performer Carolee Schneemann. For five years a camera, positioned next to her bed, framed a moment each morning when Schneemann was awakened from sleep by her pet cat, Cluny.

While the work engages modern mechanical reproduction processes such as surveillance photography and the saturation of photocopy dye on paper, it evokes ancient symbology in its reference to the stylistic use of serial repetition in art.

It also refers directly to an Egyptian relief, which Schneemann has photographed and inserted into the structure as a key to the significance of the whole. This image fragment is included to renew our hope and belief in regeneration: according to Egyptian mythology, a lion that kisses a goddess restores peace to civilization. Similar to the artist's "Kinetic Theatre" work, which was characterized by the combination of a number of mediums in the construction of one work of art with stylized imagery and multiple themes, *Infinity Kisses* contains intermedia processes that cross the disciplines of painting, sculpture, photography, and film.

Schneemann often uses herself as a subject in her work, and frequently engages the human body itself as a medium for her art. In the early 1960s, when the very nature of artists' materials and subject matter changed, her vanguard, unapologetic work was considered hostile to an art marketplace based on the value of objects and insistent on their categorization. Schneemann's application of media and mechanical devices, her unadorned nudity, and her expressions of female sexuality challenged art institutions and galleries, and ultimately restricted the reception of her artwork to underground audiences. The artist's legendary film and multimedia environments such as *Eye Body For Camera* (1963) and *Up To and Including Her Limits* (1967) create the context for *Infinity Kisses* and anticipate a trend in contemporary art practice, largely feminist, that invokes representation and its expression through innovative methods and materials. *Infinity Kisses* is the first of Schneeman's artworks to be acquired by a museum in the United States. — R R

INFINITY KISSES, 1981–87
xerox ink on linen (140 images)
7 x 6 ft. (2.1 x 1.8 m)
Accessions Committee Fund: gift of Collectors Forum, Christine and Pierre Lamond, Modern Art Council, and Norman and Norah Stone, 93.12.a-jjjj

• American, b. 1939

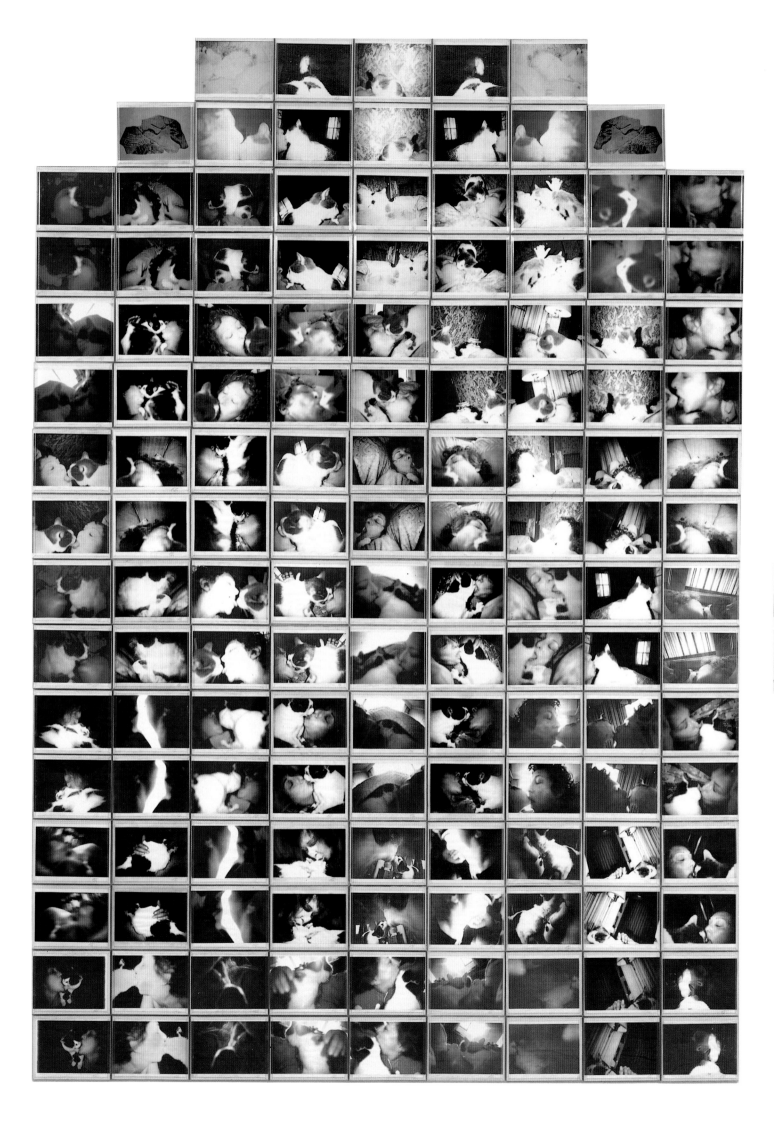

Linda Connor's photograph *Smiling Monk, Ladakh, India* functions like a snapshot. A Buddhist monk, high in the mountains of India, smiles at us openly, posed as though for our inspection. The earth on which he stands is utterly, almost spiritually barren; this is a place where apparently nothing earthly grows. He is dressed in simple, rather androgynous clothing, and his joy seems complete: the ordinarily brief gesture of a smile is revealed as a continuous and profound state of grace.

Connor's photograph of this moment is representative of a larger whole, a broad and largely Eastern-derived attitude to picture making that reflects and respects the totality and complexity of the experienced world. She is essentially a landscape photographer, but her pictures of a temple front in Ladakh, of a crumbling monument in Egypt, of a single special tree in Japan, or of a petroglyph in the American Southwest are all components of an extended, integrated project. Specifically, Connor's photographs are individual statements that express the ultimate unity of the external and internal, sacred and secular, male and female, love and death. Perhaps this attitude was derived in part from her work with Harry Callahan and Aaron Siskind, whose photography of the 1950s was accomplished in full consciousness of the mythological underpinnings of Abstract Expressionism. But Connor's photographs are likewise symptomatic of a younger generation with different ideals, of her sensitivity to trends current in California (where she has lived for twenty years), especially philosophical beliefs derived from Eastern religions, and also very likely to the circumstances of her gender. Connor's landscape photographs are not impartial or distant, but more harmonized, often intimate, and sometimes even frankly sexual.

Judith Joy Ross is primarily a photographer of people, and has photographed children consistently since first discovering them as a meaningful subject in 1982. This work began with her *Eurana Park* series, undertaken not far from the working-class Pennsylvania community where she grew up, and close to where she lives today. Like Connor, Ross can make her pictures seem as innocent and naive as snapshots, as momentary and beautiful and hopeful as the smiles on girls' faces. Although both Ross and Connor share similar training and technique (they both work with view cameras and make prints on the old-fashioned printing out paper), Ross is drawn to her subjects for the psychological possibilities she finds there. The photographic medium is both truth-telling and ambiguous, and portraiture for her is about finding as well as describing. Ross has found here three little girls, two twins and their year-older sister. The older one holds her body confidently, in lush contrapposto, while the younger two are still very girlish, their hands held awkwardly in front of them; they are beautifully plain, good, and insofar as it is possible to be so today, innocent and happy. Ross relishes this psychological and physiological contrast, and appreciates its evanescence: like actors, they are arrayed on a leafy proscenium, and we, like the boy in the distance, behold this fragile moment before it disappears. — SSP

Above right:
SMILING MONK, LADAKH, INDIA, 1985
gold chloride toned printing out paper
8 x 10 in. (20.3 x 25.4 cm)
Accessions Committee Fund: gift of Barbara Bass
Bakar, Susan and Robert Green, Christine and Pierre
Lamond, and Judy C. Webb, 92.411

• *Linda Connor* American, b. 1944

Below right:
UNTITLED (from *Easton Portraits*), 1988
gold chloride toned printing out paper
8 x 10 in. (20.3 x 25.4 cm)
Purchased through a gift of Jonathan Morgan and
Foto Forum Funds, 91.144

• *Judith Joy Ross* American, b. 1946

123

JOHN COPLANS • CINDY SHERMAN

In other cultures there exists a particular place for those who come to art after a life spent in other activity. In Japan and China, for instance, a man who has devoted years of service to affairs of state will often turn in his retirement to making art, sometimes even of acknowledged quality. In contrast, John Coplans was trained as an artist in London (after leaving his native South Africa to serve in the Air Force during the war), but when he came to the United States he acquired a talent for wearing different hats. One of the founders and certainly one of the most demanding and original early editors of *Artforum* magazine, Coplans was also by turns an adventurous curator of contemporary art (at the Pasadena Art Museum, now the Norton Simon Museum of Art) and a museum director. He had a long-standing interest in photography before he began experimenting with it himself (he is the author of an important and controversial essay on Carleton Watkins, the nineteenth-century Western American landscape photographer). He began making photographs in 1977, and since 1979 he has photographed his own body to the virtual exclusion of any other subject.

But Coplans' work is not narrowly concerned with his body. It can metamorphose to resemble a detail of a monolithic Assyrian guardian at the palace gate or, as in a detail of feet, recall an ascension of Christ or, in another, an Egyptian tomb for the delectation of a deceased pharaoh. His body has the character and history of age: it wrinkles beautifully, bulges nicely, sprouts gray and white hairs in rich abundance. Coplans' triptych of his upsidedown midsection, the knee slightly out of focus, is abstract yet vigorously organic and sensual: it resembles less a human body than the muscular heaps of rock Aaron Siskind photographed at Martha's Vineyard in the 1950s.

Coplans photographs what is real but culturally unseen: the aging male body, in a state of elegant, baroque decline. Cindy Sherman photographs what is an illusion but culturally prevalent: the roles in which modern society casts women. Between 1977 and 1980, Sherman photographed herself in a variety of

cinematic tableaux, playing various B-movie female parts—the housewife, the girl next door, the starlet, the jilted girlfriend. These *Untitled Film Stills* deploy the rhetoric of Hollywood to examine the process by which we internalize the narrative and characterizational models of movies: the way our expectations of life are manufactured for us in celluloid. In *Untitled Film Still #30,* for example, Sherman casts herself as the battered spouse; the image seems to be excerpted from some melodrama, the balance of which we are denied but can easily recite. Sherman's pictures are ultimately indebted to the Pop art tradition—the Marilyns of Warhol and teary comic-book heroines of Lichtenstein—in the way they deny the possibility of direct, authentic human emotion.

Sherman's *Film Stills* tell us no more about who Cindy Sherman is than Coplans' self-portrait tells us about the former editor and curator. Both document a certain kind of performance, but also enact a certain kind of evasion, and as such question photography's ability to show us anything except surfaces and clichés. The real subject of these works lies outside the photographic frame, in the world of ideas and social relationships: in display and disguise, psychology and ideology, spectacle and voyeurism. Coplans' and Sherman's intentional failures at self-portraiture speak to the postmodern condition, where the very concept of individuality is disputed. — SSP/DRN

Opposite:
SELF-PORTRAIT (UPSIDE DOWN NO. 1), 1992
gelatin silver print
84 x 42 in. (213.4 x 106.7 cm)
Accessions Committee Fund, 94.154.a-c

• *John Coplans* British, b. 1920

Above:
UNTITLED FILM STILL #30, 1979
gelatin silver print
30 x 40 in. (76.2 x 101.6 cm)
Accessions Committee Fund: gift of Collectors Forum, Barbara Bass Bakar, Pam and Dick Kramlich, Norman and Norah Stone, and Mrs. Paul L. Wattis, 92.119

• *Cindy Sherman* American, b. 1954

Since the late 1970s, when he began showing inflatable plastic toys in art galleries, Jeff Koons has been relentlessly provocative in his artistic endeavors. Working in the legacy of Marcel Duchamp, who in 1917 titled an ordinary urinal *Fountain* and submitted it to a museum exhibition, Koons has been recontextualizing and recreating everyday objects and images that reflect various aspects of public consumerism—consumerism of everything from road-stop souvenirs and vacuum cleaners to the Pink Panther, hard liquor, and art.

JEFF KOONS

For *Michael Jackson and Bubbles,* from the artist's *Banality* series, Koons directed Italian ceramicists to create a greatly oversized figurine from a publicity photograph of the celebrity and his chimpanzee. The performer and his pet are posed as companions, wearing matching gold band uniforms and an excess of makeup that stands in for genuine facial expression. Bubbles is nestled in Jackson's lap, their limbs confused to the point where one of the legs of the chimp could easily be mistaken for a third arm of the singer. They are instantly recognizable and undeniably beautiful. Yet right at the cold, shiny surface of their snow-white faces are rather disturbing issues of race, gender, and sexuality that are often part and parcel of our fascination with public personae. Over the course of rising from child stardom in the early 1970s, as the youngest member of The Jackson Five, to an unsurpassable level of international fame in the eighties and nineties, this cultural icon whom we know to be a black man has come to more closely resemble a white woman. The three-dimensional sculpture inhabits our space, the space of the general (albeit museum-going) public, but Michael Jackson himself is a man that we can never know. No matter how much media attention he receives, to the millions of people in whose consciousness he resides he will never be more than the flat character of tabloid reproductions and television. Koons' use of ceramic points directly to the hollowness and fragility of celebrity status. — JCB

MICHAEL JACKSON AND BUBBLES, 1988
ceramic
42 x 70½ x 32½ in. (106.7 x 179.1 x 82.6 cm)
Purchased through the Marian and Bernard Messenger Fund and restricted funds, 91.1

• American, b. 1955

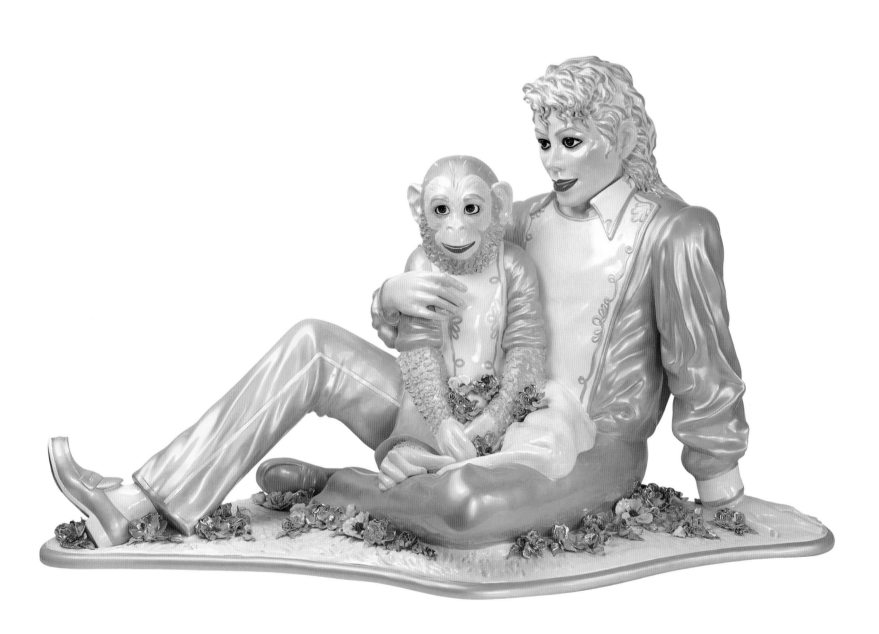

Working since the 1950s in the 35mm-photographic-transparency for-
mat, Irish conceptual artist James Coleman has developed an art form
that features image sequences combined with spoken texts that serve
as an accompaniment, a counterpoint, and a decoding

device. In his work *Charon,* Coleman challenges our
sense of reality by revealing objective thought patterns that we use to
classify and define photographic images, and by constructing unex-
pected, subjective relationships between auditory and visual stimuli.

This site-specific installation comprises a room and a series of
fourteen elliptical allegories conveyed through voice-over narration
and a sequence of projections. Coleman asks that we understand his
scenes—sets of gradually transforming pictures—and participate in
a puzzle of content informed by an evolving context.

The work takes its title from Charon, the ferryman of Greek
mythology who transports the dead across the river Styx into Hades.
Using the projected images as a conveyance between the surface of a
picture, memory, and a sense of place the viewer interprets, Coleman
raises issues regarding the act of seeing and invokes complex multi-
ple levels of sensory perception. The artist addresses the congestion of
relationships in the imagination and questions our critical arbitration
of ambiguous images and instinctual reflex to define what we see.
Coleman accentuates gaps between fact and fantasy, presence and
absence, and the known and the unknown, to create a compelling
dialectical tension between experience, meaning, and individual
memory. — RR

CHARON (THE MIT PROJECT), 1989
Installation: projected image and spoken narrative
112 35mm transparencies, automated image-dissolve projection system,
and plan
12 x 20 x 30 ft. (3.7 x 6.1 x 9.1 m); projected image: 6 x 10 ft. (1.8 x 3.0 m)
Echoing Green Foundation and Accessions Committee Fund:
gift of Frances and John Bowes, Collectors Forum, Jean Douglas,
Mimi and Peter Haas, Christine and Pierre Lamond, and
Elaine McKeon, 92.90.a-iiiii

• Irish, b. 1941

Robert Gober is a sculptor who first began to exhibit his artwork publicly in the mid-1980s. His early pieces, eccentric handmade plaster sinks without fixtures, were enigmatic and evocative, recalling the work of Marcel Duchamp and Jasper Johns, and also fusing Surrealism and Minimalism. They were recognized for their strong formal character and visual presence, as well as for a quiet but uncanny emotional poignancy, and quickly gained international prominence. By the end of the decade, Gober began to incorporate his sculptural objects into room-sized tableaux, which often included wallpapers that he would design. In 1993, at the Dia Center for the Arts in New York, he realized his most ambitious installation to date, and a section of that work was subsequently acquired for SFMOMA's collection. The artist, in close discussions with the Museum, has created a new installation of this work especially for the Museum's new building.

In the SFMOMA presentation, a white enameled sink, cast in bronze from a handmade plaster model, is mounted on the wall, and running water constantly cascades from two faucets above it. Recessed from the surface near the top of the gallery wall is a false window with bars, and hand-painted sky and clouds that are illuminated by theatrical lighting. The wall, which appears like a bucolic New England landscape, was painted by theater set painters, working closely from photographs taken by the artist and under his direction. Along the base of the wall are what appear to be a box of rat bait and a bundled stack of newspapers. However, these—like the sink—were actually carefully fabricated by the artist. Gober's sculptures are in effect images of common objects and his work continually disturbs the traditional distinctions between the sculptural and the pictoral, the real and the represented.[1]

The installation simultaneously evokes contradictory sensations of urban anxiety and pastoral reverie, claustrophobic imprisonment and idyllic pleasure. The natural and the artificial, nature and culture are inseparably fused and confounded. In Gober's work, states of consciousness, and reality itself, become questionable points along a continuum of experience. — GG

1. For further discussion of this, see Robert Riley's text on artist Nam June Paik's work *Egg Grows.*

ROBERT GOBER

Untitled installation including:

NEWSPAPER (HOW ESCOBAR.../WEDDING), 1992
photolithographs on Mohawk Superfine paper, ed. 7/10
16 x ¼ x 13¼ x 6 in. (41.2 x 33.6 x 15.2 cm)
Ruth and Moses Lasky Fund, 92.400

RAT BAIT, 1992
cast plaster with casein and silkscreen ink, ed. 4/10
9⅛ x 6⅛ x 2 in. (23.1 x 15.5 x 5.1 cm)

UNTITLED (FUNCTIONING SINK), 1992
stainless steel, painted bronze and water, ed. 4/8
32 x 30 x 20 in. (81.3 x 76.2 x 50.8 cm)

PRISON WINDOW, 1992
plywood, forged steel, plaster, latex paint, and lights, ed. 4/5
48 x 53 x 36 in. (121.9 x 134.6 x 91.4 cm)

Accessions Committee Fund: gift of Frances and John Bowes, Collectors Forum, Jean and James E. Douglas, Jr., Susan and Robert Green, Mimi and Peter Haas, Judy C. Webb, and Thomas W. Weisel and Emily L. Carroll, 92.401–92.403

• American, b. 1954

Illustration: Site-specific installation at Dia Center for the Arts, 1993.

REFLECTION IN OVAL
MIRROR, HOME PLACE, 1947
gelatin silver print
10 x 8 in. (25.4 x 20.3 cm)
Gift of Robert Fisher, 92.222

• *Wright Morris* American, b. 1910

Wright Morris has been known primarily as a writer of fiction, but in the 1930s and 40s he was also a passionate and thoughtful photographer. His work has been especially concerned with photography's unique ability to delineate traces of the passage of time, its sense of real connection with a moment and place in the past. "What we all want is a piece of the cross," he writes of the medium. "However faded and disfigured, this moment of arrested time authenticates, for us, time's existence. Not the ruin of time, not the crowded tombs of time, but the eternal present in time's very moment. From this continuous film of time the camera snips the living truth."[1]

Morris' photograph shows a mirror in which one finds reflected the corner of an old house, a dusty survivor of the Victorian era. Snapshots crowd the corner table, ancestors and descendants hover above, and a door leans awkwardly against the wall. The picture is a view into an extinct past, imperfectly reflected forever in the mirror's slightly rippled surface—a stage, framed by cheap flowered curtains bought long ago from a Sears and Roebuck catalogue, when that was the link of many rural families to the rest of civilization. Morris has long had a special regard for the integrity of that rural culture, so resolutely of the past even at the time this picture was made. Here the light is particularly delicate, the moment particularly still, but resonant with symbols of transition, of entrances and exits, a reflection of an actual world, as in a photograph.

Carrie Mae Weems has also been interested in depicting a living past photographically. She early on aligned herself with the tradition of documentary photography, particularly the street photography of Garry Winogrand, whom she knew in the 1970s when both lived in Los Angeles. As an African American woman, she has been sustained by the rich cultural tradition of the

BONEYARD

alarm clocks wake the dead on judgment day

kerosene lamps light the path to glory

the last cup, plate and spoon used by the departed
should be placed on the grave

keep a child safe from a dead person's spirit
by passing the child over the dead person's
body or coffin

If you suspect that a person has been killed by hoodoo, put a cassava stick in the hand and he will punish the murderer. If he was killed by violence, put the stick in one hand and a knife and fork in the other. The spirit of the murdered one will first drive the slayer insane, and then kill him with great violence.

If people die wishing to see someone, they will stay limp and warm for days. They are still waiting.

If a person dies who has not had his fling in this world, he will turn on his face in his grave.

**I got a black cat bone
I got a mojo tooth
I got John the Conqueroo
I'm gonna mess with you**

Harlem Renaissance, on the work of contemporary writers such as Toni Morrison and Alice Walker, and on the example of her friend, the photographer Roy DeCarava. As a politically conscious and sophisticated artist, she is interested in deconstructing the status quo of our society and its still unresolved attitudes toward race and gender. The *Sea Island* series, of which *Boneyard* is a part, was made on one of Georgia's Sea Islands, where there still exists a culture—including a language—that remains strongly African, an enclave protected by geographical isolation, a living link to a pre-slave past.

Morris is interested in expanding the experience of the photograph with his writing, and in his two earliest illustrated books set lyrical passages of text next to images. Weems also uses language to evoke the culture described in her photographs. But in place of the fictions that append Morris' pictures, Weems draws upon her training as a folklorist to furnish her images with an incantatory recitation of folk beliefs. By stacking the photographs in shaped sequences and arranging them in installations that include such items as lettered plates, she alludes to the caretaking role of women, sustainers of that island culture. Weems is as sensitive to the phrasing of her texts as she is to the suggestive juxtapositions of the various components of her works, to the curiously African sculptural forms of the crosses and the lettering in the photograph, and to the African style of bare, ungrassy but unswept graves, flecked with the debris of passing time. Both Weems and Morris give us an access to people we will never meet, and a special appreciation of cultures we might never have known. – ssp

1. Wright Morris, *Time Pieces. Photographs, Writing and Memory* (New York: Aperture, 1989).

BONEYARD
(from the series *Sea Islands*), 1992
(two parts of a four-part installation)
gelatin silver print
60 x 40 in. (152.4 x 101.6 cm)
Accessions Committee Fund, 94.178.a-d

• *Carrie Mae Weems* American, b. 1953

The Spirits that Lend Strength Are Invisible III is one of a series of five monumental abstract canvases by German artist Sigmar Polke. The series was first exhibited in 1988 at the Carnegie International exhibition, the large survey of contemporary art mounted every three years by The Carnegie Museum of Art in Pittsburgh, and later in the artists' first retrospective exhibition in this country, organized by SFMOMA.[1] The other four works now are held in private collections in San Francisco, and each has been made a partial gift to the Museum. While each of the paintings is singular in its visual qualities and in the materials from which it is made, together they are an extremely rich and cohesive ensemble and constitute one of the artist's most ambitious and important groups of abstract paintings.

The title is taken from a Native American proverb, an allusion by the artist that the works were made specifically for America and are an homage to the indigenous cultures of the continent. Polke has frequently reflected critically and skeptically on Western civilization and its suppression of the intuitive and spiritual potential of humanity in favor of systemic rationalism. His work often evokes an expanded sense of time, recalling historical events and time outside of human experience. In each of the five paintings in this series, Polke suspended different pulverized mineral materials in expanses of artificial resin. In this particular work, layers of nickel are caught in sheets and pools of the semi-transparent resin, creating a watery and atmospheric field, at once seductive and apocalyptic. The aesthetic and the spiritual are bound insolubly together, the nickel removed from production and commerce, evoking its cosmic source and final end.

Polke's work is often characterized by the unorthodox use of nontraditional materials, the layering of composition, and the incorporation of transparency, and he frequently evokes the image of the artist as seer or medium through which the unseen is given form and by which materials are transformed, not unlike the medieval alchemist or the tribal shaman. While the scale and sweep of this canvas recalls American Abstract Expressionism, Polke's work does not attempt to escape history through myth but rather to embed itself in the self-consciousness of place and time. — GG

1. See the exhibition catalogue by John Caldwell, et al., *Sigmar Polke* (San Francisco: San Francisco Museum of Modern Art, 1990).

SIGMAR POLKE

THE SPIRITS THAT LEND STRENGTH
ARE INVISIBLE III (NICKEL/NEUSILBER), 1988
nickel and artificial resin on canvas
157½ x 118¼ in. (400 x 300 cm)
Gift of the friends of John Garland Bowes, William Edwards, and Donald G. Fisher, and the Accessions Committee Fund: gift of Frances and John G. Bowes, Shirley and Thomas Davis, Mr. and Mrs. Donald G. Fisher, and Mimi and Peter Haas, 89.2

• German, b. 1941

Passage, a video and sound environment, has an immense video screen and a viewing time of six and one-half hours. In duration it is, without question, the longest work in the Museum's collection.

Viewers enter the artwork through a narrow passageway opening into a shallow enclosure that severely restricts one's perspective of the wall-to-wall, floor-to-ceiling moving video image. The image—which measures twelve by sixteen feet—is a videotape record of a child's

BILL VIOLA

birthday party projected at one-tenth its normal speed. The process of the videotape as it is slowly drawn through the machinery amplifies the slight, jarring movements of its hand-held camerawork into a high-impact experience. Large scale and slowed motion affect the viewer's sense of time and perspective: in such an environment, any gesture overwhelms, small details ascend to symbolic proportion, and all color is explosive. Viola uses this effect to ritualize the passage of time and articulate the tensions of old age within youth and death within life.

Passage is an expression of Viola's fascination with video, an artists' medium that allows perceptual capacities to extend beyond the eye and the body into an electronic and mechanical system of representation. For Viola, video is an intimate art form through which conveyance from a private vision to a public record is realized. In the title of this monumental work, Viola pronounces his three-fold ambition: the passage into art of visual information in which narrative relationships occur; the embrace of social rituals marking the passage of time, such as birthday parties, as subject matter in art; and the message that constructions of memory and vision originate from primary experience. – RR

PASSAGE, 1987
Installation: single-channel video with sound
video projector, projection screen, videotape, and plan
12 x 16 x 55 ft. (3.7 x 4.9 x 16.8 m); projected image:
12 x 15 ft. (3.7 x 4.6 m)
Accessions Committee Fund: gift of Susan and Robert Green,
Mr. and Mrs. Donald G. Fisher, Pam and Dick Kramlich,
and Mr. and Mrs. Brooks Walker, Jr., 90.110

• American, b. 1951

We should not view the Eames conference and projection room—extracted from their building at 901 Washington Boulevard in Venice, California, and rebuilt in the new galleries at the San Francisco Museum of Modern Art—as a period room in the tradition of the decorative arts. This

space not only illustrates the working environment of one of the most creative and influential design teams of this century, but is a work of design in its own right. It condenses the ethos of the work of Charles and Ray Eames, an uncommon mixture of unaffected aesthetics and poetic impulses. We can easily overlook its art, so close is this environment—entirely devoid of self-consciousness and provocatory gestures—to our daily experience, until we realize that our rekindled awareness of ordinary objects is largely indebted to theirs.

There is no doubt about the importance of Charles and Ray Eames in the history of twentieth-century design. The scope of their work enfolded nearly the whole spectrum of creative endeavors of the modern era, from the design of objects to architecture, photography, film, and graphic design, and to a further extent than that of most of their contemporaries.

The Eameses' view of the world was fragmentary: it was composed of a collage of traditional symbols, things, and customs mixed with objects of their invention. The habitual critique of modernism is that it pursues universal truth but ignores or eliminates individual distinctions; that it implies a comprehensive system, which by its very nature is constricting and exclusive; that behind any designer lurks the ghost of despotism. But this critique does not apply to the Eameses, who, in contrast to many of their contemporaries, did not conceive an all-encompassing utopia. They began no movement and founded no school. Their work spoke for itself and was rich with suggestion. Its lucidity showed that it was the result of a long process, of peeling away until what remained was unassailable and was, and looked, essential.

The Eameses worked not according to system but to discipline—a patient, methodical, meticulous process of incremental improvement of what exists around us that manifested artistic canon without depending on unbending theory. Their modernity was not an illusion, the dressing up of current needs with style. They believed that design should embody function, not simply follow or represent it. They found and taught others to find artistic purpose and delight in ordinary, anonymous things such as food, crafts, and toys. The Eameses connected these fragments conceptually and formally—juxtaposing what was distant culturally and geographically; separating what was interesting from the obvious; and approaching what already existed with an open mind and from an often fresh, unexpected direction.

Their office mirrored their beliefs. The Eameses took possession of this former car-repair shop in 1943. During the war, it served as a factory for the production of molded plywood chairs and leg-splints for the U.S. Navy. In 1947, it became the permanent home of the Eames office. But this office was not very office-like. In fact, it was a unique combination of workshops for experiments and the small-scale production of some pieces, a design office, as well as a film studio. The space was dense with people, posters, memorabilia, photographs, signs, toys, equipment, seashells, books, movable panels, and prototypes. A natural extension of the rest of the building, the conference and projection room had a large screen for the viewing of slide shows and films, a table surrounded by prototypes of the Eames Executive Chairs, and walls lined with images large and small.

Each object in the room has a purpose: each detail and every artifact, no matter how mundane, becomes a celebration of human creativity. There are no superseded things: there is no marked predilection for the new versus the old, for modern design versus traditional crafts; everything is susceptible to being reused. In the context of the room, what was once discarded regains a fresh presence, a visible reminder that the pursuit of excellence can assume many guises—the mismatched silver candlesticks on the plastic-laminate table, the flag and mask on the wall, the old tin toys on the shelf, the collection of photographs all around. The Eameses taught us to look at the world with unending wonder. — PP

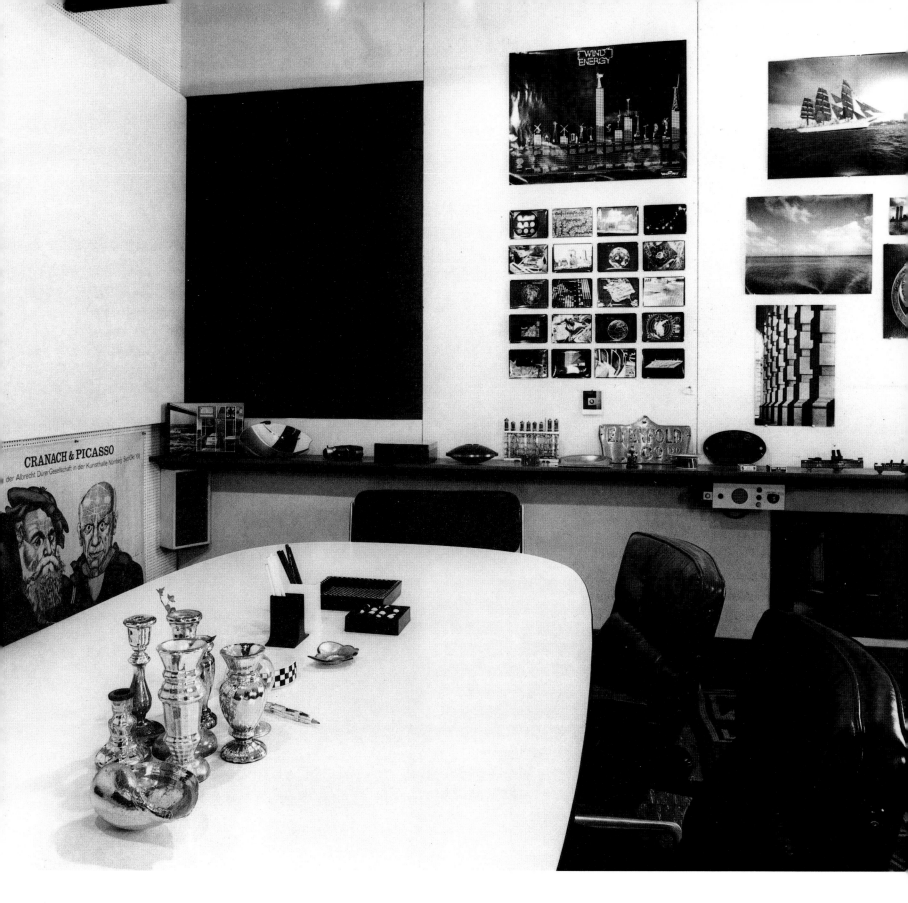

CONFERENCE ROOM, n.d.
photograph of the former Eames meeting and projection room in Venice,
California. A reconstruction of this room, using original materials,
is featured in the Museum's new building.

Architecture and Design Forum Fund and Accessions Committee Fund:
gift of the Modern Art Council, Frances and John G. Bowes, Mr. and Mrs.
Donald G. Fisher, and Byron R. Meyer, 89.3

• *Charles Eames* American, 1907–1978
• *Ray Eames* American, 1912–1988

In the early 1970s, every serious architectural magazine published Sea Ranch Condominium no. 1 by Moore, Lyndon, Turnbull, and Whitaker. Its crisp lines set against clear sky, sharp angles, and uninterrupted surfaces transformed the canon of international architecture, and Sea Ranch occupied a place next to those buildings in modern history—Villa Savoye, Barcelona Pavilion, Fallingwater—that set the standards of an age. Sea Ranch became the visual trope of American architecture.

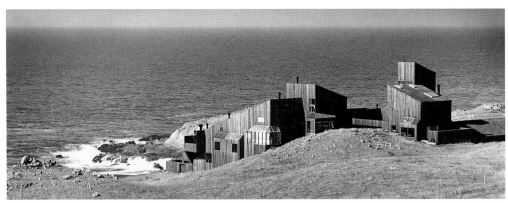

Sea Ranch is a residential complex situated along a particularly picturesque stretch of Northern California coast, just south of Mendocino. It was planned around open courts, taking into account the qualities of the site, the asperity of the terrain, the view of the ocean, the brightness of the light, and the strength of the wind. In its layout, it recalls a Tuscan hill town, with a tower announcing its presence, crooked streets, a small piazza, and a surprising view at every corner. But the real surprise is to enter one of the units, with its single open space expanding from the floor to the ceiling two or three stories above. Fragmented by sleeping lofts, ladders, and canopies, this space evokes the world as seen through the eyes of a child. This is the kit of parts that is reassembled in different compositions inside each unit of the complex.

The architects did not start out to design a modern building. The complex avoids the gleaming surfaces of functionalist architecture; there is no concrete, no steel, and little glass to celebrate technology. The architects' material of choice is redwood. If anything, their scope was to carefully sidestep precedents. "The Sea Ranch condominium," Charles Moore, Gerald Allen, and Donlyn Lyndon wrote, "was not meant to look 'like' anything in particular."[1] Still, the condominium establishes an Arcadian relationship between architecture and the land. From a distance, the graying redwood boards merge with the coastline. Since its construction, it has become part of the vernacular, a continuation of the barns that punctuate the coastal meadows.

This sketch is one of a significant group of drawings by William Turnbull, who was part of the original design team, that are in the Museum's permanent collection. These drawings document salient phases of the process of designing this important complex. – PP

Above:
SEA RANCH, CONDOMINIUM I, 1966

Opposite:
SEA RANCH SKETCH, ca. 1966
graphite on tissue
17 x 34 in. (43.2 x 86.4 cm)
Gift of William Turnbull, 79.79.7.1

• American, b. 1935

1. Charles Moore, Gerald Allen, and Donlyn Lyndon, *The Place of Houses* (New York: Holt, Rinehart and Winston, 1974), 34.

Shiro Kuramata dealt with extremes, combinations of seemingly non-negotiable concepts—such as transparency and solidity—engaged in an unyielding tension. In the course of his work, he negotiated with the idea of transparency, of real but nearly invisible objects that seem to disavow the physical world. Solidity is for him the polar opposite of transparency, the magnetic field against which he could measure the validity of his designs.

Miss Blanche, named after a character in Tennessee Williams' *A Streetcar Named Desire,* is one of several designs by Kuramata in the Museum's permanent collection. It represents the culmination of a period in Kuramata's career that began with *Glass Chair,* which he designed in 1976. Both chairs explore the notion of transparency, but *Miss Blanche* avoids the nearly Platonic purity of the earlier design. The seat, arms, and back are made of clear acrylic resin, in which red silk roses seem to float, an ironic memory of chintz upholstery. The arms and back are gently curved, but are joined and almost awkwardly proportioned to stand out as individual elements rather than as parts of a whole. The purple, anodized legs are inserted into slots carved out of the underside of the seat. All these elements may suggest a decorative purpose, but this would be an erroneous assumption, as *Miss Blanche's* elusive elegance evokes anything but charm. Its sweetness, Andrea Branzi, an Italian designer friend of Kuramata, has suggested, is the sweetness of poisonous exhalations. The false flowers, incongruous curvatures, and abrupt angles introduce tension—a counterpoint of dissonant melodies—and provide the quiet of static noise.

This chair, like many other pieces Kuramata designed during his career, demands attention; it does not disappear quietly in the background. Kuramata's designs, for all their apparent simplicity, raise serious questions about the role of designers and the objects they create in today's environment. For better or for worse, we own too many pieces of furniture and appliances in our homes to have feelings for any of them. Most of these objects—the metal and leather chair, the black stereo, or the ergonomically designed blender—are so commonplace that they no longer communicate anything about us, their users: they are anonymous. Kuramata's designs have character—they demand attention, evoke memories; they become our friends, question our taste, and welcome us in our homes. – PP

MISS BLANCHE, 1988
Plexiglas, artificial flowers, pink anodized aluminum
25½ x 21½ x 23½in. (90 x 55 x 60 cm)
Accessions Committee Fund: gift of Mr. and Mrs.
Donald G. Fisher, Mrs. George Roberts, and
Mr. and Mrs. Brooks Walker, Jr.; and the National
Endowment for the Arts Museum Purchase Plan, 91.27

• Japanese, 1934–1991

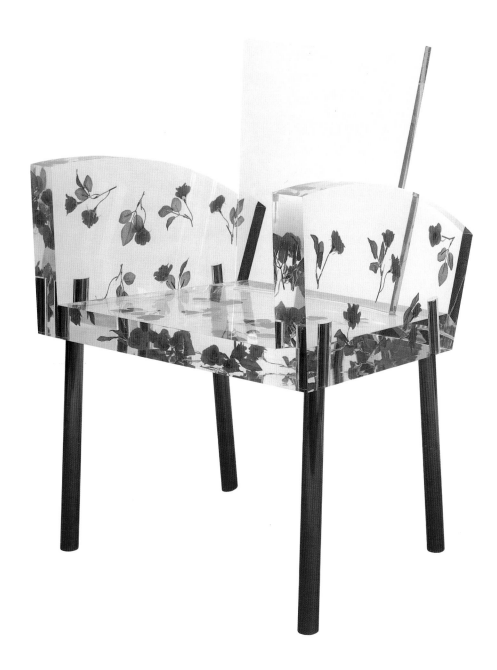

'92 Chaise could at first appear like a relatively straightforward redesign of an older object, still serviceable but slightly out of touch, brought back to a new life in a contemporary environment. Of course purists would view this reconfiguration of an

HOLT HINSHAW PFAU & JONES

original model— the *Chaise Longue,* which was designed by Le Corbusier and Charlotte Perriand in 1929 and subsequently became an icon of modernism—as a radical act ripe with conceptual undertones akin to, say, adding finishing touches to Picasso's *Les Demoiselles d'Avignon.* Still, even such a revolutionary gesture could easily be sucked into the spongy norm of our age rife with similar extremism, if it were not for this work's complexity, which cautions against facile stereotypes. '92 Chaise is not a mere redesign and does not express a simple rebellion against the burden of precedent. In fact, it manages to communicate reverence for its predecessor while asserting its own independence. We may also perceive the directness of *'92 Chaise* as a critique of stale functionalist clichés, so trite that they have lost definition even for their staunchest supporters. Design represents not just a function but a time-specific idea of function—objects are designed for a certain time and place, and with a certain person in mind.

We imagine the original *Chaise Longue* at home in a set out of a Fred Astaire film—strategically positioned in the middle of a vast expanse of impeccably polished marble, its metal structure softly gleaming from indirect lighting, surrounded by equally spare but precious furniture, a small table at its side with a conical cocktail glass resting on it, and in the background a shimmering view of a city teeming with skyscrapers. In contrast, *'92 Chaise* resides in the corner of a converted loft where walls and floors are left in their original, unclad concrete. A multimedia workstation, laser printer, plotter, and a skein of telephone cables fill one corner, a black pile of authoritative stereo equipment made in Japan sits next to the Italian bed, and a chopped motorbike is leaning against a single, implausibly thin strut in another corner.

The *Chaise Longue* is often portrayed as a perfect synthesis of form and content. Unlike more traditional chairs, it shows no distinction between structure—which is usually hidden and built without regard for appearance—and its exterior—upholstered with selected materials, pleasing to sight, touch, or even, in the case of leather, smell. Here, the structure is the exterior, and its function is evident: this is a modern interpretation of the daybed,

an emblem of domestic comfort since ancient Roman times, and the seat is the focus of the designers' attention. The chair is ostensibly machine-made, although this is more a symbolic than an actual fact, since its industrial-looking material, tubular steel, needs a good deal of craftsmanship to acquire its polished finish. Still, the very absence of embellishments—with the exception of the soft, naturalistic touch of the pony hide and the delicately tapered legs of the base—conveys the full elegance of early-modern design and its goal of mass-reproducibility and quality combined with affordability. This is industrial expression at its best, sanguine and flamboyant.

By contrast, *'92 Chaise* shows no synthesis. It communicates instead differentiation, indeed separation, between seat and base. It makes no attempt to disguise its line of descent from the heroic period of modernism, but subverts its predecessor's priorities: the seat remains unchanged, and the designers focus their entire effort on the base, making this the real object of the redesign. This separation of parts is the result of a deeper analysis into the chair's purpose, its dissection into a set of subfunctions, each to be treated—as parts of a machine are—separately.

The base is squat, lepidopteran, matte black, nearly threatening, and stripped of the refinements of the earlier chair. While *Chaise Longue* embodies the aesthetics of industrial production, this one shows the engine under the hood, its only affectation being the visual gratification granted by the logical arrangement of its mechanical parts—the confidence that everything not only looks right but is right. It communicates not industrial imagination but engineering uniqueness; its design connotes the precision and minute handmade adjustments that are essential in customized cars.

'92 Chaise is inspired by the same object-driven pleasure that hot-rodders have for cars, or computer hackers have for discarded logic boards. It exemplifies the continuum of which each design, no matter how illustrious, is part. Each is subject to redesign—not just to reinterpretation, but to improvement. This chair represents an approach to design that is characteristic of the Pacific region and of California in particular, and that may also be found in architecture, in the entire tradition from Bernard Maybeck to Stanley Saitowitz. These designers and architects stress appropriateness of materials and forms, favor experimentation, regard performance as their highest priority, and feign disdain for style. Their work looks "right" only in a theoretically undefinable manner. — PP

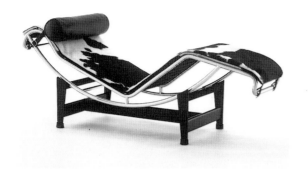

Left:
CHAISE LONGUE, 1929
Le Corbusier (Charles Edouard Jeanneret) and Charlotte Perriand

Below:
'92 CHAISE, 1985–92
steel, plastic, rubber, and pony hide
18 x 24 x 72 in. (45.7 x 61 x 182.9 cm)
Accessions Committee Fund: gift of Collectors Forum, Helen and
Charles Schwab, Danielle and Brooks Walker, Jr., Thomas W. Weisel
and Emily L. Carroll, 93.10.a-b

• *Paul Holt* American, b. 1952
• *Mark Hinshaw* American, b. 1955
• *Peter Pfau* British, b. 1958
• *Wes Jones* American, b. 1955

During his life, Fumihiko Maki has seen Tokyo changing from a city of wooden buildings to one where the increasing demographic and economic pressure has gradually eroded the fragile continuity of the Japanese urban tradition. Architecture has not survived this process of transformation without cardinal changes. Traditionally, architecture relies on continuity and expresses the order and purpose of the urban environment. But the order of the contemporary city is, as Maki has written, "the unstable equilibrium of a cloud." In this setting, buildings become ephemeral items of consumption, rapidly outmoded by newer and better ones; they do not express a lasting urban or architectural attribute, only the makeshift alacrity of commercial convenience. Some buildings—those with the monumental ambition to emerge from this background—preserve their autonomy only by casting an insurmountable barrier of silence against the surrounding cacophony. Maki has chosen another, more complex alternative, an architecture that establishes a dialogue with the city but maintains a visible integrity.

FUMIHIKO MAKI

Spiral, of which a model is part of the Museum's permanent collection, is a building situated along Aoyama Dori, one of the busiest streets and most prestigious addresses in Tokyo. At first its facade—a collage of different materials and forms—gives no hint of the interior. Only gradually does an order appear and out of it emerges a grid with tesserae composed of different materials and shapes. These compositions crystallize—vaguely at first, but with increasing clarity upon observation—into a spiroid pattern. This design never achieves a complete geometrical shape and ostensibly disregards the physical margins of the building to persist on a theoretically endless course.

The open form of Spiral melts into the openness of the connective tissue of Tokyo, relentlessly pulsating with new life. Its materials—glass, concrete, and aluminum—recall those of the adjoining structures and, to a slack observer, the building may indeed assume the familiar opacity of the background. But the careful composition, the modernist perfection of its elements, and the craftsmanship of their assembly quickly dissipate this first impression. The smoothness of the aluminum tiles; the calibrated uniformity of their joints; the syncopated rhythm of the window mullions; the abrupt presence of sensual forms lurking behind the surface; the very randomness of the openings on the

facade counter any presumed hackneyed streak. There is nothing raw or commercial in its industrial idiom. There is instead the craft of a Japanese gardener in inducing the gradual discovery of the facade of Spiral as a landscape delicately inserted in the urban fabric.

In Maki's buildings, such conceits are never skin deep, and Spiral is no exception. The spiroid pattern suggests a vertical movement, and indeed the facade conceals a staircase. But to arrive at it, visitors must first follow a tortuous path through the ground floor, up a circular ramp, and back across the whole length of the building. Nor is a spiral a mere pretext to give coherence to an otherwise disjointed sequence of interior spaces. Each turn introduces new elements, and each element resonates with this theme, from the small scale of the details to the larger one of the floor plans and sections. To make this ensemble work spatially amounts to the architectural equivalent of a symphonic composition. Each interior space is a self-contained unit, yet it merges harmoniously with the preceding and following spaces. But harmony does not preclude surprise. Visitors can follow one of several routes, and each visit brings with it a revived exploration. The progression through the interior to the top floor becomes increasingly anxious and fragmented, and it is with a sense of elation that one finally emerges on the open roof garden, but with the memory of a journey longer than it was in reality. The sequence of these spaces is a natural extension of the spatial and temporal order of the city, fragmented daily by new buildings, different destinations, and memories.

The modernity of Spiral is not the modernity of a new architectural or urban order. There is no archetypal purity in its form that requires a similarly punctilious echo throughout the city; there is no arrogance in its participation in urban life. Its sympathetic gesture toward Tokyo should not be viewed as merely contextual—a postmodern trick. But there is something deeply modern in the discipline that informs this edifice, a logic that gives it not only a formal but also an ideal coherence. All of its elements, from the smallest to the largest, reveal painstaking precision of craftsmanship and assembly, a result that is far from casual and is the manifestation of a long devotion to the highest standards. In the end, Spiral is evidence of an uncompromising approach to life itself. — PP

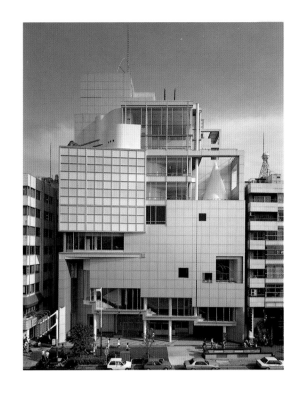

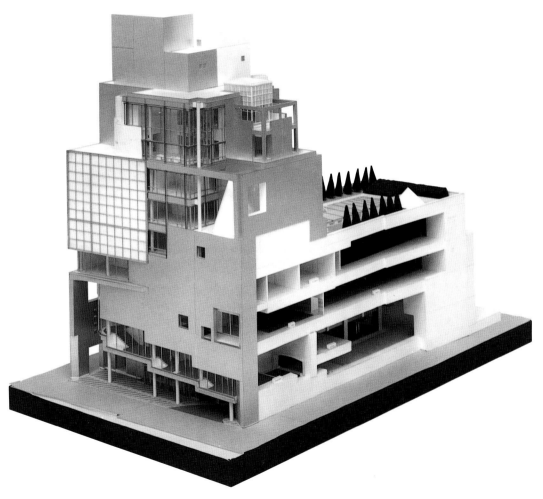

Above:
SPIRAL BUILDING
front elevation

Left:
SPIRAL BUILDING (model), 1985
styrofoam board, acrylic acetate, and mylar
43½ x 31½ x 55½ in. (110.5 x 80 x 141 cm)
Gift of Fumihiko Maki, 93.3

• Japanese, b. 1935

Office of the Director

Dr. John R. Lane
Director

Mary Beth Roberts
*Executive Assistant to the Director and
Assistant Secretary, Board of Trustees*

Gregory Johnson
New Museum Project Coordinator

Division of the Deputy Director

Inge-Lise Eckmann
Deputy Director

Curatorial Department

Gary Garrels
*Elise S. Haas Chief Curator and
Curator of Painting and Sculpture*

Dr. Sandra S. Phillips
Curator of Photography

Robert R. Riley
Curator of Media Arts

Janet C. Bishop
*Andrew W. Mellon Foundation
Assistant Curator of Painting and
Sculpture*

Douglas R. Nickel
Assistant Curator of Photography

Barbara Levine
Exhibitions Manager

Thom Sempere
Graphic Study Coordinator

Margaret Lee
John Losito
Mark Petr
Curatorial Assistants

Jill Davis
Assistant to the Deputy Director

Carol Nakaso
Sandra Poindexter-Gary
Sarah Poor
Marcelene Trujillo
Secretaries

Conservation Department

J. William Shank
Chief Conservator

Jill Sterrett-Beaudin
Conservator

Neil C. Cockerline
Paula DeCristofaro
Associate Conservators

Valerie Wolcott
Administrative Assistant

Sarah Grew
Museum Technician

**Graphic Design and Publications
Department**

Catherine Mills
*Director of Graphic Design and
Publications*

Kara Kirk
Publications Manager

Tracy Davis
Assistant Designer

Alexandra Chappell
Publications Assistant

Education Department

John S. Weber
*Curator of Education
and Public Programs*

Peter S. Samis
*Assistant Curator of Education;
Program Manager, Interactive
Educational Technologies*

Dr. Susan Spero
Docent Coordinator

Gail Indvik
*Coordinator of Public Education
Programs*

Eduardo Pineda
*Coordinator of School and
Youth Programs*

Margarita Cruz
Secretary

Gail Camhi
Slide Librarian

Library

Eugenie Candau
Librarian

Karen Brungardt
Library Assistant

Registration Department

Tina Garfinkel
Head Registrar

Stephen Mann
Registrar, Permanent Collection

Jane Weisbin
Associate Registrar

Olga Charyshyn
Jeremy Fong
Marla Misunas
Pam Pack
Jennifer Small
Assistant Registrars

Rose Candelaria
Registration Assistant

Gail Camhi
Secretary

**Operations and Installation
Department**

Kent Roberts
Operations/Installation Manager

Operations

Dirk Foreman
*Manager, Computer Information
Systems*

Jeff Phairas
Chief Engineer

Duane Jepson
Assistant Engineer

Paul Eckert II
*Assistant Project Manager,
Computer
Information Systems*

Scott Havlak
*Computer Information Systems
Technician*

Richard Peterson
Assistant Operations Manager

Cynthia Raedeke
Mail and Supplies Clerk

Michelle Waddy
Shipping and Receiving Clerk

Ruth Miller
Secretary

Barbara Fullwood
Carolyn Valdez
Receptionists

Alicia Villahermosa
Coat Clerk

Installation

David Wheeler
Senior Museum Technician

Carol Blair
Douglas Kerr
Dawn Nakashima
Rico Salinas
Niles Snyder
Greg Wilson
Museum Technicians

Human Resources Department

Anne Johnson
Human Resources Manager

Dina Blair
Human Resources Assistant

Carol Singer
Volunteer Coordinator

Finance Division

Ikuko Satoda
Chief Financial Officer

Karen Molzan
Accounting Manager

John Kwan
Accountant

Mary Lee
June Bussiere
Accounting Assistants II

Victoria Schirado
Secretary

Tia Winkler
Data Entry Operator

MuseumStore

Irma Zigas
*Director of Retail and
Wholesale Operations*

Robert Lieber
*MuseumStore/Admissions
Manager*

Stuart Hata
Buyer

Charles Gute
Assistant Buyer

Edgar Maxion
Stockroom Supervisor

Stella Tong
Accounting Assistant II

Marcia Brooks
Patricia Gabriel
Dennis Levy
Bookstore Assistants II

Christopher Ambridge
Mary Marsh
Bookstore Assistants I

Rental Gallery

Marian Parmenter
Director

Andrea Voinot
Rental Gallery Coordinator

Steven Pon
Senior Museum Technician

Sue Sproule
Executive Assistant

Leo Bersamina
Museum Technician

Lauren Klein
Accounting Assistant II

Suzi Sasaki
Secretary

Admissions

Joseph Shield
Admissions Assistant II

Edna Gonzales
Christine Huizar
Kristin Bach
Admissions Assistants I

**Development and Membership
Division**

Virginia Carollo Rubin
Director of Development

**Development and Membership
Department**

Lori Grant Fogarty
*Associate Director of Development,
Corporate, Foundation, and
Government Support*

Susan Lefkowich
*Associate Director of Development,
Membership*

Sue Martin
*Associate Director of Development,
New Museum Campaign*

Robin Seltzer
*Associate Director of Development,
Individual Gifts and Donor Recognition
Events*

Anne Hayden
Assistant Director of Development

Margaret Russell-Harde
Grants Manager

Hillary Adams
*Manager, Meetings and Events
Marketing*

Kehaulani Proctor
*Development Associate/
Meetings and Events*

Pilar Furlong
Joan Hooper
Development Associates

Kerri Condron
Membership Assistant

Gabriella Espinosa
Development Assistant

Tina Hawkinson
Bina Shah
Secretaries

Michael Doyle
Systems Administrator

Art Tours and Travel Department

Margy Boyd
Program Director

Jean Halvorsen
Modern Art Adventures Assistant

Suzanne Tan
Administrative Assistant

Auxiliaries

Jan Cohen Stessman
Modern Art Council Manager

Kerri Condron
*Contemporary Extension
Coordinator*

Jackie Kitaen
Collectors Forum Coordinator

Suzanne Tan
SECA Coordinator

Marcelene Trujillo
Foto Forum Coordinator

Theodore Taplin
Clerk Typist

**Public Relations and Marketing
Division**

P. Chelsea Brown
*Director of Public Relations
and Marketing*

Sandra Farish Sloan
Public Relations Associate

Genoa Shepley
Communications Assistant

Elizabeth Garrison
Secretary